EXTINCTION

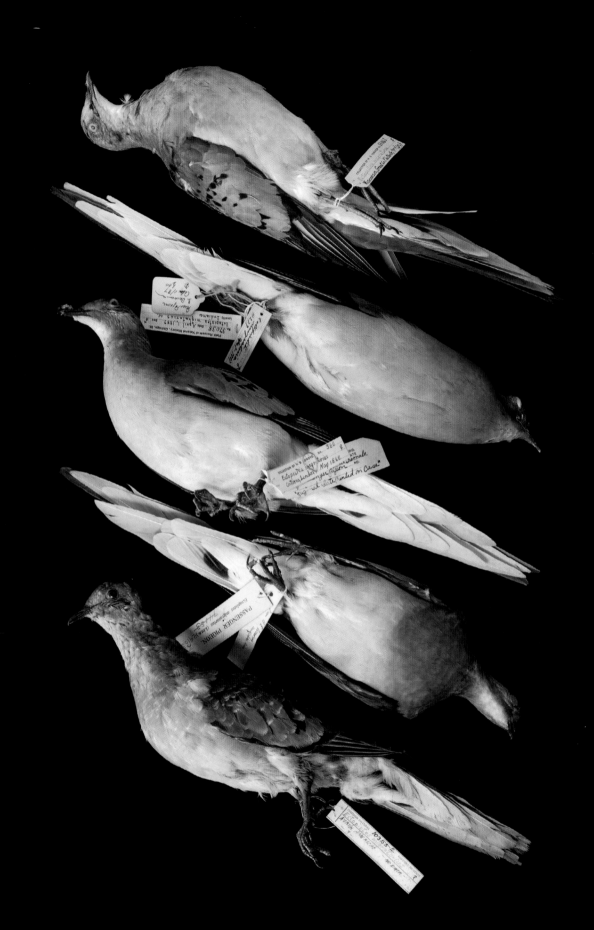

EXTINCTION

OUR FRAGILE RELATIONSHIP WITH LIFE ON EARTH

MARC SCHLOSSMAN

TEXT BY LAUREN HEINZ, BEN SCHLOSSMAN, AND NATHAN WILLIAMS

AMMONITE
PRESS

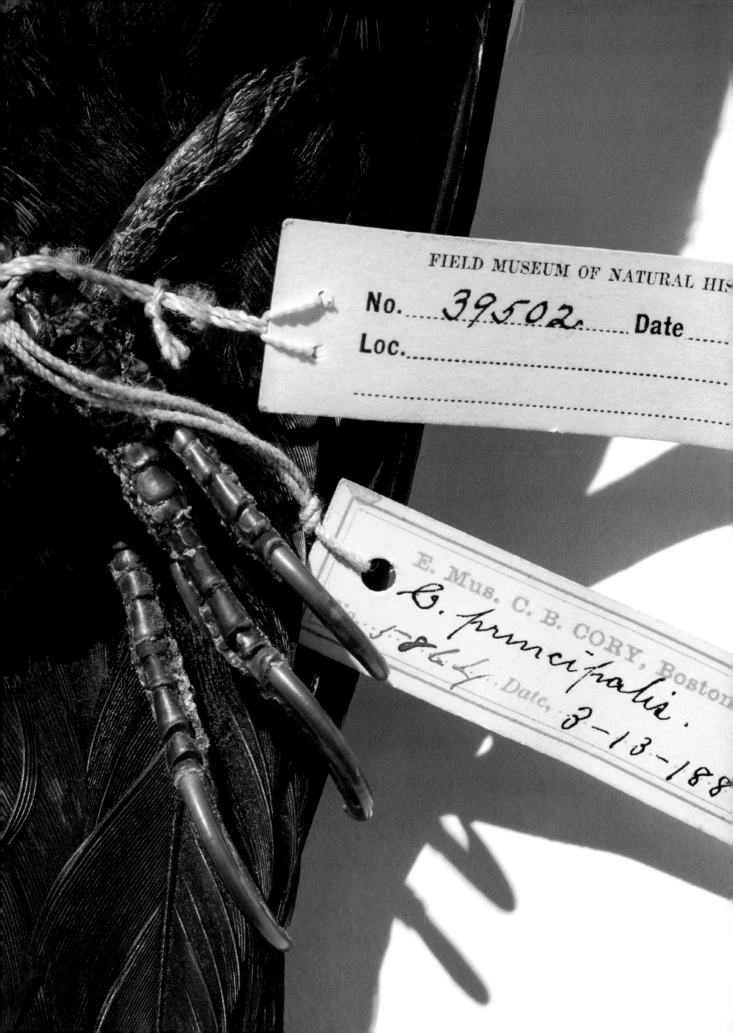

FIELD MUSEUM OF NATURAL HIS

No. 39502c Date

Loc.

E. Mus. C. B. CORY, Boston

C. principalis.

Date, 3-13-188

Contents

Species Overview

The specimens in this book were photographed exclusively in the Field Museum, Chicago, Illinois, US. Of the 82 species in this book, 23 are extinct. The conservation status designated by the International Union for Conservation of Nature (IUCN) has been assigned to each species.

Conservation Status

The IUCN's Red List of Threatened Species™ was established in 1964 and has become the world's most authoritative, comprehensive, and essential tool for guiding and informing conservation work and policy development throughout the world. In addition to assessing and listing information on over 138,000 species, various criteria are used to assign a conservation status to each species on the IUCN Red List:

Extinct (EX)

Extinct in the Wild (EW)

Critically Endangered (CR)

Endangered (EN)

Vulnerable (VU)

Near Threatened (NT)

Least Concern (LC)

Data Deficient (DD)

Not Evaluated (NE)

For more information, go to www.iucnredlist.org.

Taxonomic Classification

Taxonomy is the science of classifying, describing, and naming extinct and living organisms. The system consists of a hierarchy to organize and better understand biodiversity, accounting for similarities and differences, from the lowest to the highest level taxon (or group): species, genus, family, order, class, phylum, kingdom, and domain. The classifications most often encountered in this book are the genus and the species of each organism, a Latin binomial (a two-part scientific name) accompanying each common name.

Conservation Status Key

- **Least Concern**
- **Near Threatened**
- **Vulnerable**
- **Endangered**
- **Critically Endangered**
- **Extinct**

Conservation Successes

Seventeen conservation successes are featured in the book, symbolized by the yellow label to the left. The species' story associated with each specimen image highlights the dedicated work of biologists, conservationists, ecologists, and museum curators to understand threats to biodiversity. Natural history collections are crucial to conservation efforts because without historical data in the form of specimens, many lines of research to help protect species and their habitats would not be possible. Many of these conservation success stories are about species that have been brought back from the brink of extinction.

With just a few exceptions, the book highlights species that are near threatened, vulnerable, endangered, critically endangered, or extinct. Species here with least concern conservation status are either conservation success stories or too little is known about the species to assign a higher level of threat. None of the species featured have been designated by the IUCN as extinct in the wild (known only by individuals in captivity or as a naturalized population outside its historic range due to extreme habitat loss).

Threatened Species

Extinct Species

Foreword

Dr. John Bates

Curator of Birds, Negaunee Integrative Research Center,
Field Museum, Chicago

Our species, *Homo sapiens*, is just one of millions of species on Earth. In evolutionary terms, we have been in existence for a relatively short period of time. Yet never has a single species had the capacity to do more damage to the planet while also knowing how they can prevent it. The evolution of biodiversity on Earth across billions of years is the single greatest thing we are part of. Not only do we have an obligation to preserve this biodiversity, but we also have a fundamental need. We are at a crucial point in history where our actions dictate the future of our planet. The fact is, every species, including *Homo sapiens*, will eventually become extinct, and they may or may not leave behind descendant lineages. But for now, humans dominate the Earth, such that no corner remains untouched by some aspect of our activities.

I have spent more than 30 years working with natural history collections, which include specimens of extinct and endangered plants and animals. Scientific collections are an essential learning component to help us develop the tools to successfully coexist with the rest of biodiversity. They represent an essential record of the past but going forward they are of great value too. Every scientific specimen documents a point in time with information about the species and populations they represent. In current lexicon, advocates for these collections describe them as "extended specimens" because of how they have been used in the past and, thanks to the enormous advancements in scientific technology over the last 100 years, the mind-boggling fact that we can now gather and share data from them to study their genomes, phenotypes, and the environments they lived in.

Despite the dreams and efforts of some colleagues, I very much doubt that we will ever be able to bring back animals that we have driven to extinction. Recreating a passenger pigeon is a flight of fancy to me; the complexity of accurately recreating an entire genome when we have no blueprint to go on is likely futile. However, we can marvel at what was lost and why, and we can change our ways to do more to help species and habitats on the brink recover. But to do this we need to know enough to put sensible plans in action. Specimens provide records and associated information to help us do this.

As a modern curator, I am constantly reminded that I am stewarding the collections I work with so that future generations can learn even more from them and come to appreciate them and the species they represent as I do. To be successful stewards, we will need to add to these collections to study change over time.

Through his captivating photographs of scientific specimens from the collections of my institution, the Field Museum in Chicago, and the accompanying text, Marc Schlossman highlights the essential role museums play in facilitating our learning. His work reveals the fates and challenges already faced by species that are gone, or nearly so, and presents us with inspirational accounts of successful conservation efforts, so that we may learn and take hope from these examples.

I intend to die an optimist. I believe that humans can learn to be more effective guardians of the planet for the good of all biodiversity. There are stories of successes in that vein documented throughout our collections as well, many of which you will find here. As I turn the pages of Marc's book, I see little value in pessimism. When I do modern fieldwork, working with students enrolled in collection-based research, or I show a student the collections for the first time, we are not thinking about things that will never be again, we are documenting and studying change over time for the future—because we want there to be a future.

Humans are a species that can make a difference. These specimens document that, despite having a history of lamentable mistakes, of driving species to extinction, we have the capacity to create a mindset in future human generations to avoid such mistakes. I see Marc's book as a celebration of life and a stirring documentation of how far we must go to make sure my optimism is warranted.

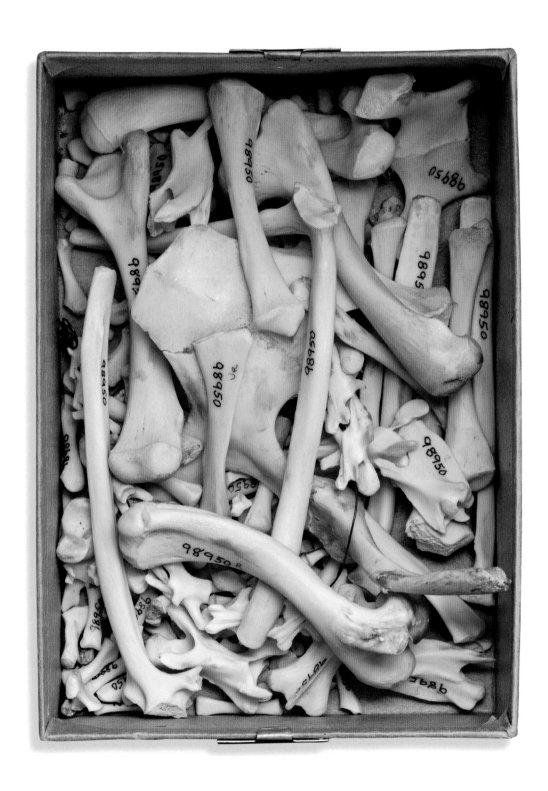

Above: Central American river turtle (*Dermatemys mawii*).

Introduction

Marc Schlossman

"As one grows older, one realizes how little one knows: 'the more you learn, the more ignorant you become.' The joy of being a scientist is to discover this."

Professor Michael J. Benton OBE FRS FRSE

Fourteen years ago, my nine-year-old twin sons, Ben and Theo, and I were given a tour of the Zoological Collections at the Field Museum in Chicago by Dr. John Bates, Associate Curator of the Birds Collection at that time. At one point in the tour, he opened a drawer that contained an astonishing set of bird specimens, some of which were extinct species. We picked them up, held them, and read the handwritten labels. It was a rare opportunity to see species such as an ivory-billed woodpecker and a passenger pigeon up close without the glass case between us and them. My overpowering thought at that moment was that these animals are gone. Forever. The last chance to see them is here, right now, in our hands.

John generously gave me access to the Birds Collection in 2008 and I began making photographs of endangered and extinct species in the Botanical and Zoological Collections. I started the project because I felt that the key causes of biodiversity loss were not receiving enough public exposure and debate. Over ten years, I photographed a list of 82 species whose stories collectively illustrate these driving factors: climate change, disease, habitat loss, invasive species, overexploitation, pollution, and the wildlife trade. The seven chapters in this book present these photographs and are arranged as the collections exist in the museum: Amphibians and Reptiles (stored together), Birds, Botany, Fishes, Insects, Invertebrates, and Mammals.

I have included many overlooked and uncharismatic species because the conservation of these species needs greater public attention, increased funding, and more research compared to charismatic species with donor appeal. It is far easier to raise money to protect the internationally recognizable giant panda than it is a freshwater mussel, so rarely seen outside its river habitat—yet both species are equally important to their respective ecosystems.

Extinction is happening right now, minute to minute, day by day. However, today's extinction rate is between 1,000 and 10,000 times the background rate (i.e., the number of species we expect to become extinct when referring to the history of species in the fossil record). A 2011 study states that 1.2 million species have been discovered and catalogued and estimates that 86 percent of all species on Earth have not been found. Human-related activities are almost certainly contributing to the extinction of species we do not even know exist.

Holding those extinct birds in my hands ten years ago gave rise to a series of questions that underpin this project: why is biodiversity loss happening so fast; is it too late; and what can be done? Our planet cannot sustain current levels of natural resource extraction and rising consumption in developed and emerging economies. In a report published in 2020, Dr. Anne Lariguaderie, Executive Secretary of the Intergovernmental Platform on Biodiversity and Ecosystem Services (IPBES) says, "Incremental change will not be sufficient—the science shows that transformative change is urgently needed to restore and protect nature.... transformative change can expect opposition from those with interests vested in the status quo, but such opposition can be overcome for the broader public good."

By far the biggest driver of extinction is loss of habitat. Corporations and financial institutions with vested interests in the production of, for instance, beef, palm oil, forest products, and soya profit from deforestation and the resulting loss of biodiversity. Everything we do or buy has a positive or negative effect on these vested interests and on the status quo. As the economist Kenneth Boulding remarked in 1973, "Anyone who believes that exponential growth can go on forever in a finite world is either a madman or an economist." Our consumer choices must become compatible with the kind of world we want to live in, grounded in the fact

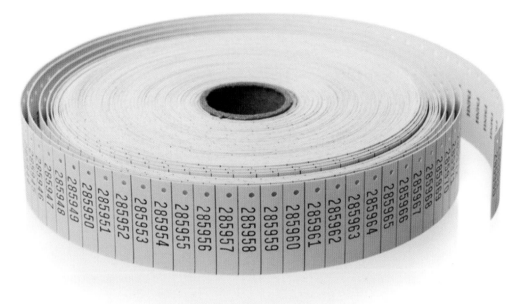

Above: Every specimen in a collection is tagged with a consecutive number, starting with the number one nearly 200 years ago when collections were established. This roll is unique—when it is finished, a collection manager orders the next series of numbers.

that we are part of nature and that we share this planet with every other species, all with the same right to exist.

In a 2006 report on the future of conservation biology, Professors Andrew Balmford FRS and Richard M. Cowling wrote, "Conservation is primarily not about biology but about people and the choices they make." I recently presented this project to some very smart people—three classes of nine-year-old students at a school in East London. At the end of the day, a boy in the front row asked me, "So, if we buy less stuff, recycle more, and get along better with animals, we can make the world better, right?" Two renowned professors of conservation science and a young student reach the same conclusion. Making better lifestyle choices requires increasing awareness through education—and collections are crucial in this process.

Right now, there are new species already in the drawers and cabinets of collections, sometimes decades after they were collected, waiting to be discovered, waiting for researchers to ask the right questions—possibly using tools that have not been invented yet. For instance, any specimens collected before the 1970s could not have been subjected to the kinds of questions that have been answered since then with advancing DNA sequencing technology.

Collections are time machines with roughly two centuries of data in a physical, three-dimensional form. Researchers unlock the information in specimens which leads to the discovery of new species and better ways to maintain biodiversity, thereby protecting the connections between all forms of life, including mankind. However, as our technological abilities advance, we find consequences for our actions that we could not have realized before. These consequences have accumulated since the Industrial Revolution, with a huge acceleration in the postwar period, making it pointless to blame any single generation more than another.

Will we transform ourselves and become the ideal stewards of our natural world? Or will we cause our own demise by neglecting the intrinsic connections between the health of ecosystems and our own well-being? We are witnessing a pivotal moment, one of many in the four billion years of the evolutionary time scale. To imagine this length of time is to feel awe. Awe is "a feeling of reverential respect mixed with fear and wonder." Alone in the Field Museum's corridors, surrounded by millions of specimens, I felt wonder at how life has evolved and sometimes fear of the future humanity is making now. Being in awe of nature is the starting point as we work to fulfill ourselves as stewards of life on Earth.

1 Amphibians and Reptiles

Opposite: Komodo dragon
(Varanus komodoensis).

"Reptiles and amphibians are sometimes thought of as primitive, dull, and dim-witted. In fact, of course, they can be lethally fast, spectacularly beautiful, surprisingly affectionate, and very sophisticated."

Sir David Attenborough

The transition from water to land in backboned animals (vertebrates), beginning over 400 million years ago, marks one of the most pivotal episodes in the history of life. The development of weight-bearing limbs and the ability to breathe air allowed a branch of fish to venture onto terrestrial habitats where they thrived on an abundance of unexploited food sources, free from competition. Amphibians were the first class of vertebrates to evolve from these pioneering ancestors and have since diversified to occupy an exceptional range of habitats across three distinct taxonomic orders: salamanders, caecilians, and frogs. The salamanders most closely resemble the extinct ancestors of modern amphibians, having preserved a tail and all four limbs. The caecilians are limbless with unusually elongated bodies and are confined to the warmer regions of the world. Comparatively little is known about this group, unsurprising given their mostly burrowing lifestyle. By far the most numerous and diverse group are the frogs, with over 5,500 described species.

The dire status of the world's amphibians has been recognized since the 1980s, when the golden toad (*Incilius periglenes*) of Costa Rica disappeared, subsequently becoming a "poster child" of the global amphibian extinction crisis. Amphibians are especially vulnerable to changes in their environment given their decreased overall mobility that exacerbates the effects of habitat degradation, coupled with a strong dependence on environmental factors for various life processes, and highly permeable skin. These factors increase their susceptibility to pollution, droughts, and ultraviolet radiation. However, especially across Latin America, crashes in amphibian populations coincide with the spread of the deadly chytrid fungus (*Batrachochytrium dendrobatidis*). High-altitude species, such as those occupying cloud forest ecosystems, are being ravaged by this disease as climate change renders these habitats more suitable for this particular fungal pathogen.

In other parts of the world, where the effects of chytridiomycosis are less pronounced, the principal factor driving amphibian declines is more uncertain. Nevertheless, around half of amphibians are now threatened and even the most conservative estimates of current extinction rates suggest that nearly 10 percent of all frog species may be lost by the end of the century.

While amphibians are extremely diverse, they remain geographically quite restricted. Numerous factors, such as the need to keep their skin moist for gas exchange, mean that amphibians are tied to places with a reliable

"The dire status of the world's amphibians has been recognized since the 1980s, when the golden toad (*Incilius periglenes*) of Costa Rica disappeared."

supply of water, so their conquest of the land is relatively incomplete. Following the evolution of watertight scaled skin and eggs with a hardened outer shell—leading to the permanent transition to terrestrial habitats—the first fully land-based vertebrates would diversify into two great lineages. One branch would eventually give rise to the mammals and the other to several orders commonly referred to as the "reptiles," including the tuatara, tortoises, crocodiles, and lizards and snakes.

Around 20 percent of all reptile species are believed to be at risk of extinction, with the dominant threat being habitat loss following the conversion of land for agriculture and urban developments supporting rapidly increasing human populations. In general, the tropics harbor the greatest proportion of threatened species after correcting for total species richness, owing to less well-enforced environmental regulations that are common in less developed countries. Moreover, some reptiles exhibit temperature-controlled sex determination and current

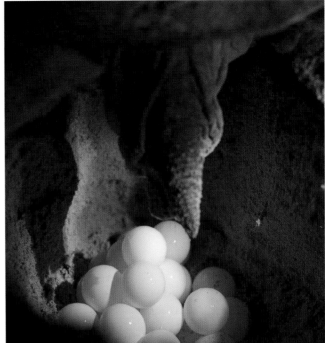

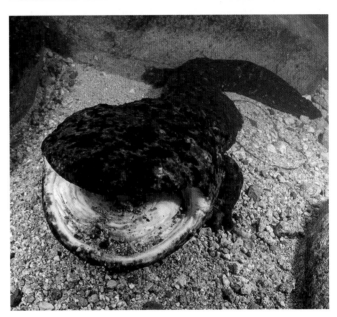

Above left: Scanning electron micrograph of a frozen intact zoospore and sporangia of the chytrid fungus (*Batrachochytrium dendrobatidis*).

Top right: The green sea turtle (*Chelonia mydas*) can lay as many as 200 eggs in one clutch.

Bottom right: The Japanese giant salamander (*Andrias japonicus*) can live for more than 70 years.

rates of climate change may outpace their capacity to adapt, skewing the sex ratios of populations and eventually contributing to the extinction of certain species. Alternatively, some taxa may benefit from the impact of climate change, allowing them to inhabit previously cooler regions of the world formerly beyond their reach, given their reliance on the ambient environment to regulate their body temperature.

Despite having persisted for hundreds of millions of years, surviving the most profound mass extinction events of the geologic past, amphibians and reptiles (collectively known as "herpetofauna") contain some of the most imperiled species. As particularly ancient lineages with many important ecological roles, their extinction will have the joint impact of a major loss of evolutionary history and the compromised health of ecosystems. Despite the fact that present reptile extinction rates are thought to be lower than that of amphibians, they too face an uncertain future against a backdrop of rapid anthropogenic changes to the biosphere. Neither group should be neglected from global conservation initiatives.

Quito Stubfoot Toad

Atelopus ignescens

Some of the estimated 113 species of frogs that make up the genus *Atelopus* are among the most brilliantly neon-colored amphibians in the world. Native to Central and South America, these neo-tropical toads are small—no larger than 1½ inches (38 mm)—and inhabit high elevations and rainforests. Along with pollution and habitat loss, *Atelopus* toads have been greatly affected by the spread of a waterborne chytrid fungus that infects the skin of amphibians, with up to 80 percent of the genus in rapid decline. Known as chytridiomycosis, the disease is easily spread through direct contact. It is deadly to amphibians by making their skin too thick to absorb water, their only way of drinking, while also affecting other physiological functions. Its spread is largely attributed to the pet and food trade, an epidemic that can only be controlled by quarantines and trade restrictions. There is no cure for chytridiomycosis, nor can it be eradicated from wild populations.

The Quito stubfoot toad was once incredibly abundant in the Andes of Ecuador—in the early 1980s, scientists described the difficulty of not stepping on them as thousands occupied the rainforest floor—until the chytrid fungus started to seriously affect its numbers, leading to it being declared extinct by 1989. The herpetology world was surprised when a relict population of 27 *A. ignescens*, with their jet-black bodies and fiery orange bellies (its species name *ignescens* means "to catch fire") was found alive and well in Ecuador in May 2016.

Researchers relocated individuals into a lab so that they could monitor breeding and increase the species' chances of survival. While this is often the last resort taken in conservation efforts, it remains to be seen whether it will result in a viable population. Said Andrew Gray at the University of Manchester, UK, "These frogs could disappear at any time, so if scientists manage to aid their reproduction, that's a safety net for the future." It is thought that just under 250 individuals exist in the recently discovered subpopulation and the species has been recategorized as critically endangered.

Conservation Status

● Critically
 Endangered

The evolution and dispersal of the *Atelopus* species has been used to date the closing of the Panama Isthmus in Central America to around 4 million years ago.

Number of identified and described *Atelopus* species

32

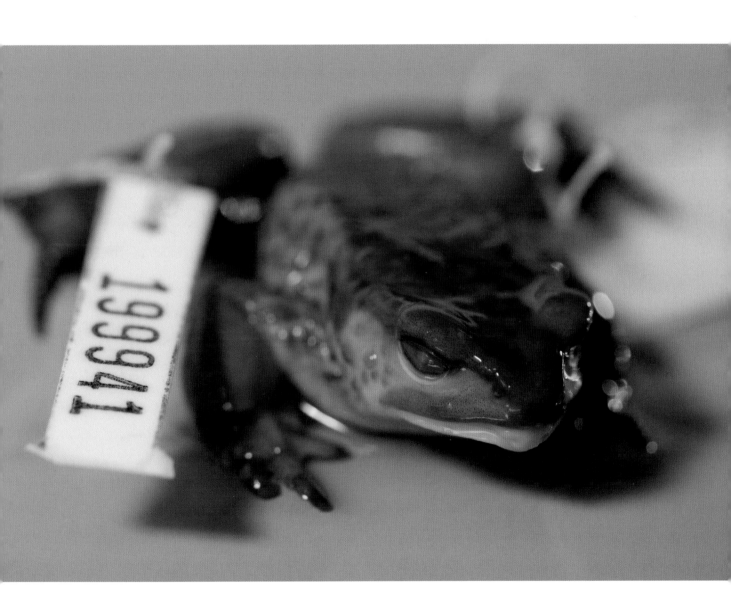

Goliath Frog

Conraua goliath

As its name implies, the goliath frog is the largest living species of frog in the world, weighing up to 6½ pounds (3 kg) and measuring 13½ inches (34 cm) long. According to a study in 2019, these frogs are believed to have evolved to such a large size due to their unusual technique of nest building—often digging into gravel riverbanks and placing large rocks, sometimes weighing more than half of the frog's weight, around their nests.

The goliath frog has a small range, found only in sandy-bottomed rainforest rivers and streams in Equatorial Guinea and Cameroon. It has reached endangered conservation status because its population is estimated to have decreased more than 70 percent over the past 15 years.

Goliath frogs are severely threatened by the bushmeat trade and more sophisticated traps have recently made them easier to capture. Added to this pressure are river pollution, deforestation (for agriculture and logging), and residential and commercial development encroaching on its already limited habitat. Due to their size, goliath frogs are a popular species imported into the United States for zoos, the pet trade, and even to be used in frog jumping competitions. The species does not breed in captivity.

At present, international trade of the frogs remains unrestricted. The government of Equatorial Guinea was the first to set a limit on the numbers of goliath frogs that can be exported in one year—300 individuals—but it remains to be seen whether other countries will follow suit. Protecting the remaining goliath frog habitat is just as crucial as regulating international trade. There are now three wildlife sanctuaries in Cameroon and one national park in Equatorial Guinea established in an attempt to conserve what remains of the frog's habitat.

Overleaf: The skeleton of a goliath frog.

Conservation Status

● Endangered

Goliath frogs have significantly lower genetic diversity compared with other frogs in the order Anura, meaning its future hardiness to disease and environmental change is extremely limited.

Current number of individuals per square mile in natural habitat

22 (8.5/km²)

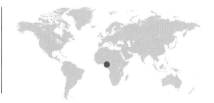

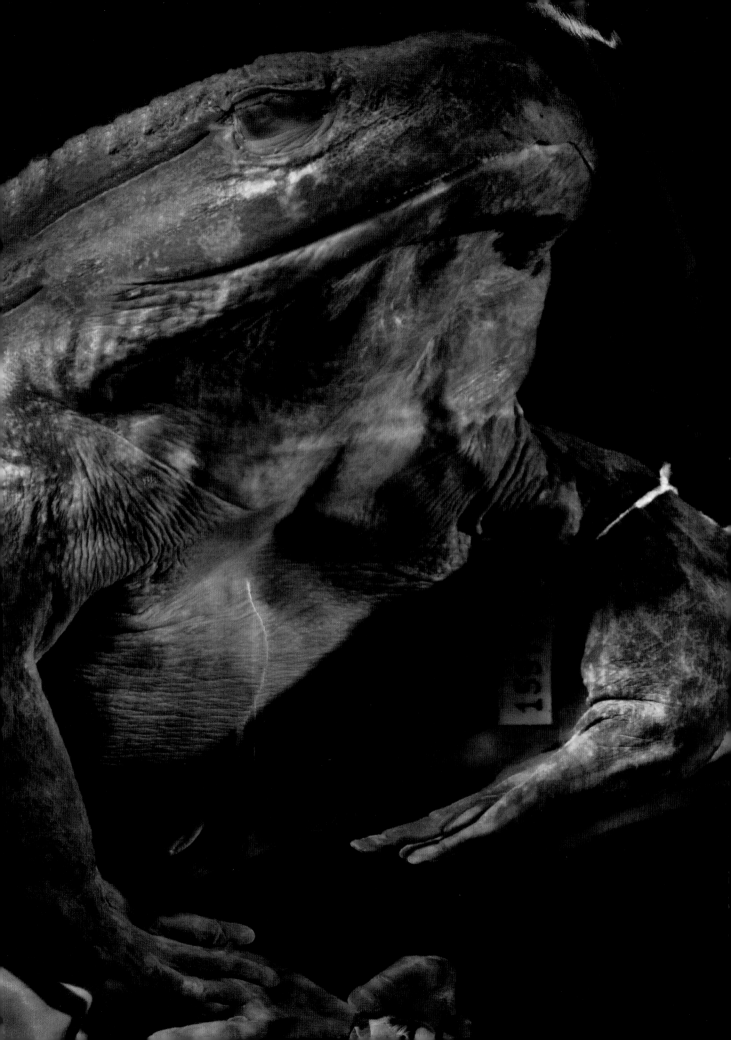

FMNH No.
Conraua
Cameroo

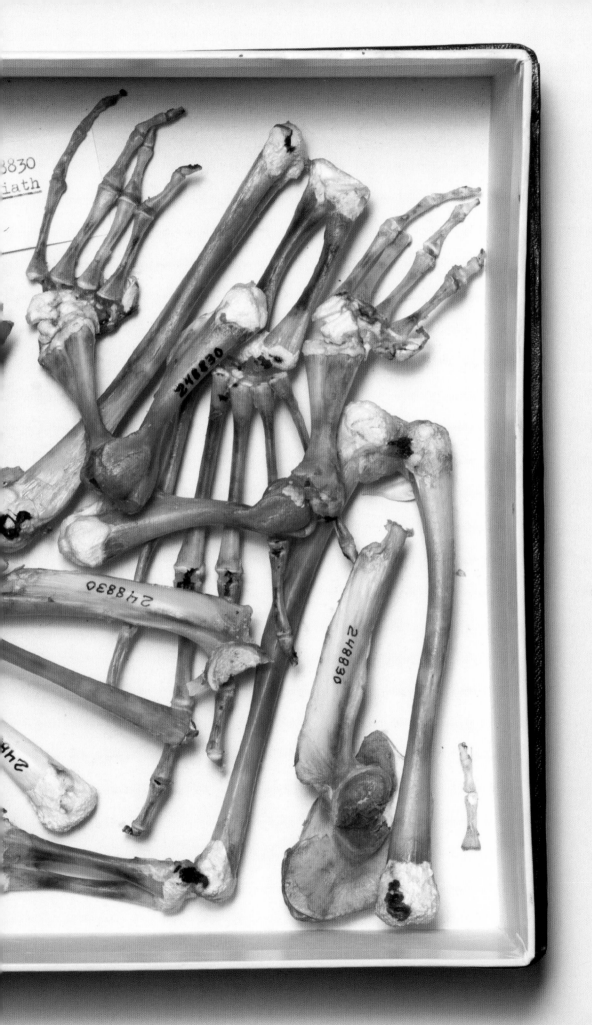

Santa Catarina Leaf Frog

Phrynomedusa appendiculata

The task of correct identification in museum collections is immense. The individual pictured here was originally identified as a spiny-knee leaf frog (*Phrynomedusa fimbriata*) when Werner Bokermann, a Brazilian herpetologist, sent it to the Field Museum in 1959. The spiny-knee leaf frog is considered extinct. It was endemic to Brazil and the species was described from the holotype, collected in 1898. A holotype is the single specimen used to formally describe the species and the specimen to which all other specimens are compared.

After this photograph was made in 2015, Collection Manager Alan Resetar questioned the identification and contacted Dr. Carlos Alberto G. da Cruz, a herpetologist in Brazil. After examining photographs sent to him, Doctor Cruz confirmed that the specimen was not a spiny-knee leaf frog but the closely related Santa Catarina leaf frog.

A live Santa Catarina leaf frog has not been documented since 1970. Despite a lack of evidence over five decades, it is not yet considered extinct (it is listed as near threatened on the IUCN Red List) but it is widely believed to have suffered the same fate as many other tropical, high-altitude small frogs, having succumbed to ecosystem changes and to chytridiomycosis, a disease caused by the rampant chytrid fungus.

Conservation Status

● Near
Threatened

Phrynomedusa tree frogs are rarely found in the Atlantic forest of Brazil, with several others species only identified from a holotype.

Maximum length in inches

1¾ (44 mm)

Golden Toad

Incilius periglenes

The golden toad was a small amphibian ranging from 1½ to 2¼ inches (39–56 mm) long. Males were a brilliant, bright orange and females exhibited a variety of colors, sometimes black, yellow, green, red, or white. It was once abundant in the cloud forest north of Monteverde, Costa Rica—a tropical, montane forest that experiences frequent cloud cover. They spent most of their lives in underground burrows, particularly during the dry season, and gathered in the hundreds in small pools to breed during only a few days of the wet season.

The species was only discovered in 1964; however, it experienced a sudden, damaging crash in 1987, along with nearly half of all other frogs and toads within 18½ miles (30 km) of its range. The species was last seen in 1989 when researchers found just one male. Ongoing extensive searches have been unsuccessful in locating any more individuals.

Some researchers say the golden toad was the first species to become extinct as a direct result of climate change. Others hypothesize that it was the 1986–87 El Niño event, during the time the species was disappearing, that resulted in hotter, drier conditions and made the toad vulnerable to chytridiomycosis, a disease caused by fungi that affects vital functions of amphibians' skin.

Amphibians can be particularly sensitive to subtle changes in their environments brought on by an increase in temperature or pollutants and they are early indicators of catastrophic changes in ecosystems. The impact of one El Niño cycle on Central and South American amphibians shows that warming due to climate change can have devastating consequences.

In 1991, the IUCN established a task force, the Amphibian Specialist Group, to conduct research into the 30 percent of amphibian species that are threatened with extinction, in an attempt to save them from the same fate as the golden toad.

Conservation Status

● Extinct

Chytrid fungus is often spread by local human activity and made worse by climatic disruptions of vulnerable populations.

Average amount of time all frog species spend hiding throughout the day

95%

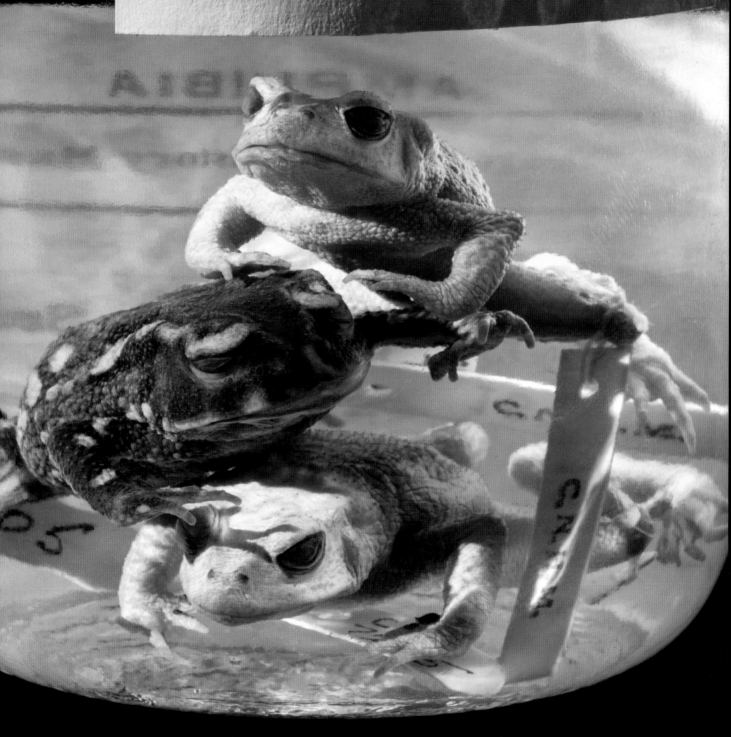

Olm

Proteus anguinus

The olm, or cave salamander, is a unique species of salamander that differentiated from its nearest relative about 56 million years ago. It is the only species in the genus *Proteus*. This entirely aquatic amphibian inhabits the waters flowing through subterranean limestone caves in central and southeastern Europe and has specifically adapted to that environment. In one form, the skin has no pigment and has an almost translucent glow. The second form, occurring in a small area of Slovenia, is darkly pigmented. Living in complete darkness, its eyes are vestigial yet light sensitive. It has heightened senses of smell, taste, hearing, and electro-sensitivity. Olms can go without food for up to 10 years and can live to well over 50 years and possibly up to 100 years.

Like many other amphibians, it is very sensitive to changes in its environment, especially those caused by water pollution. Land development above the cave systems it inhabits—for agriculture, tourism, and construction—has a direct influence on the quality of its habitat. As an unusual species, the olm also suffers from illegal collection for the pet trade.

The IUCN has classified the species as vulnerable because its numbers are continuing to decline along with increasing threats to its habitat. It is protected by law in many of the countries in its range and in 2016 researchers were able to successfully breed olms in a scientifically controlled environment in a cave in Slovenia. Establishing a breeding colony allows further research into the evolution and conservation of the olm.

Proteus anguinus also benefits from being a very celebrated species. In Slovenia it is considered a national treasure—colloquially referred to as baby dragons—and in 2012 Sir David Attenborough chose the species as one of 10 that he would select to save from extinction. "The olm lives life in the slow lane which seems to be its secret for living a long life," said Attenborough. "And perhaps that is a lesson for us all."

Conservation Status

● Vulnerable

Collecting genetic material from their surroundings, the noninvasive survey method of environmental DNA (eDNA) has been used to identify olm in 15 caves across Croatia.

Length of reproductive cycle

12 years

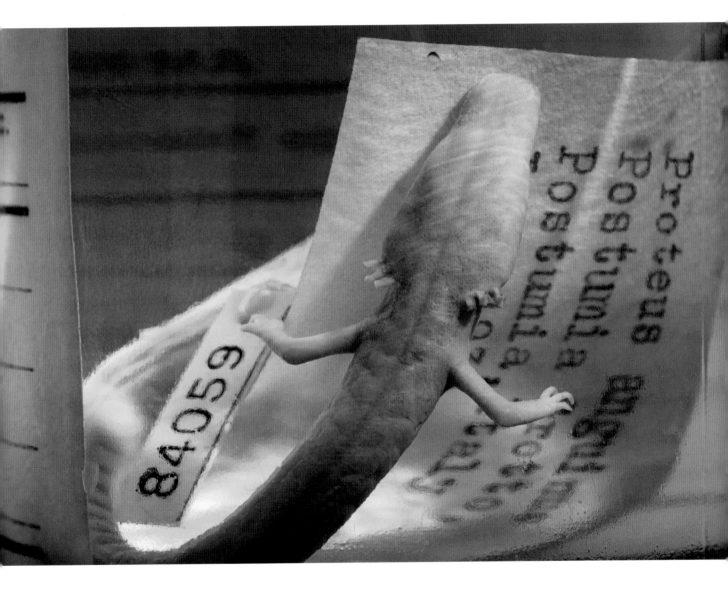

Komodo Dragon

Varanus komodoensis

The Komodo dragon is the largest living species of lizard in the world—the biggest recorded individual was over 10¼ feet (3 m) long and weighed 366 pounds (166 kg). Komodo dragons are carnivorous and can eat up to 80 percent of their body weight in a single feeding. They are adept at hunting a variety of prey—anything from birds and rodents to horses and water buffalo—using their shark-like teeth and venomous saliva that induces shock and blood loss, killing anything that escapes their jaws. Native to five Indonesian islands, including the island of Komodo where it gets its name, the lizard's large size has been attributed to island gigantism, whereby a species inhabiting an island dramatically increases in size in comparison to its relatives on the mainland, usually due to the lack of competitors and predators.

There are approximately 3,000 Komodo dragons remaining in Indonesia, which is only a fraction of its population a mere 50 years ago. They are listed as vulnerable due to habitat destruction from development and natural disasters, loss of large prey (such as deer) from widespread hunting, and illegal hunting of the lizards themselves.

The Komodo National Park was established in 1980, covering the islands Komodo, Rinca, and Padar in an attempt to conserve the species' habitat (although the lizard has not been seen on the island of Padar since the 1970s). The park is now listed as a UNESCO World Heritage Site and attracts tens of thousands of tourists annually. Indonesian authorities tried to impose a ban on tourism for the year 2020 to allow habitat regeneration but local residents were concerned about their livelihood and the ban was reversed. They instead announced a plan to limit visitor numbers by raising entry prices to visit Komodo Island.

Around the same time, plans for a major tourist attraction on Rinca Island, dubbed "Jurassic Park," were unveiled in an architect's video rendering, complete with the theme song from the movie. Residents and environmental groups protested the development, concerned that it is more motivated by financial gain than conservation. The attraction is due to be completed in 2021 and in an example of "life imitating art," one worker was attacked and severely injured by a Komodo dragon just months after construction began.

Conservation Status

● Vulnerable

Komodo dragon blood has been used as biological inspiration to design a powerful antimicrobial and wound-healing molecule for future medical use.

Number of toxin types detected in its venom

5

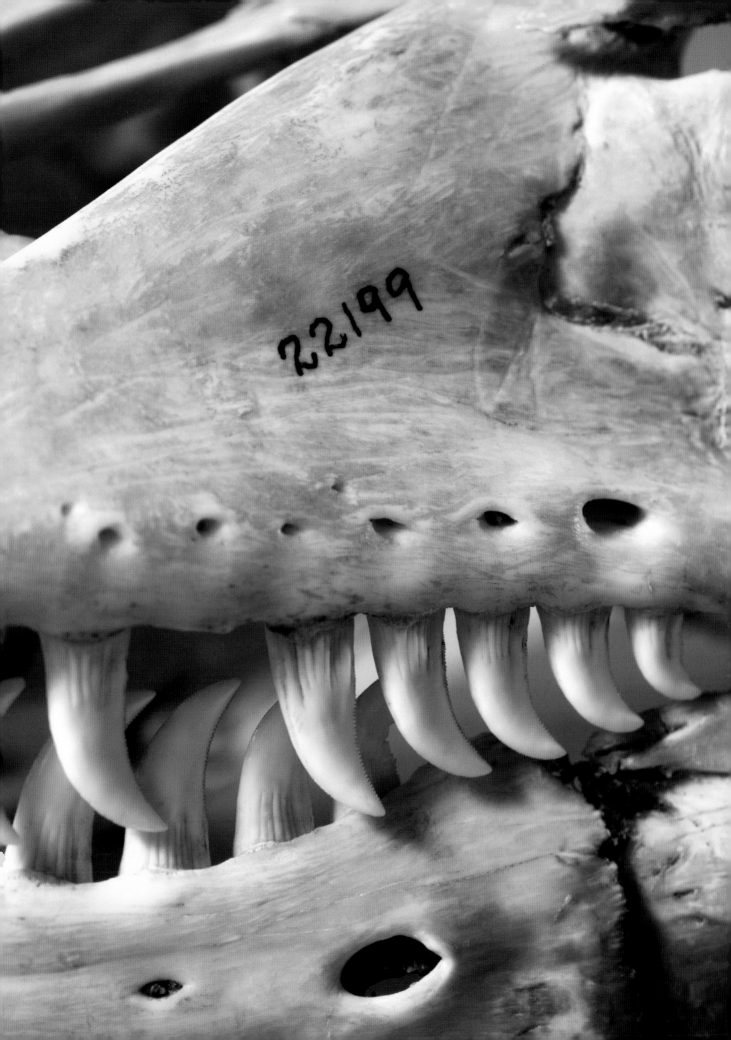

Chinese Alligator

Alligator sinensis

The Chinese alligator is endemic to the lower Yangtze (Changjiang) River region of China. This freshwater reptile inhabits slow-moving bodies of water and during long periods of low temperature it brumates, in which it rests in a hibernation-like state of inactivity. It is one of the smaller crocodilian species, at around six feet (1.8 m) long and weighing only 85 pounds (38.5 kg).

The Chinese alligator is one of the most endangered species of crocodilians. Once occurring widely throughout the lower Yangtze River system, today its population is severely fragmented and almost eradicated. Along with several other species endemic to the Yangtze River, destruction or alteration of their habitat have been the driving forces behind the Chinese alligator's critical endangerment, namely through the building of dams and the conversion of marshland to agriculture. The species also has to contend with human contact. Alligators are killed out of fear, for their meat, and for their organs that are coveted in traditional Chinese medicine.

The Anhui Research Center for Chinese Alligator Reproduction was established in 1979 and has been very successful in the captive breeding of *A. sinensis*, housing about 75 percent of the 20,000 individuals that have been produced in captivity worldwide in 26 protected reserves. As of 2019, 228 Chinese alligators have been released into the wild at the Anhui Chinese Alligator Nature Reserve. There is also an attempt by the Chinese government to create habitats in other provinces in which captive-bred animals can be reintroduced. Nonetheless, as with any species that is perceived as a threat or as a source of profit, public education on the decline of the Chinese alligator is paramount to its survival.

Conservation Status

● Critically
Endangered

During brumation in low temperatures (a reptilian form of hibernation), *A. sinensis* expresses 25 percent of its protein coding genome differently to when it is active in warmer temperatures.

Time since significant population bottleneck

25,000
years ago

Philippine Crocodile

Crocodylus mindorensis

There are approximately 100 Philippine crocodiles remaining in the wild, making it the rarest and most threatened crocodile in the world. It can reach a maximum size of about 10 feet (3 m) and, while it is endemic to the Philippines and was originally found around the country, its population is now fragmented and limited to only a few islands.

It is one of two species of crocodile found in the Philippines. The other, the larger Indo-Pacific crocodile, is an aggressive saltwater crocodile known to attack humans. The Philippine crocodile is much more timid and shies away from human contact—there are no accounts of these creatures ever killing a human—yet they are regularly mistaken for their saltwater relatives and killed. This has had a great impact on its numbers, as has the destruction of their habitat for agriculture or development.

Traditionally, there has been little motivation from the public or government to work to conserve the Philippine crocodile. The word "crocodile" is actually an insult in the Filipino language, an indication of the cultural obstacles in the way of protecting the species. International trade in the crocodiles is prohibited but there is only one officially protected, yet poorly enforced, conservation area for *C. mindorensis* in the country. In one positive step toward saving the species from extinction, a captive breeding program is in place and as many as 50 of the freshwater crocodiles have been released into the wild over the past decade.

Conservation Status

● Critically Endangered

Analysis of Philippine folklore shows a past of harmonious coexistence with the species, contrasting with the current corrupted state of this interaction.

Average egg clutch size

20

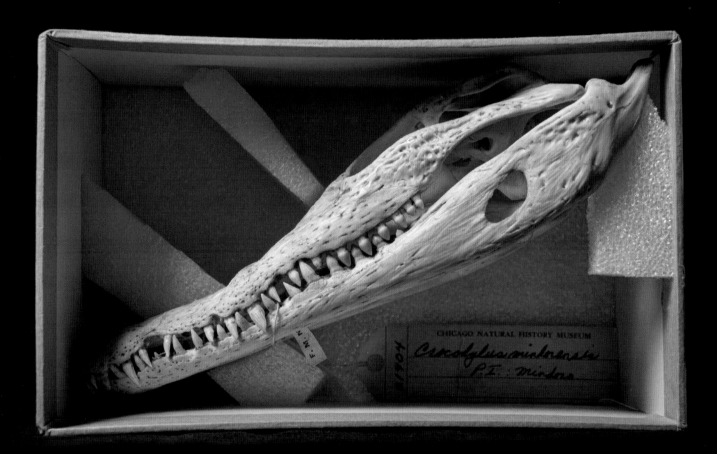

Egyptian Tortoise

Testudo kleinmanni

With an average shell length of 5½ inches (14 cm), the Egyptian tortoise is one of the smallest tortoises in the world. It is named after Édouard Kleinmann, a French financier and naturalist, who apparently acquired the first specimens in the 1870s. It occurs in arid areas along the Mediterranean in Libya, Egypt, and Israel. However, since 2001, only two individuals have been spotted in Egypt, restricting its small numbers still in the wild to Libya and Israel.

Habitat destruction is a major factor in its presumed eradication from Egypt and its critical endangerment as a species. Its desirability in the international pet trade over the past 20 years due to its rarity and small size encourages poaching. The species is currently protected under the Convention on International Trade in Endangered Species (CITES), making it illegal to sell, purchase, and transport the animal without permits. Yet a quick Internet search can lead prospective collectors to several sites where captive-bred hatchlings of the tiny tortoise are sold for the hefty price tag of US$1,000 or more.

As of 2021, project grants have been implemented by the Critical Ecosystem Partnership Fund (CEPF) to assess populations of the Egyptian tortoise, conserve habitat, and identify areas for reintroduction in Egypt. Raising awareness of the plight of this species has also found success. A local community in Libya recently reported a smuggling attempt to CEPF who were able to save 250 tortoises and return them to their natural habitat.

Conservation Status

● Critically
Endangered

Future conservation efforts may focus on acclimatizing tortoises to their environment before their release to improve the success of future populations.

Number of species of plants in diet

34

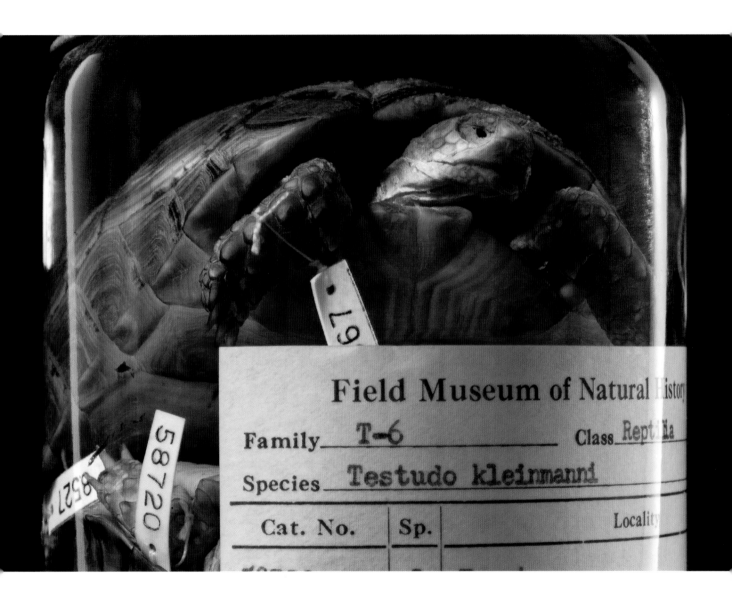

Field Museum of Natural History

Family_____ T-6 _____ Class_ Reptilia

Species_ Testudo kleinmanni _____

Cat. No.	Sp.		Locality

Leatherback Sea Turtle

Dermochelys coriacea

The largest of all turtles, the leatherback sea turtle can grow up to 9 feet (2.7 m) long and weigh between 550 and 1,540 pounds (250–700 kg)—although the largest ever recorded individual weighed 2,019 pounds (916 kg). The leatherback differs from other turtles as its ridged shell is flexible and leathery, hence the name. Because they are able to maintain a high body temperature, leatherback sea turtles have the ability to dive to more than 3,280 feet (1,000 m) in search of food. These migratory creatures are one of the few turtles that are found throughout the world and can travel as much as 4,350 miles (7,000 km) in a matter of months. Rising sea temperatures and changing ocean currents are resulting in leatherbacks making longer journeys from nesting to feeding grounds searching for jellyfish, their main food source. They are apparently migrating toward the poles to reach cooler waters.

Female leatherbacks tend to choose sandy tropical beaches to nest once every one to three years. They lay as many as nine clutches of eggs each breeding season. Only about 1 in 1,000 hatchlings survive to adulthood. The sex of a hatchling is determined by temperature, which means that in line with global warming, the leatherback population could gradually be dominated by females, making the species extremely vulnerable. Added to this are the threats of beach erosion, changing ocean tides, drowning in commercial fishing nets, and consuming floating plastic bags mistaken for jellyfish.

While leatherbacks are considered vulnerable as a whole, its two subpopulations in the Pacific are widely considered to be critically endangered. In 2013 the IUCN estimated that there were 1,400 adults in these subpopulations and speculated that this would drop below 1,000 by the year 2030.

The collection number of this specimen makes it just the 58th entry into the Amphibians and Reptiles Collection of the Field Museum, collected on or before 1893. The handwritten label states that it came from Ward's Natural Science Establishment in Rochester, New York. Ward's founder, Henry Augustus Ward (1834–1906), was a pioneer in supplying specimens to feed "collection fever" as academic institutions and museums voraciously acquired them for education and research, thus enabling the golden age of collecting in the late 1800s. Collections were intended to educate the public and create awareness at a time when taxidermy and museum exhibits were extremely popular in presenting the new and unknown. However, as collecting became big business and expeditions were dispatched around the globe to return with huge quantities of specimens, serious discussion evolved regarding conservation, loss of biodiversity, and humankind's relationship to the natural world—issues commonly believed to be contemporary have been considered for over a century.

Conservation Status

● Vulnerable

Leatherbacks maintain consistent body temperature using countercurrent exchange, where temperature is exchanged via blood flowing in opposite directions.

Number of longitudinal ridges on their backs that improve hydrodynamic performance when swimming

5

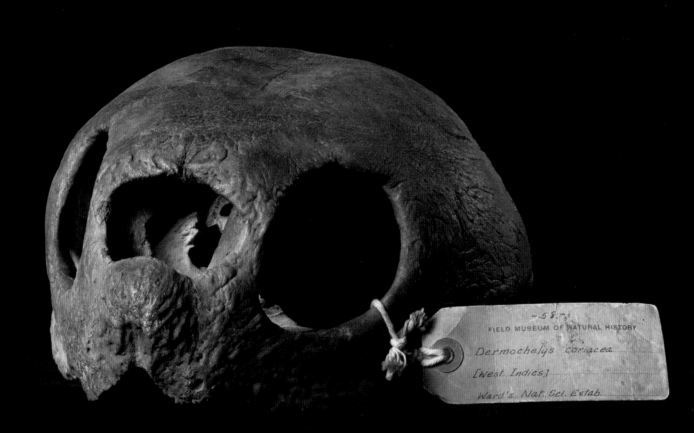

Hawksbill Sea Turtle

Eretmochelys imbricata

The hawksbill sea turtle is found in shallow, tropical, and subtropical waters, including coral reefs, and has an important role in the ecosystem: it eats sponges that can harm the reefs. Relatively small compared with other sea turtles, hawksbills grow up to 4 feet (1.2 m) in shell length and 150 pounds (68 kg) in weight. Like other sea turtles, the hawksbill sea turtle is threatened by several factors: loss of habitat from coastal degradation and development, hunting for its meat (which can be toxic due to its diet of sponges) and its eggs, and accidental capture in commercial fishing and pollution.

One of the biggest threats to the hawksbill, however, is the illegal wildlife trade, contributing to an 80 percent decline in their numbers over the past century. Its beautiful carapace is used to make "tortoiseshell" decorative items, including jewelry, combs, and furniture. Before the ban on the tortoiseshell trade in 1977, it is estimated that Japan imported two million hawksbill between 1950 and 1992. Today, a thriving black market for tortoiseshell still exists—an estimated 1,243 pounds (564 kg) of hawksbill shells were seized by Japanese customs between 2000 and 2019. This, combined with other threats, may eventually drive the species to extinction.

Conservation Status

● Critically
 Endangered

Found around the world, all hawksbill sea turtles are descended from either the Atlantic or Indo-Pacific basin, with the African and American continents functioning as evolutionary barriers.

Minimum time to reach reproductive age

14 years

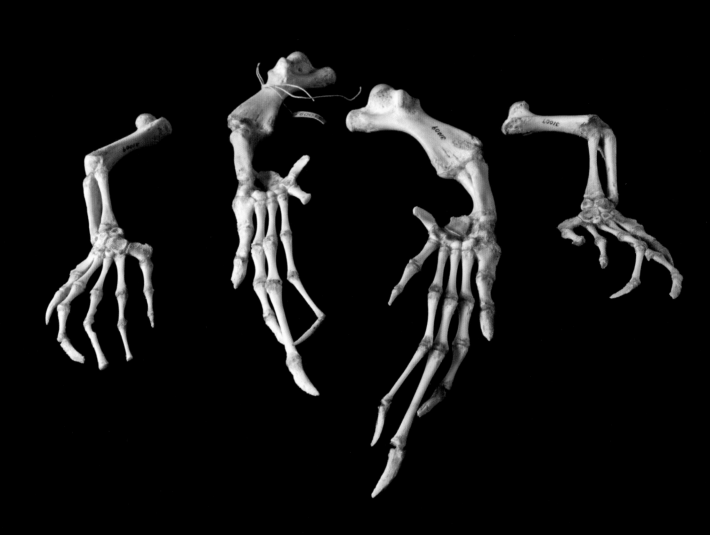

Floreana Giant Tortoise

Chelonoidis niger

In 1835, Charles Darwin, a young naturalist aboard the second voyage of the HMS *Beagle*, spent five weeks studying the flora and fauna of the Galapagos Islands. His observations of the Galapagos tortoises on San Cristobal and Santiago Islands, and the distinct variations between tortoises living in the humid highlands (larger, with domed carapaces and short necks) versus the dry lowlands (smaller, with flatter carapaces and longer necks) played an important role in his theory of evolution.

There are 15 species of giant tortoises on the Galapagos Islands, three of which are officially declared extinct. Another, the Fernandina giant tortoise (*Chelonoidis phantasticus*), was rediscovered in February 2019. Darwin found no live tortoises on Floreana (known as Charles Island at the time) but he did find carapaces and noted that the species was the primary food source for the islanders. It is thought that the tortoise was hunted to extinction by 1850 and no live individuals have been observed there since.

This specimen, with a handwritten "extinct" label, was collected by Karl Patterson Schmidt, one of the most important herpetologists of the twentieth century and Assistant Curator of Amphibians and Reptiles at the Field Museum in the 1920s. In 1930, Sidney Nichols Shurcliff published his account of the Field Museum's Crane Pacific Expedition of 1928–29—when Schmidt collected this shell—titled *Jungle Islands: The Illyria in the South Seas*. It reads: "We let ourselves down a dark narrow shaft with a long rope and came into a large underground cavern... we discovered several dozen shells of the extinct Charles Island tortoise, three in perfect condition... this type of tortoise has been extinct for more than a hundred years. The ones we found must have fallen down the shaft and died in the cave through lack of food." Recent research suggests that voluntary entry and exit via the cave was possible by more gradual inclines that are now obliterated.

Some 80 years later, in 2008, new information about the species emerged. Scientists believe that the tortoise may still exist but on another island in the Galapagos archipelago. They uncovered a "bizarre mix of genes" in 80 tortoises that inhabit Isabella Island, showing clear ancestry to the Floreana giant tortoise. They hypothesize that whalers and pirates may have been responsible for transporting the tortoises to another island—they were sometimes brought to different islands by ship or thrown overboard to lighten their load. As these tortoises are known to live up to 150 years, there is a possibility that some of the original species are still alive. Although it would be extremely fortuitous to find a live specimen, researchers claim that the hybrid tortoises that exist could provide enough of a link to resuscitate the extinct species, using specialized breeding methods.

Conservation Status

Extinct

It is thought that they could survive falls of up to 20 feet (6 m), owing to their hard and tough body.

Projected cost of future genome and population conservation in USD

$2m

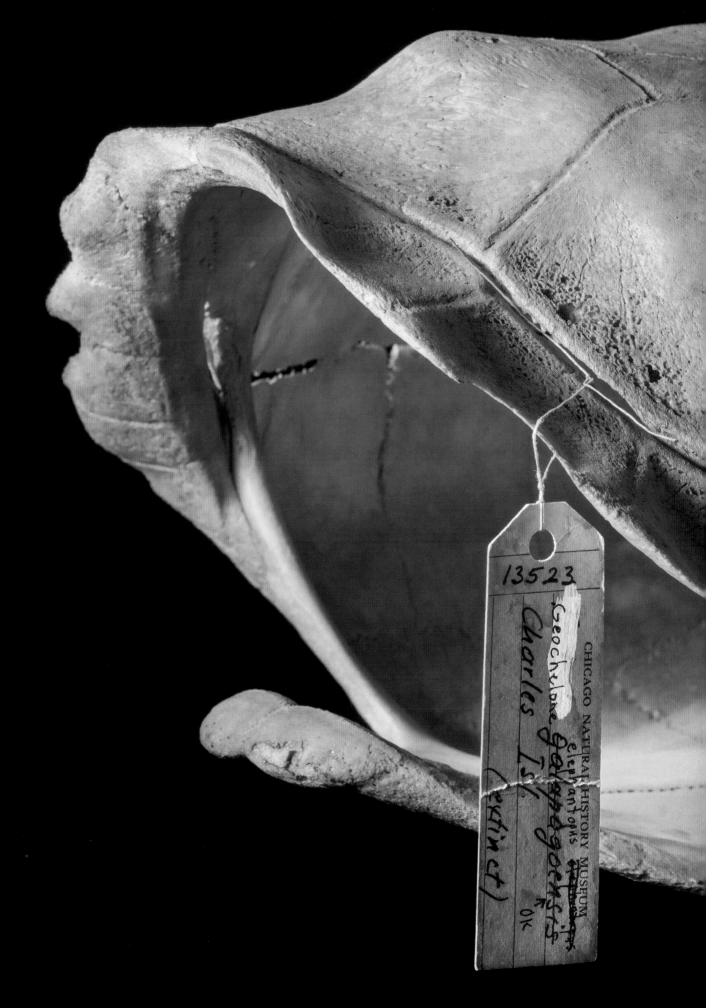

13523

Geochelone elephantopus
galapagoensis
Charles Isl.
(extinct)

OK

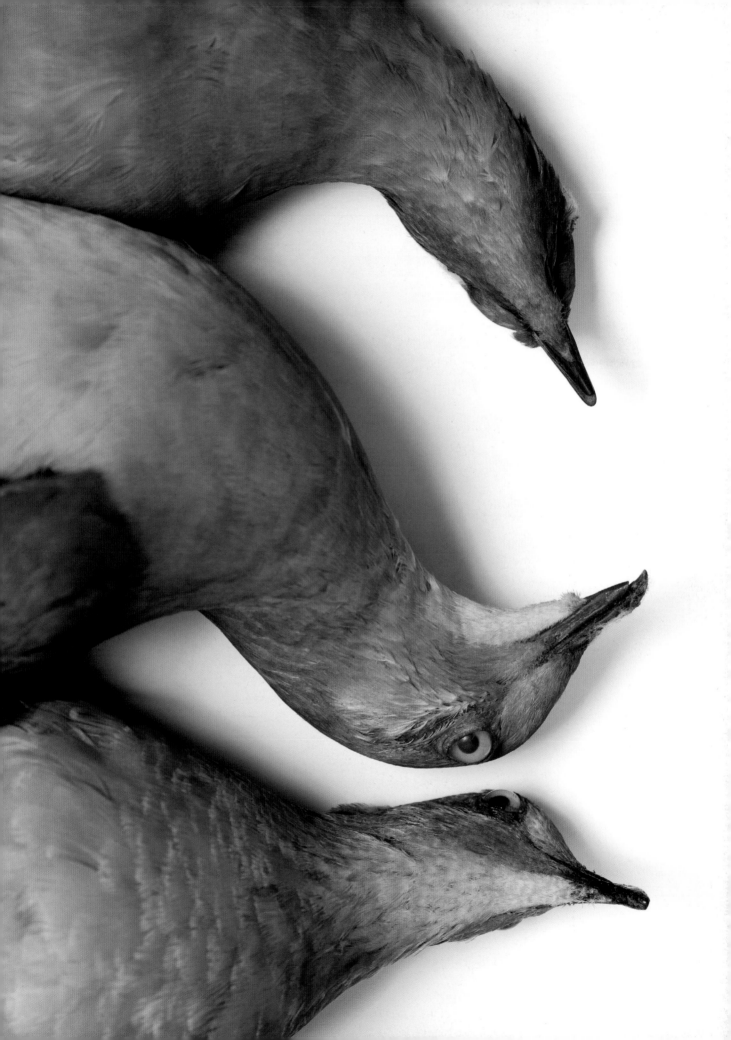

2 Birds

"One reason that birds matter—ought to matter—is that they are our last, best connection to a natural world that is otherwise receding. They're the most vivid and widespread representatives of the Earth as it was before people arrived on it."

Jonathan Franzen

Opposite: Passenger pigeons (*Ectopistes migratorius*).

While describing a new species of theropod dinosaur, *Deinonychus*, in the late 1960s, the eminent paleontologist John Ostrom noticed certain anatomical similarities between his specimen and modern birds. This led him to resurrect the now widely accepted hypothesis that birds are the descendants of dinosaurs, nearly a century after it was first proposed by Thomas Henry Huxley, nicknamed "Darwin's Bulldog" given his vehement support for the theory of evolution. Consequently, the Cretaceous-Tertiary mass extinction event did not wipe out the dinosaurs—their descendants, birds, are alive and well with nearly 10,000 living species.

The oldest known bird in the fossil record, *Archaeopteryx*, was discovered by quarrymen near Bavaria in the mid-nineteenth century. This strange creature of the Jurassic period has a number of attributes more typically thought of as reptilian than avian, such as teeth, a bony tail, and clawed fingers. However, it is the presence of feathers that identifies it as a primitive form of bird. Originally believed to have evolved for the purpose of temperature regulation, feathers are outstanding, lightweight aerofoils, facilitating the avian conquest of the skies. Indeed, while *Archaeopteryx* was unlikely to have been a strong flyer, some modern birds are astonishing aeronauts. One of the most impressive is the Arctic tern (*Sterna paradisaea*), a species that undertakes an annual migration from its Arctic breeding grounds to the Antarctic where it overwinters. Moreover, the circuitous route taken to fly between the two poles adds to the total distance traveled substantially, such that in their lifetime an Arctic tern may cover the equivalent of three round trips to the moon.

Few birds are as prolific on two wings as the Arctic tern and, at the opposite end of the spectrum, numerous species have independently evolved an entirely ground-dwelling lifestyle. This is very commonly observed among species confined to islands where, without the risk of mortality from terrestrial predators, they could abandon their powers of flight. The dodo (*Raphus cucullatus*), a giant, flightless member of the pigeon family endemic to the remote island of Mauritius in the Indian Ocean, was one such example. Evidently, it was the inaccessibility of its insular home that provided sanctuary from all natural enemies until European sailors first discovered the island in the sixteenth century. The helpless dodo provided a readily accessible source of fresh meat for the human seafarers, who slaughtered them in their droves until the last of them were killed in around 1681.

> "The Cretaceous-Tertiary mass extinction event did not wipe out the dinosaurs—their descendants, birds, are alive and well with nearly 10,000 living species."

The dodo's name is now synonymous with extinction, such was the speed of their extermination, and their fate actually reflects a broader pattern observed among avian extinctions—strikingly, 92 percent of recorded avian extinctions since AD 1500 were species indigenous to islands. In general, the avian communities of islands are particularly vulnerable to foreign species, against which they lack any protective behaviors. For instance, the native avifauna of New Zealand, Australia, and Hawaii have all been decimated by alien species, including rats and the domestic cat. In another notable case, several species were swiftly extirpated from the island of Guam following the invasion of the brown tree snake (*Boiga irregularis*), a highly efficient nocturnal predator accidentally introduced by the United States military at the end of World War II.

Despite the fact that island endemics are disproportionately susceptible, around 14 percent of contemporary birds are considered at risk of extinction, including many species found on the mainland. In addition to invasive species, a myriad of anthropogenic

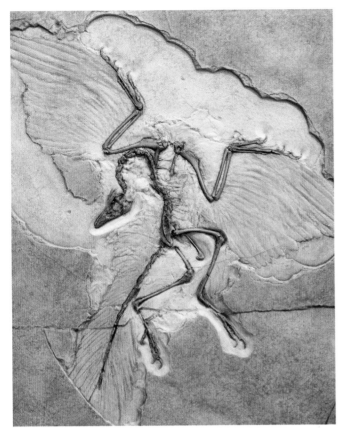

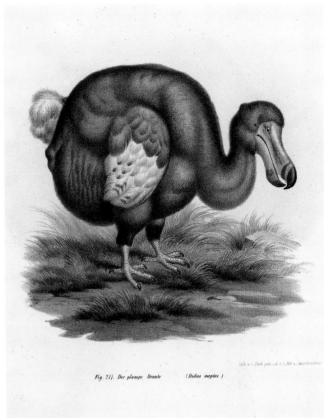

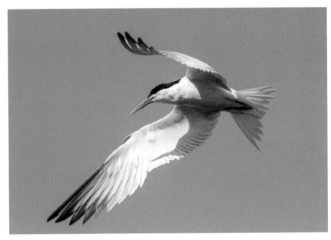

Above left: The first *Archaeopteryx* fossil was found two years after Charles Darwin published *On the Origin of Species*.

Top right: Because the dodo had no predators, females could afford to lay just one egg at a time.

Bottom right: The longest recorded Arctic tern annual migration is nearly 60,000 miles (96,000 km), equivalent to over twice the circumference of the planet.

stressors are threatening bird populations across the world, with habitat loss being the most dominant reason for decline. However, as outlined in 1962 by Rachel Carson in her book *Silent Spring*, environmental pollution due to the overuse of certain agricultural chemicals is also particularly harmful for birds. For example, DDT, a widely banned insecticide, causes eggshell thinning and reproductive failure. Furthermore, climate change is likely to present yet another major challenge in the future. Birds usually time their breeding events so that their eggs will hatch at a period of peak resource availability in the spring. However, warmer average annual temperatures are causing a number of annual environmental changes to occur earlier, such as the time in which leaves first appear on trees in the spring. This in turn is causing key items of prey such as caterpillars to emerge sooner, increasing the risk of starvation. Proportionately fewer birds are threatened with extinction than most other well-surveyed taxa, but they have not escaped the impact of human activity. With a continuation of "business-as-usual," we are likely to see their situation worsen over the coming decades.

Millerbird

Acrocephalus familiaris

 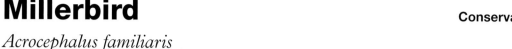

Millerbirds are a species of Old World warbler and get their name from the miller moth, the birds' preferred food source. There are two subspecies of *A. familiaris*: the Laysan millerbird (*Acrocephalus familiaris familiaris*), pictured here, which was declared extinct by 1923 after rabbits that were introduced to Laysan Island in Hawaii devastated the vegetation there; and the Nihoa millerbird (*Acrocephalus familiaris kingi*), which is endemic to the small Hawaiian island of Nihoa and is now critically endangered.

The brown songbirds are small at around five inches (13 cm) long, weigh about one ounce (28 g), and have what has been described as a "metallic and bubbling" call. As their habitat on Nihoa Island is limited—the island is only 155 acres (63 ha)—the small Nihoa millerbird population is at risk from fire, storms, and non-native invasive animals and insects such as rats and grasshoppers.

In 2011, the US Fish and Wildlife Service (USFWS) initiated a relocation effort in an attempt to save the Nihoa millerbird, in which 24 individuals were released on Laysan Island (which was cleared of rabbits and revegetated), followed by a second translocation of 26 birds one year later. The birds were carefully transported across the 620 miles (1,000 km) of ocean separating the two islands and within five years their population was thought to be 250 to 1,000. As Holly Freifeld, a USFWS biologist commented, "The project is really a 'we can do it' beacon in the very challenging landscape of conservation in the islands."

The Nihoa millerbirds that now inhabit Laysan Island were honored in 2014 with a traditional Hawaiian name. They are now called ulūlu niau: ulūlu meaning "growing things," in reference to the species' population growth; and niau meaning "moving smoothly, swiftly, silently, and peacefully," which refers to the uncharacteristically calm ocean journey the birds made to their new home on Laysan Island.

Conservation Status

● Laysan millerbird: Extinct

● Nihoa millerbird: Critically Endangered

The translocation protocol was designed to not impact endemic birds already present on Laysan Island; the Laysan finch primarily eats grains and invertebrates, while the millerbird eats insects.

Estimated number of remaining breeding individuals before translocation in 2011

5–13

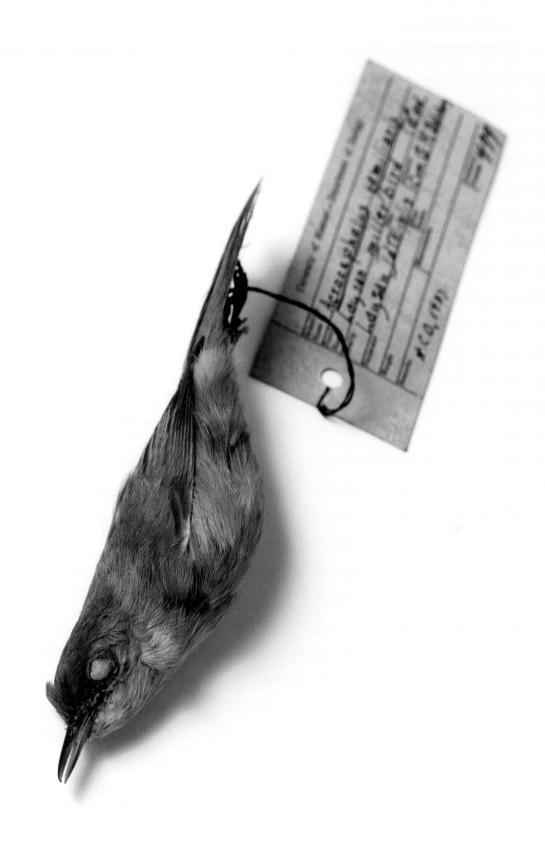

Dusky Seaside Sparrow (pictured right)

Ammodramus maritimus nigrescens

Cape Sable Seaside Sparrow (pictured left)

Ammodramus maritimus mirabilis

Declared extinct in 1990, the dusky seaside sparrow was one of 11 *Ammodramus* subspecies to inhabit the coastal marshlands on the Atlantic seaboard of the United States. It was nonmigratory and lived only in the marshes of the St. Johns River and Merritt Island on Florida's mid-Atlantic coast. A 70 percent decline in its population was recorded from 1942 to 1953, following the use of the insecticide DDT to control mosquitoes on Merritt Island, which contaminated its food supply and caused thinning of its eggshells.

In further efforts to eliminate mosquitoes in the Kennedy Space Center region, in 1956 the Merritt Island nesting grounds were flooded to make mosquito control impoundments, causing another drop in numbers. Later, marshes along the St. Johns River were drained to aid highway construction, putting yet more pressure on the population.

By 1980, six remaining individuals, all males, had been captured to establish a captive breeding program that was eventually unsuccessful because no females were ever found. They lived out their lives in a Walt Disney World nature reserve called Discovery Island. The last male, named Orange Band, died on June 17, 1987.

The Cape Sable seaside sparrow is one of eight remaining subspecies of seaside sparrow. It is native to the prairies of the everglades on Florida's peninsula. The large-scale conversion of South Florida for agriculture and its limited range mean that the Cape Sable seaside sparrow is currently endangered. It is also threatened by fires, hurricanes, and the alteration of water flow in the area—any of these could cause a catastrophic drop in numbers making the population unviable, meaning the birds would not be able to reproduce quickly enough to increase their numbers. Efforts to ensure the birds have the right amount of water have resulted in the Everglades Restoration Transition Plan (ERTP) to improve conditions for the sparrow and save it from impending extinction.

Conservation Status

● Dusky seaside sparrow: Extinct

● Cape Sable seaside sparrow: Endangered

The decline of seaside sparrows has raised calls for future "genetic management" policies to reintroduce gene diversity to populations at serious risk of extinction.

Time since subspecies diverged from nearest relative subspecies

250,000
years

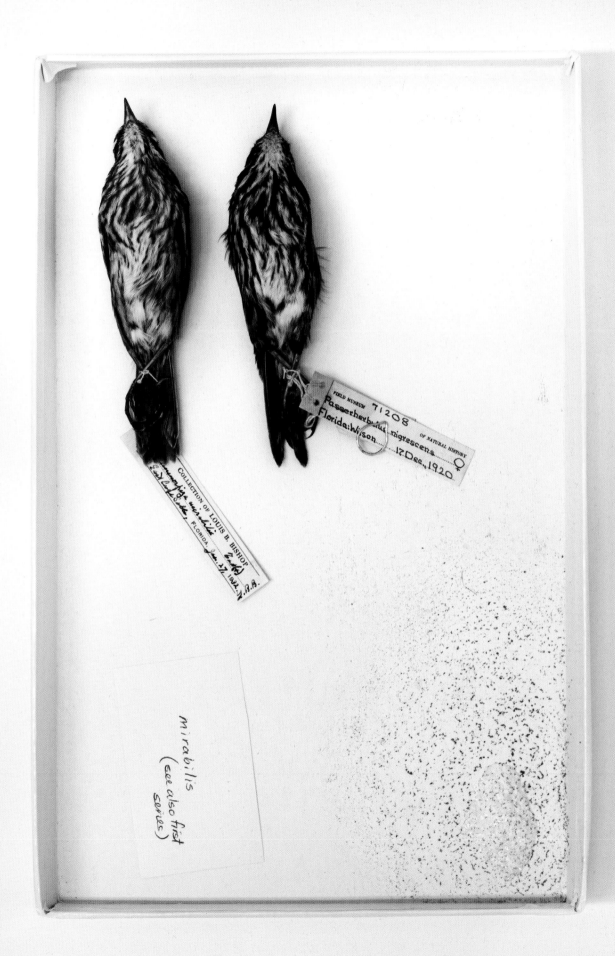

FIELD MUSEUM 71208 OF NATURAL HISTORY
Passerherbulus nigrescens ♀
Florida: Wilson
17 Dec., 1920

COLLECTION OF LOUIS B. BISHOP
mirabilis
FLORIDA.
N.B.B.

mirabilis
(see also first
series)

Rusty Blackbird

Euphagus carolinus

Euphagus carolinus is a species of blackbird distinguished by the reddish-brown tips of its feathers. It ranges widely across the boreal zone of North America from New England, through Canada to Alaska—the northernmost breeding range of all North American blackbirds—and it winters in the southeastern and midwestern United States. Its habitat is restricted to wooded wetlands year round (one of only a few species of bird with these habitat requirements) and it tends to nest close to water sources.

It is estimated that numbers of rusty blackbirds have declined around 85 to 99 percent since 1966—one of the steepest declines of any North American species—and it is not clear why. The destruction of wetland and woodland habitats may play a part, depriving the species of their preferred breeding sites, or climate change may have altered the fragile chemical composition of these areas as they become more dried out. In Canada in particular, the practice of stripping forests and wetlands for tar sands (to produce petroleum products) continues—it is predicted that more than 700,000 acres (283,280 ha) will be directly affected over the next 30 to 50 years. Industrial pollution that contaminates food sources and pest control methods—the spraying of their roosts, aimed at other blackbirds that destroy crops—may also be threatening the species.

Despite the rusty blackbird's alarming decline, the species is not yet protected by the US Endangered Species Act and remains categorized as vulnerable instead of endangered by the IUCN. In one step toward better understanding the threatened species, the International Rusty Blackbird Technical Working Group was established in 2005 by Dr. Russell Greenberg, head of the Smithsonian Migratory Bird Center in Washington, DC, to research remaining population numbers, identify threats, and determine a course of action to try and halt its extinction. Says Dr. Greenberg along with co-author Steven M. Matsuoka in a 2010 paper, "Research to date has not delivered the much-needed answer to the mysterious question: what is causing the Rusty Blackbird's decline? The negative trend continues, and considerable research challenges remain before we can reverse it.... The most important looming question is, do we have the will and the resources to address the mystery of the Rusty Blackbird's decline."

Conservation Status

● Vulnerable

Potential future risk factor: an increasingly restricted range of environmental conditions are able to support this species as flock size increases.

Average egg clutch size

4.5

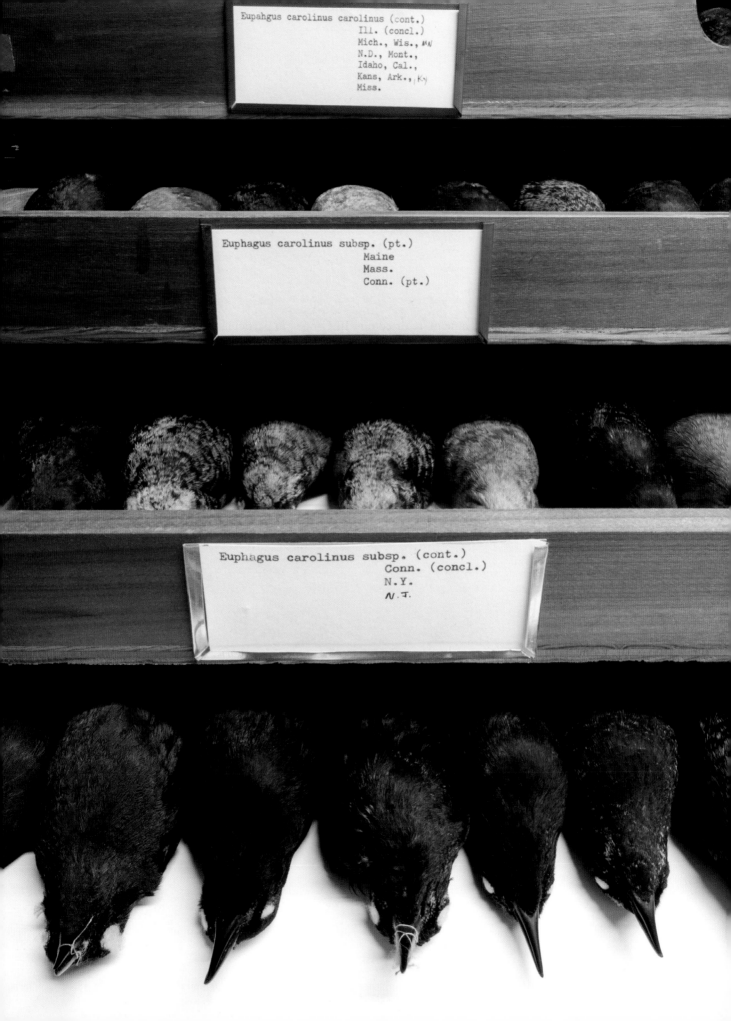

Eupahgus carolinus carolinus (cont.)
 Ill. (concl.)
 Mich., Wis., MN
 N.D., Mont.,
 Idaho, Cal.,
 Kans, Ark., KY
 Miss.

Euphagus carolinus subsp. (pt.)
 Maine
 Mass.
 Conn. (pt.)

Euphagus carolinus subsp. (cont.)
 Conn. (concl.)
 N.Y.
 N.J.

Bush Wren

Xenicus longipes

Endemic to the three main islands of New Zealand, the bush wren was a small, 3½-inch
(90 mm) long, nearly flightless bird. It inhabited both dense, mountainous forest and coastal
forest. It has been classified as extinct since 1994, having been last recorded on North Island
in 1949, Stewart Island in 1965, and South Island in 1972.

Of the six species in the New Zealand wren family Acanthisittidae, only two survive.
They are called wrens only due to their superficial resemblance to true wrens of the family
Troglodytidae. As the bush wren was a ground nester and hopped around on the forest floor,
it was very susceptible to predators, as were many of the country's now extinct wrens. The
extinction of bush wren is widely attributed to the 1880s' introduction of stoats and rodents,
such as ship rats, to the island. In 1964 the New Zealand Wildlife Service translocated six
individuals from Big South Cape Island to a nearby rat-free island, in a desperate last
attempt to rescue the species. The experiment failed but did, however, inspire more proactive
conservation attempts to save New Zealand's birds from predators, which has seen the
successful translocation of 50 species of bird since the 1960s.

Conservation Status

● Extinct

Museum specimens are an
important source of genetic
information, even after extinction.
In 2016 scientists extracted DNA
from the bone of a bush wren
from Hawkes Bay, stored at the
Canterbury Museum, New Zealand.

**Number of extant
Xenicus species left**

1

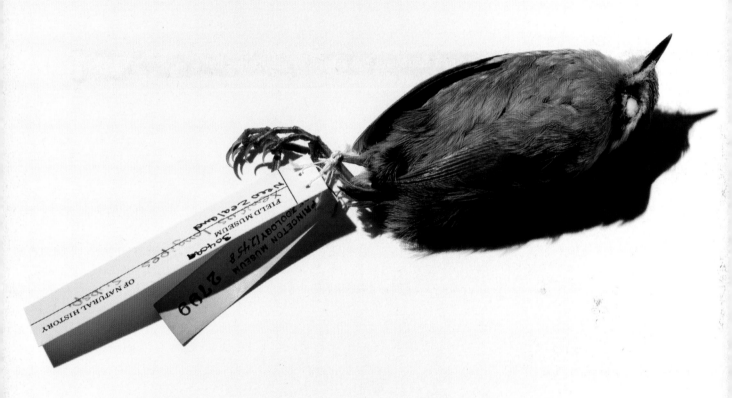

Kirtland's Warbler

Dendroica kirtlandii

Kirtland's warbler is a large species of warbler native to north and central Michigan and sometimes observed in Wisconsin, Ontario, and Quebec. The bird migrates in winter to a small area of the Bahamas and is characterized by its bright yellow belly, black or brown body, and white ring around the top and bottom of its eyes. They average six inches (15 cm) long and have a distinctive call described as "chip-chip-che-way-o."

This species was named after Ohio doctor and amateur naturalist Jared Potter Kirtland (a name that activists are working to change to be more descriptive of the species or its habitat, along with the names of several other eponymous birds). They have very specific habitat requirements, a major liability contributing to their historic decline in numbers. They only nest in dense jack pine forest, in jack pines that are 5 to 20 feet (1.5–6 m) tall and 9 to 13 years old (which continues to baffle scientists), and near to the ground on lower branches. In addition, jack pines are reliant on forest fires for reproduction and therefore, Kirtland's warblers depend on fires for their continued survival. Intense heat causes pinecones to open and release seeds and the fires also create new areas for jack pines to grow and develop in time into suitable breeding habitat.

Numbers of Kirtland's warbler dramatically declined as European settlers arrived in North America, clearing land and, as a result, preventing the incidence of forest fires. By the mid-twentieth century the species was near extinction. In addition to loss of habitat, Kirtland's warbler was—and still is—threatened by the parasitic brown-headed cowbird, which replaces a warbler egg with one of its own that the warbler then unknowingly rears.

The Kirtland's Warbler Recovery Plan was developed in Michigan in 1975 to trap the cowbird, successfully reducing the occurrence of brood parasitism from 70 percent to one percent by 2018. Land was also conserved for the cutting and planting of young jack pines, allowing the warbler population to quadruple between 1990 and 2000. It was officially removed from the US federal list of endangered species in 2019 and is currently listed by the IUCN as near threatened, making the recovery of Kirtland's warbler a shining example of successful conservation.

Conservation Status

● Near Threatened

Jack pine habitat for the warbler is expected to contract by 75 percent by 2099.

Average egg clutch size

5

FIELD MUSEUM

Dendroica k...

Mich.·Oscoda Co. 10...

Dendroica kirtlandi. ad ♀ †
Oscoda Co. Mich. July 10, 1914

...LECTION OF MAX MINOR PEET

...kirtlandi.......... Sex ad. ♀.
Date July 7. 1914
No........

...COLLECTION OF LOUIS B. BISHOP.

...ndroica kirtlandi ♀ ad.
...Luzerne, Michigan, July 7, 1914.

Oscoda Co Mich
Aug 31. 15 ad ♂.

COLLECTION OF LOUIS B. BISHOP.

No. 27499 Dendroica kirtlandi ♂ ad. [♂]
Oscoda Co., Michigan, Aug. 31, 1915.

COLLECTION OF LOUIS B. BISHOP.

No. 27625 Dendroica kirtlandi [♂ ad.] [♀]
Oscoda Co., Michigan, Aug. 27 1915.

...da Co Mich
27, 15

COLLECTION OF MAX MINOR

Name Dendroica kirtlandi
Locality Luzerne, Mich.
Collected by Max M. Peet

Oscoda Co Mich

'I'iwi

Drepanis coccinea

Hawaiian honeycreepers are so dissimilar between species—they can resemble finches, hummingbirds, parrots, warblers, or woodpeckers—that they are regarded by evolutionary biologists and ornithologists as a prime example of adaptive radiation. They are an incredibly diverse subfamily of songbirds composed of many genera. There were 39 extant species observed upon European arrival, of which only 17 now remain. They rapidly diversified into several different forms from one ancestor that was similar to a rose finch.

One of the most striking of the honeycreepers is the forest bird 'i'iwi (previously known widely as the scarlet Hawaiian honeycreeper), pronounced "ee-EE-ve," whose unique call has been likened to a child playing a rusty harmonica. The bird is instantly recognizable with its vibrant, scarlet body, black wings and tail, and long, thin bill that curves downward, perfectly designed for sucking nectar from tubular flowers. The iconic 'i'iwi lives at elevations of 4,000 to 5,500 feet (1,220–1,680 m) on the islands of Hawaii and Maui and it has become very scarce on Kauai in the last five years. A few pairs survive on Oahu, but it is extinct on the island of Lanai.

The biggest threat to the 'i'iwi is the invasive southern house mosquito (*Culex quinquefasciatus*), which transmits avian malaria and avian pox and arrived on American and European ships in 1826. Living at high elevations, the 'i'iwi was traditionally out of mosquito range. Yet as climate change gradually warms the forested mountains, mosquitoes are moving upward. Only a few honeycreepers have developed malaria resistance but the few remaining pairs on Oahu live at lower elevations and probably have some resistance to malaria. The IUCN estimates that its population will decline by 30 to 49 percent over the next 10 years.

Conservation Status

● Vulnerable

Seasonal movement strategies follow the gradual bloom of the ōhi'a tree, a primary nectar source, in neighboring regions.

Current number of individuals per square mile in natural habitat

347 (134/km²)

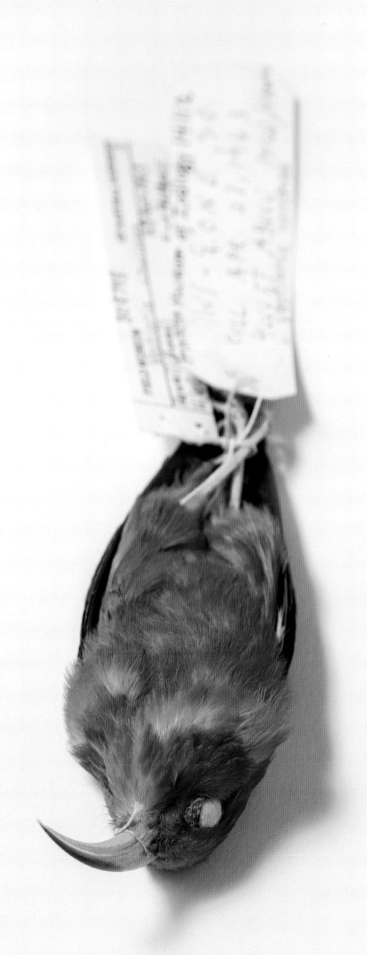

Huia

Heteralocha acutirostris

In 1901, on an official visit to New Zealand, the Duke of York was presented with a single tail feather from a huia bird during a Maori welcoming ceremony. The distinctive black feather with a rounded white tip was sacred in Maori culture, worn only on the heads of high-ranking chiefs and gifted as tokens of respect. Yet adorning the Duke's hat with the feather was one in a series of events that led to the ultimate downfall of the huia, as aristocracy in England and New Zealand began to covet huia feathers for their own hats. The price of feathers ranged from US$1 up to US$7 (equivalent today to US$170 up to US$865) making the hunting and selling of huia feathers a very lucrative business. Unfortunately, the huia were very easy prey.

The huia is one of three species of wattlebirds unique to New Zealand and named for the two fleshy wattles at the base of its beak—the huia's being a bright orange color thought to denote breeding status. The degree of sexual dimorphism between the male and female bills was remarkable and biologists of the nineteenth century ranked it as one of the world's most fascinating birds. The long, curved beak of the female huia, similar to that of a hummingbird, was for seeking out insects embedded in decaying trees. The male, with his stubby beak, would chisel away while the female used her slender beak to reach deeper in search of huhu grubs or weta, a type of giant flightless cricket. Huia often practiced cooperative feeding like this and mated for life. Like many forest birds in New Zealand, huia were not great flyers and tended to hop around on the forest floor, or leap from branch to branch.

Fossils have confirmed that before the arrival of people in New Zealand, huia were found on the whole of the North Island. Huia experienced losses due to hunting and habitat destruction when Maori people arrived in New Zealand about 800 years ago. This pressure accelerated once Europeans arrived, who not only brought with them predators—rodents and stoats—but also began cultivating vast areas of land, burning and clearing huia forest habitat. The species was unable to adapt.

Perhaps the most devastating contribution to the extinction of the huia is that of the naturalists of the day, intent on collecting specimens for museums and collectors abroad. As written by Sir Walter Buller, an avid huia collector, on the decline of its numbers, "To show how much scarcer this bird is than it was formerly, I may mention that in 1892, accompanied by Mr. Morgan Carkeek, I made an expedition into the wooded ranges at the back of the Waikanae… During the whole expedition we only saw a single Huia—which I shot—a male bird, which visited our camp in the early morning. Mr. Carkeek assures me that when exploring and surveying these ranges only five or six years before the Huia was comparatively plentiful."

The last confirmed huia sighting was on December 28, 1907—two males and a female. Yet its tail feathers are as valuable and sought after as ever. At an auction in 2010 a single plume fetched US$5,577, making it the world's most expensive feather ever sold.

Conservation Status	Juvenile female huia bills were similar to their male counterparts but grew longer throughout their lifetime.	Estimated maximum population before extinction
● Extinct		89,538

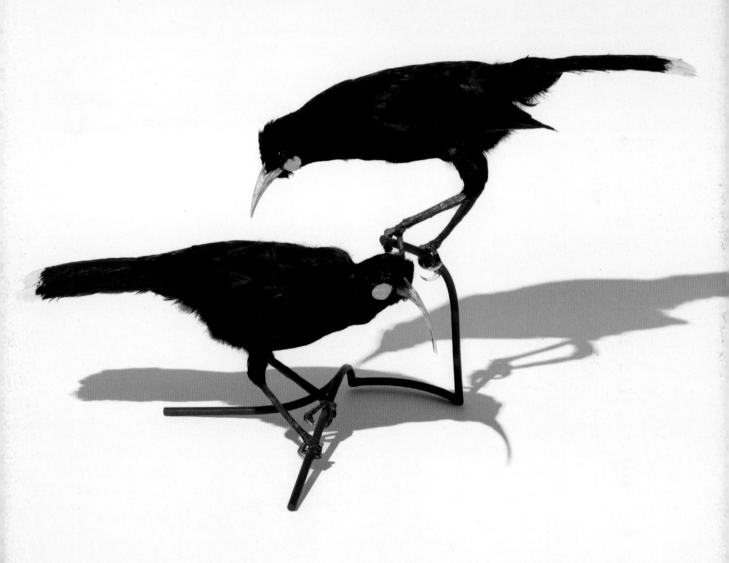

Kakapo

Strigops habroptilus

The kakapo is an extremely unusual species of green-feathered parrot native only to New Zealand. The kakapo has a long list of unique characteristics: it is the only flightless parrot in the world (they have wings but use their strong legs to "jog" along the ground); it is the world's heaviest parrot (weighing up to eight pounds [3.6 kg]); it is nocturnal (the name "kakapo" means "night parrot" in Maori); and it is one of the longest living birds, with reports of some reaching 90 years of age. They are known as "owl parrots" because their faces are owl-like, and they have a sweet, musty scent similar to honey.

Before human colonization of New Zealand, kakapo inhabited the entire country, from North Island to South Island, from mountains to sea level, in every habitat imaginable, confirmed by fossil discoveries. Their numbers began to dwindle with the arrival of the Maori people, who hunted birds and also introduced land mammals such as cats, rats, and stoats to New Zealand for the first time. Kakapo's natural defense mechanism is to freeze when threatened, usually a strategy to avoid aerial predators but not a successful tactic against the new terrestrial predators. When European settlers arrived in the early 1800s, the bird was largely confined to North Island. They too introduced land mammals and began clearing forest, which continued to decimate the kakapo population. Kakapo reached their lowest number in 1995, with only 51 known individuals remaining.

Thanks to a successful relocation and recovery program supported by the New Zealand government, the surviving population was evacuated to offshore island sanctuaries in 1987, islands where predators such as rats and stoats were eradicated before relocation. By 1995, with the situation still critical, the Kakapo Recovery Plan was initiated and resulted in a 68 percent increase in the bird's numbers over a period of eight years. As of 2021, 204 kakapo remain and with the attention and care of devoted rangers and researchers, that number is expected to rise.

In 2019 kakapo had their most successful breeding season when 76 chicks hatched. Then a chick died of aspergillosis, a fungal respiratory disease. Fifty-one kakapo were sent to veterinary and human hospitals in Auckland for diagnosis and treatment. An antifungal drug was administered and of 21 cases, 12 birds recovered and nine died, a success given the difficulty of containing the outbreak.

Ongoing conservation efforts by the government involve creating more predator-free islands where kakapo can be relocated—at present there is not one large enough to hold more than 100 kakapo. A 2016 government initiative, Predator Free 2050, began the controversial use of a vertebrate pesticide called 1080. As stated by the Kakapo Recovery Plan website, "Ultimately, a distant dream is to be able to reintroduce kakapo to the mainland."

Conservation Status

● Critically
 Endangered

In 2020 it was shown that decreased breeding success was a result of embryo mortality, rather than infertility as previously thought.

Separation of New Zealand from Gondwana, establishing the endemic parrot superfamily

82 million
 years ago

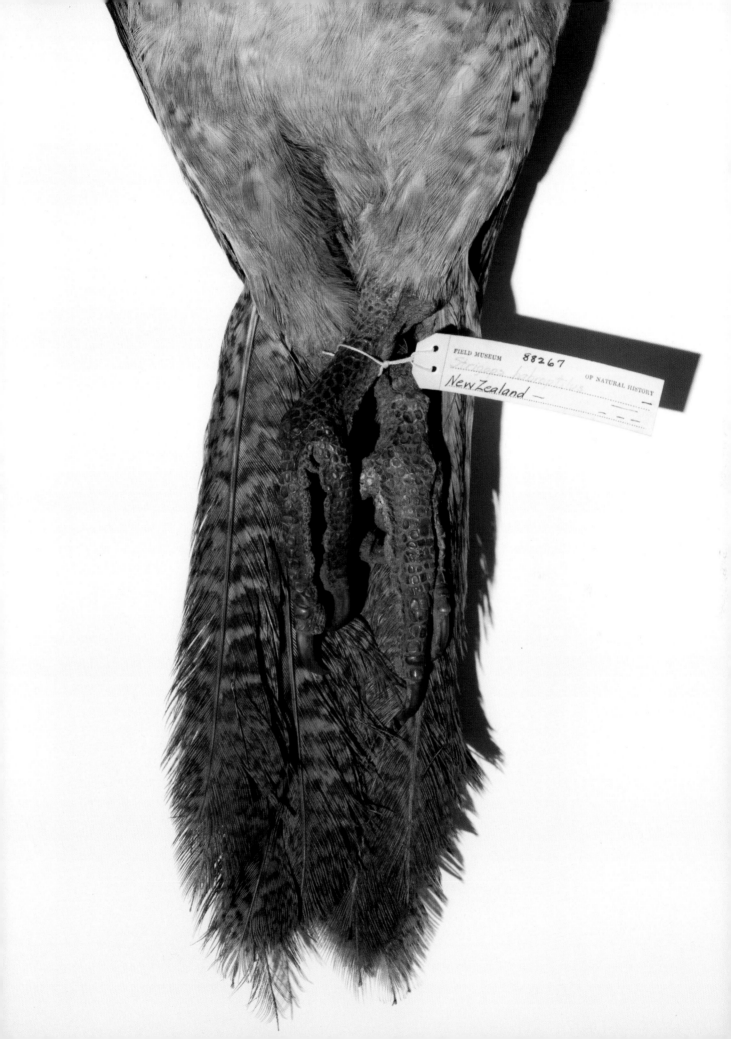

FIELD MUSEUM 88267 OF NATURAL HISTORY

New Zealand

Carolina Parakeet

Conuropsis carolinensis

The Carolina parakeet was the only indigenous parrot in North America. As its forest habitat was cleared in the 1800s, and as crops were planted in its range in the eastern United States, it began to feed on cultivated fruit, adding to its traditional diet of wild fruits and the seeds of plants. Farmers exterminated the birds in fields and orchards because they saw them as agricultural pests. They were also hunted for their colorful feathers, used to adorn women's hats. The task of hunting was made easier by the highly social parakeet's flock behavior of returning to where birds were killed or injured.

By the mid-1800s the species was rare and the remaining population was restricted to Florida, with the last sightings made in the early 1900s. Ironically, by then the remnant flocks in Florida were tolerated by farmers and hunting for their decorative feathers had stopped.

It was thought that poultry disease and competition for tree nesting cavities from newly introduced honeybees were the final causes of extinction. However, a 2019 project to sequence the species' genome put this theory to rest. The study confirmed that due to its sudden, sharp decline in numbers and lack of any evidence of inbreeding or viruses, humans were the sole driver of the Carolina parakeet's extinction. The last individual died in 1918 in the Cincinnati Zoo, in the same aviary where Martha, the last passenger pigeon, died four years earlier.

Conservation Status

● Extinct

The species diverged around 3 million years ago from South American conure parrots.

Year of earliest recorded geolocated sighting

1564

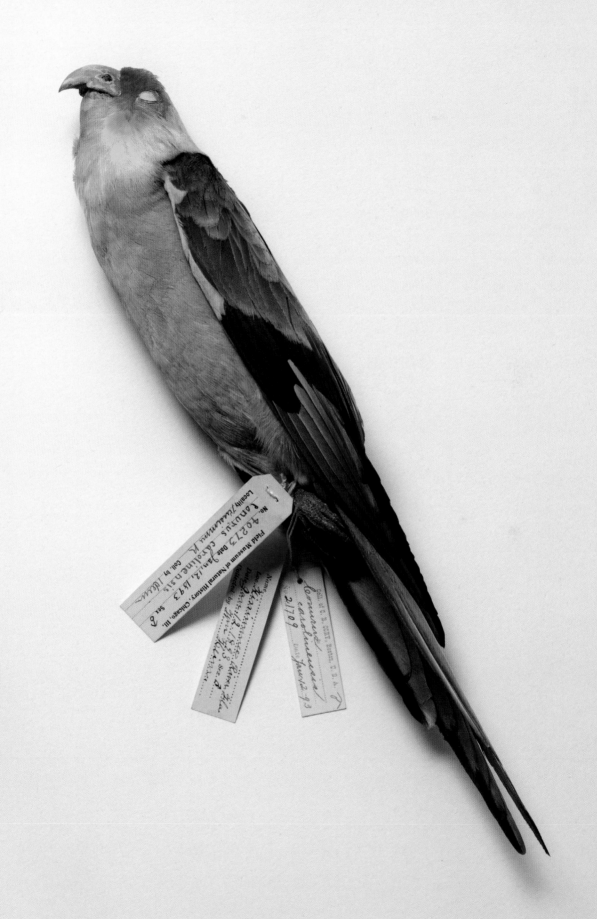

Whooping Crane

Grus americana

The whooping crane is one of the rarest and tallest birds in North America, standing at five feet (1.5 m) tall. In 1941, hunting and habitat loss had reduced the whooping crane to just 16 individuals in one population that inhabited Wood Buffalo National Park in the Northwest Territories, Canada. Its second population, a nonmigratory flock in Louisiana, had completely died out. However, intensive efforts over the years to bring the bird back from extinction have resulted in a unique success story.

A 1975 experiment to establish a second wild migratory flock transferred *G. americana* eggs from Wood Buffalo to sandhill crane nests in Grays Lake National Wildlife Refuge in Idaho. The sandhill crane foster parents raised the chicks and taught them to migrate to the flock's wintering grounds in New Mexico. However, the fostered whooping cranes formed pair bonds only with sandhill cranes and the program ended in 1989.

Starting in the 1990s, a joint US and Canadian team worked to rear nonmigratory captive cranes and in 1993 released 33 birds in Central Florida. Several birds were introduced over the years but the flock experienced a high rate of mortality and low reproductive success. Just nine birds remain and biologists continue to study this remnant population.

A more successful effort to establish a migratory flock was started in 1999 by the Whooping Crane Eastern Partnership, another joint US and Canadian effort. Chicks are raised at Necedah National Wildlife Refuge in Wisconsin by costumed handlers working in silence to ensure the chicks do not imprint on humans. Ultralight aircraft engine noise is piped into the nest from egg stage to condition the birds to follow the aircraft along the 1,200 mile (1,931 km) migration route from Necedah to two national wildlife refuges on the gulf coast of Florida. Thanks to these ongoing efforts, this population has grown to 85 individuals.

In 2011 a reintroduction project began in Louisiana and saw the release of 10 whooping cranes into a conservation area, another attempt at establishing a nonmigratory flock. With continued monitoring, the flock now numbers around 76 birds, which have now started nesting in the wild again. Out of 14 chicks that hatched there in 2021, four survived.

Current numbers of whooping crane in the wild are approximately 650, spread across these four populations, with the original population in Wood Buffalo thriving at around 500 individuals. However, overall numbers of whooping crane remain relatively low, predisposing the species to disease or to a catastrophic weather event that could devastate a flock.

Conservation Status

● Endangered

The migration corridor for whooping cranes is narrowing by just under half a mile (0.7 km) per year, indicating a need to improve conservation protocol for this species.

Minimum number of species consumed in summer whooping crane diet

17

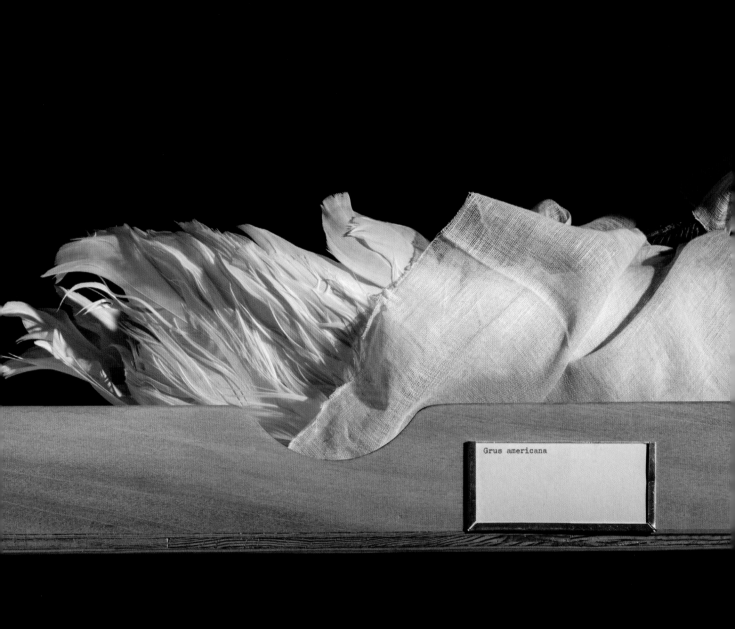

Grus americana

Passenger Pigeon

Ectopistes migratorius

On September 14, 1914, the last passenger pigeon, named Martha, died in a cage at the Cincinnati Zoo. It is one of the few species for which we know the exact date of extinction and one of the first whose extinction is credited to human behavior.

When Europeans settled in North America in the late 1500s, the population of passenger pigeon was as high as six billion in its forest habitat in eastern North America, up to 40 percent of the total bird population on the continent. Just a few decades of reckless overhunting and deforestation in the late 1800s brought the world's largest ever bird population to zero.

Flocks in the 1800s were so dense that the birds could simply be batted out of the air with clubs as they flew over ridges; one shotgun blast could bring down as many as 50 birds. A description from 1854: "There would be days and days when the air was alive with them, hardly a break occurring in the flocks for half a day at a time. Flocks stretched as far as a person could see, one tier above another." The naturalist John James Audubon observed one flock for three days and estimated the birds were flying past at a rate of 300 million per hour.

Professional hunters tracked the nomadic flocks and met the demand for meat and feathers by suffocating birds nesting in trees with sulfurous fires, knocking nests and squabs (young pigeons) from trees, baiting and intoxicating them with alcohol-soaked grain to make them easier to catch, and by using live decoys with their eyes sewn shut. By 1880, overkill had made commercial hunting unprofitable. In April 1896, hunters found the last remnant flock of 250,000 and in one day killed all but 5,000 birds, with some accounts claiming all were killed.

Despite commercial hunting, the passenger pigeon probably would not have survived the progressive loss of the vast expanses of eastern woodland habitat they needed to survive. Captive breeding efforts failed and Martha is stored in the National Museum of Natural History at the Smithsonian Institution, Washington, DC.

Overleaf: Passenger pigeon eggs.

Conservation Status		Martha's age at death	
● Extinct	The extinction of such a large population had severe consequences for other species' ecological interactions, particularly for seed-bearing trees—a primary food source.	29	

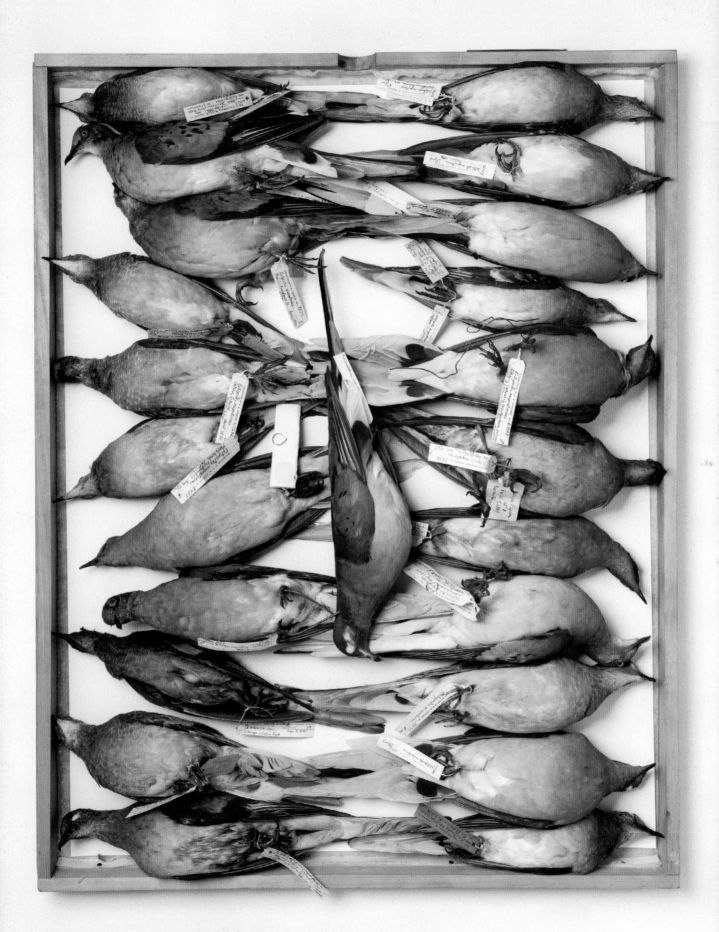

FIELD MUSEUM 1924 OF NATURAL HISTORY

.Ectopistes.migratorius.................1...

WISCONSIN: --- F.Laberteaux

--- May --,1871

CHICAGO NATURA

Ectopiste

Passenger

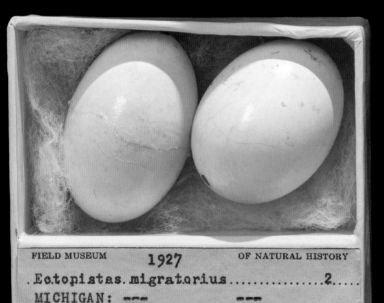

FIELD MUSEUM 1927 OF NATURAL HISTORY

.Ectopistes.migratorius.................2.....

MICHIGAN: --- ---

--- about 1860-70

FIELD MUSEUM 124

.Ectopistes.migrat

722 HISTORY MUSEUM

igratorius l

geon--- No data

OF NATURAL HISTORY

...us.....................

W.B.Porter

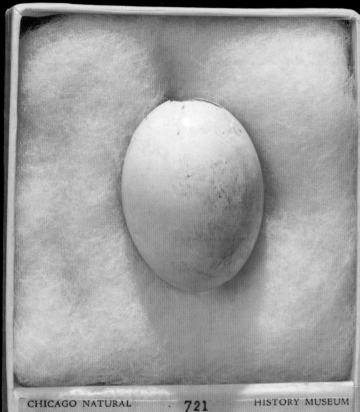

CHICAGO NATURAL · 721 HISTORY MUSEUM

Ectopistes migratorius l

Passenger Pigeon--- No data

California Condor

Gymnogyps californianus

The California condor is North America's largest land bird, with a wingspan of nearly nine feet (2.7 m). It inhabits rocky shrublands, forests, and savannas and can fly at altitudes of up to 15,000 feet (4.5 km). By the time of westward expansion, the condor's range was reduced to the mountains of the Pacific Coast. Shooting and poisoning by humans decreased its numbers to 600 by 1890 and by 1982, there were just 22 condors left in the wild.

Initiated in 1975, the California Condor Recovery Program is a cooperative effort by federal, state, and private agencies in the western United States. Controversial debate over how to best manage the condor resulted in all 22 remaining birds being captured by 1987 to start a captive breeding program. "Double clutching" was used, a technique in which a condor's single egg is removed to encourage the laying of another egg in that year. Chicks from the incubated eggs were then handled and raised using condor puppets so they did not imprint—a time when young animals form an attachment and develop their sense of identity—on humans.

Between 1992 and 2019, a total of 287 condors have been released into the wild and the first wild condor chick hatched in 2002. Condors have been reintroduced to various locations in Arizona, California, and Baja California, Mexico. As of 2020 there were over 500 condors, with more than 300 living in the wild. If the population continues to grow the species will be downgraded to endangered by the IUCN in 2024.

Yet today, wild condors continue to be victims of human action. As they mainly feed on carrion—the dead and decaying flesh of animals—condors are extremely vulnerable to lead poisoning from ingested lead shot, which is the leading cause of mortality for the species. Since 2008 hunters are required to use non-lead ammunition in condor recovery areas.

Wildfires in the condor's range are another factor that could have a devastating future impact on the species. The Dolan Fire of 2020, in Big Sur, California, engulfed 123,553 acres (50,000 ha) and ripped through a condor sanctuary, killing 11 of the birds. Without a significant increase in population, which would cushion them from wildfires and climate change, the California condor is still very much in limbo.

Future plans for the species include the establishment of a captive breeding facility in northern California's Redwood National Park in 2021, initiated by the area's Yurok Tribe. California condors are sacred to the Yurok and were identified by elders as the most important animal to return to ancestral lands. Tiana Williams-Claussen, the director of the Yurok Tribe's wildlife department, told the *Guardian*, a British newspaper, "When I actually see a condor in the sky again it's just mending that wound that was carried by my elders, is carried by me, and that, at least in part, is not going to be carried by my children."

Conservation Status

● Critically Endangered

Northerly and easterly winds influence the probability of condors to be found in flight significantly more than southerly or westerly winds.

Furthest distance traveled per day in miles

140 (225 km)

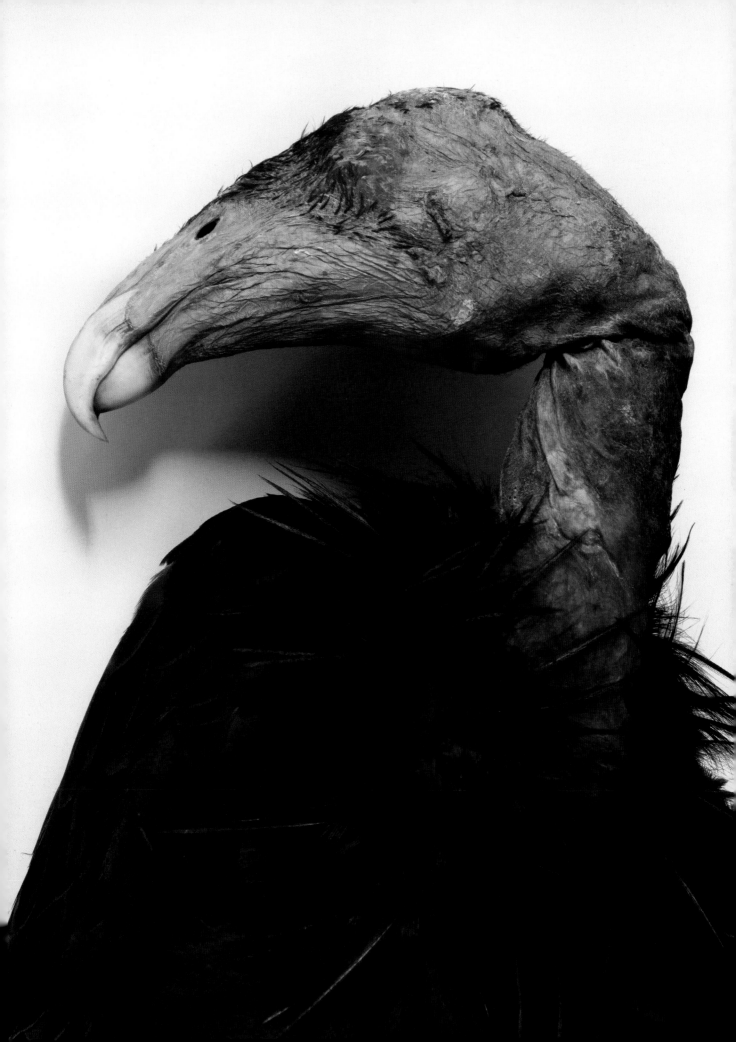

Cinnamon Screech Owl

Megascops petersoni

The cinnamon screech owl is found in the tropical and subtropical montane regions of Colombia, Ecuador, and Peru. It weighs less than half a pound (227 g) and is about eight inches (20 cm) long. The species has only been known to biologists for 30 years and there is still very little information available on this diminutive owl.

We consider our knowledge of birds to be very good compared to other classes in the animal kingdom and tools to set conservation status like the IUCN Red List are excellent. However, the cinnamon screech owl is a prime example of the limitations of both. Lack of knowledge of this species has led to a risk classification no higher than least concern. According to Dr. John Bates, Curator of Birds at the Field Museum, this owl's existence has only been known since the early 1980s and very little is understood of its biology, life history, or population density and trends. Incomplete knowledge of such species results in a classification that can only go so far in estimating the risk of extinction. Ultimately, we do not know enough about it to ensure its long-term survival.

New species are discovered (two new species of South American screech owls were described in early 2021) as others are declared endangered or extinct, and not every species will be studied sufficiently to determine its Red List classification. As stated on the IUCN website, the Red List system categorizes species with a "high degree of consistency" but in certain cases, "the risk of extinction may be under- or over-estimated."

Conservation Status

● Least Concern

Genus *Megascops* contains many cryptic species (those that look the same but are genetically different) that are extremely difficult to identify because plumage variations are very subtle.

Number of extant *Megascops* species

21

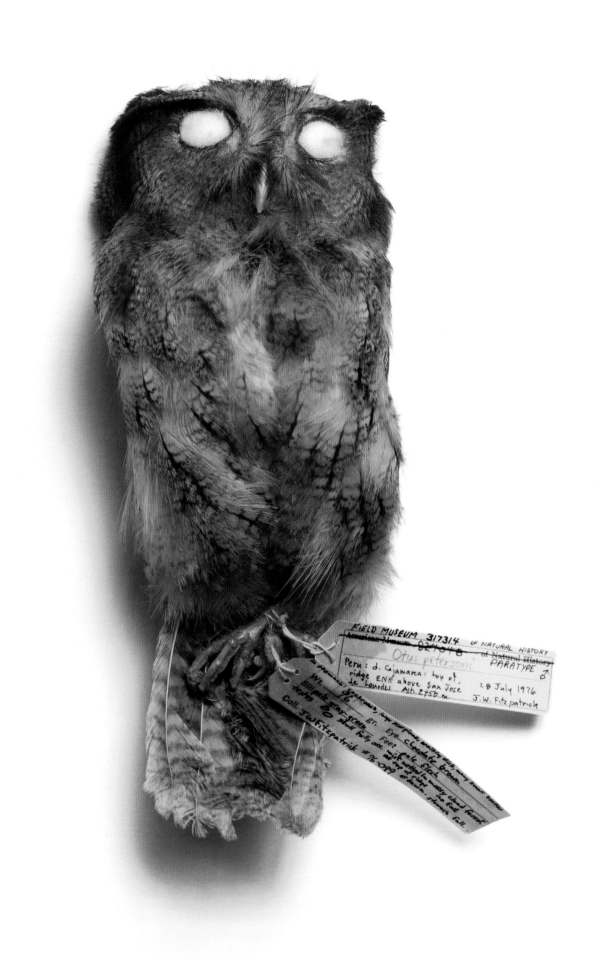

Ivory-Billed Woodpecker

Campephilus principalis

Thought extinct for more than 60 years, the ivory-billed woodpecker has become the species most people associate with extinction in the Americas. The huge appetite for lumber to rebuild after the American Civil War led to the destruction of the ivory-billed woodpecker's habitat and its primary food source, beetle larvae. Demand from collectors increased as it became rarer, speeding its elimination. The bird was last seen in 1944.

In February 2004, a large woodpecker was seen by two kayakers in the Cache River National Wildlife Refuge in Arkansas and based on the evidence, including a two-second video clip, many believe the species still exists. The sighting stirred enough excitement to launch searches for this "Lazarus species" in Arkansas, Florida, and Texas, coordinated by the US Fish and Wildlife Service, the Cornell Lab of Ornithology, and state wildlife agencies. There was even a US$50,000 reward for positive photographic evidence, offered by an anonymous donor.

Their habitat (swampy, bottomland hardwood forest) was rough terrain for those seeking the bird and so far, no indisputable evidence has emerged to confirm its existence. Many experts think the 2004 sighting was of a pileated woodpecker, a bird very similar in appearance and size. In September 2021 the US Fish and Wildlife Service proposed that this species be declared extinct, based on the inability to find any individuals in the wild for such a long time. The possibility that the ivory-billed woodpecker, one of the largest and most majestic of woodpecker species, was still surviving was tantalizing to some but as with many species whose habitat has been all but destroyed by human activity, any extant population was unlikely to recover to a viable level.

Once considered a subspecies, the Cuban ivory-billed woodpecker (*Campephilus principalis bairdii*) was discovered to be a distinct species in 2006 by researchers who extracted ancient DNA from tissue samples of museum specimens at the Smithsonian National Museum of Natural History. Last seen in the 1980s, the Cuban ivory-billed woodpecker is now thought to be extinct. The clearing of old-growth forest for sugar plantations and the lumber industry decimated its habitat and beetle larvae. By the 1950s, the bird was confined to an isolated area of pine forest in eastern Cuba, where its numbers continued to rapidly decline. As around 80 percent of its suitable habitat in Cuba remains to be searched, some ornithologists hold onto the belief that the species may one day be rediscovered.

Conservation Status

● Extinct

Latest efforts to find *C. principalis* involve flying drones with 4K cameras at an altitude of 130 feet (40 m) to search trees that are potential foraging sites.

Latest extinction date based on specimen-based computational modeling

1980

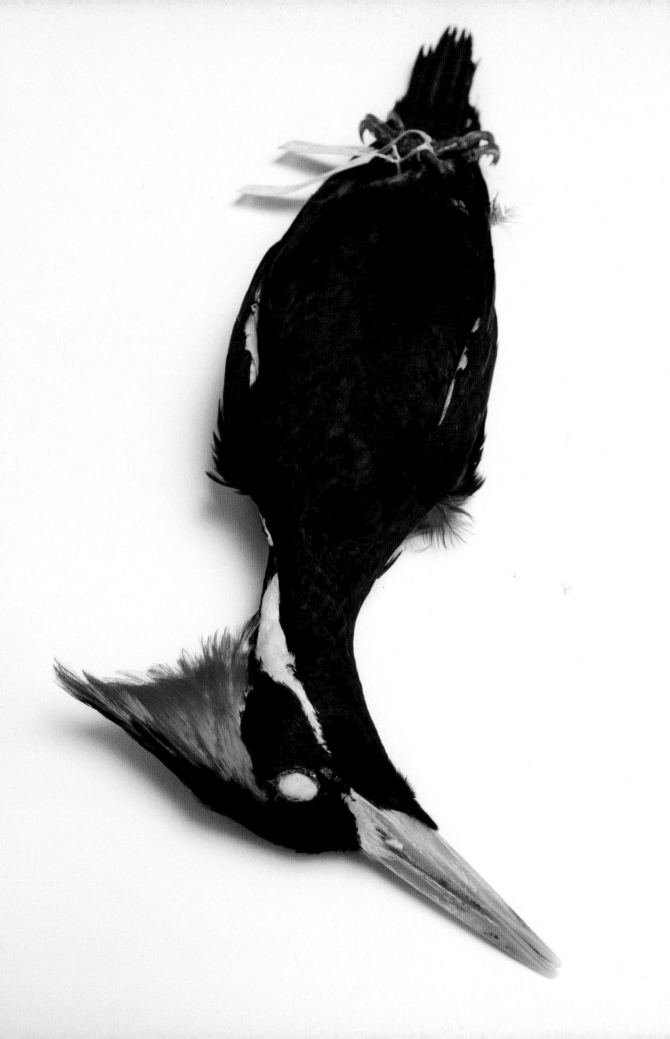

Peregrine Falcon

Falco peregrinus

The peregrine falcon is the world's fastest animal, able to dive at speeds of over 200 miles per hour (320 km/h) while hunting for prey. It is the largest falcon in North America and its adaptability and vast breeding range make it the most widespread raptor in the world, occurring on all continents except Antarctica. The word "peregrine" means "wanderer" and most northern populations migrate long distances during the winter (a study in 2020 recorded a peregrine migrating from Alaska to Peru, a distance of over 6,524 miles [10,500 km]).

The peregrine falcon is classified as least concern by the IUCN. However, it was nearly brought to extinction from the 1940s to the 1970s, primarily from exposure to DDT and other pesticides. In use as a pesticide since 1939, DDT is stored in fatty tissues and is not metabolized easily. DDT caused thinning of peregrine eggshells and a resulting crash in hatching rates.

Largely due to the 1962 publication of the book *Silent Spring* by author and conservationist Rachel Carson, DDT was banned in the United States in 1972. The book started a movement away from faith in technology and raised public awareness of the vulnerability of nature, resulting in greater regulation of industry (the chemical industry vehemently opposed Carson's work) and the emergence of the environmental protection movement. Ironically, the use of DDT has saved hundreds of millions of human lives since the 1940s by controlling insects and other small arthropods that are vectors for many infectious diseases, including malaria. Said Carson in 1964, "Man's attitude toward nature is today critically important simply because we have now acquired a fateful power to alter and destroy nature. But man is a part of nature, and his war against nature is inevitably a war against himself. [We are] challenged as mankind has never been challenged before to prove our maturity and our mastery, not of nature, but of ourselves."

Captive breeding programs became very successful after DDT was banned in 1972 and the peregrine was removed from the US Endangered Species List in 1999—the North American peregrine population increased by a staggering 2,600 percent over 40 years. As a cliff dweller that adapts easily to urban environments, peregrines live successfully side by side with humans, nesting on balconies and ledges as they hunt pigeons and other birds.

Conservation Status

● Least
 Concern

The falcon's worldwide range improves its genetic resilience, ensuring genetic diversity and robust recovery from its previous decline.

Oldest recorded peregrine falcon

19.9 years

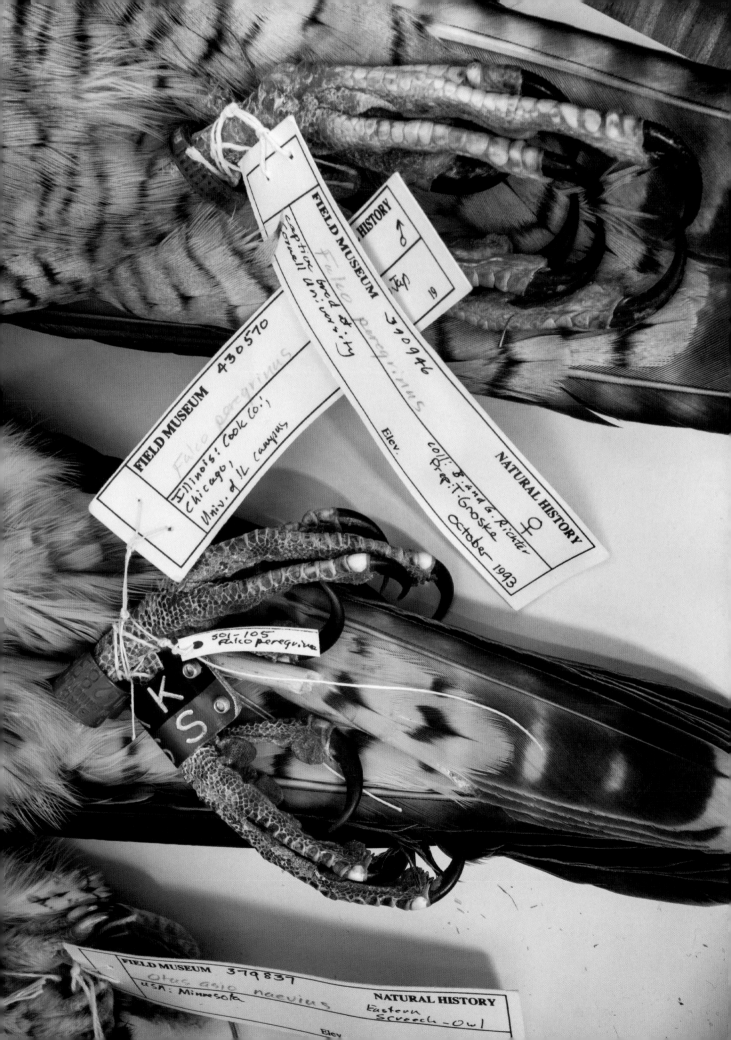

Atitlán Grebe

Podilymbus gigas

The Atitlán grebe, also known as the poc, was a large, flightless water bird endemic to Lake Atitlán in Guatemala's Sierra Madre mountain range. The species was first described in 1929 and was declared extinct by 1994.

In a strange, unfortunate twist of fate for the poc, the actions that led to its extinction can be primarily attributed to Pan American Airways. In an attempt to encourage tourism in the Lake Atitlán area, Pan Am convinced the government to entice fishermen to the area by populating the lake with the invasive but popular sport fishing species of bass of the genus *Micropterus*. The fish literally dropped out of the sky one day in 1958, released from seaplanes into the lake. The bass quickly began eating the crabs, snails, and fish that previously sustained the poc, as well as eating poc chicks. They became the area's apex predator and significantly stunted the biodiversity of Lake Atitlán. In 1960 there were 200 individual poc; by 1965 this number had more than halved.

The poc would have suffered a more rapid decline if it were not for the efforts of American ecologist Anne LaBastille. In 1966 LaBastille set up a refuge for the poc on the banks of the lake (during the brutal Guatemalan Civil War, no less) and by 1975, numbers of poc rose to 232. However, after a 1976 earthquake, the lake's water level dropped six feet (1.8 m), having a devastating impact on their numbers once again. Only 30 individuals remained by 1983, with the last reported sighting in 1986.

Today, Lake Atitlán continues to be affected by the ill-advised idea to introduce bass to the ecosystem. Because the bass preyed upon all of the creatures that controlled bacteria levels in the lake, bacteria thrive and fish numbers are low. The pollution and stench coming from the lake has meant that the once burgeoning tourism industry has suffered the same fate as the airline that sought to profit from it.

Conservation Status

● Extinct

Three different genera have evolved flightlessness separately in response to an exclusive diet of fish.

Estimated population size when the invasive fish species were released

200

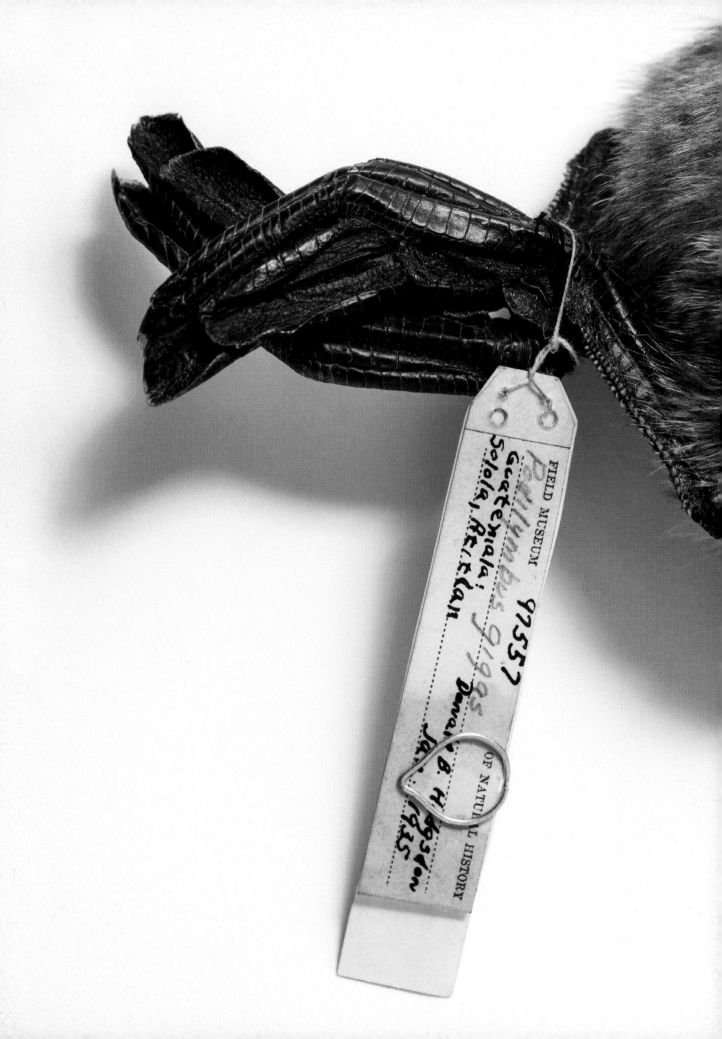

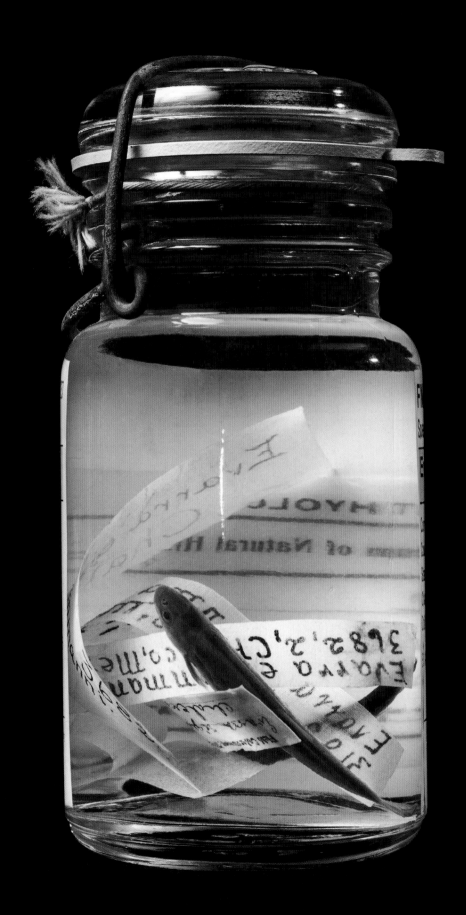

3 Fishes

"People still do not understand that a live
fish is more valuable than a dead one,
and that destructive fishing techniques
are taking a wrecking ball to biodiversity."

Dr. Sylvia Earle

Inhabiting shallow marine waters across much of the world are around 35 species of lancelets, tiny animals lacking a well-defined head or limbs. Fossils presumed to be early lineages of lancelets have been found in rocks dating back to the Cambrian explosion, an event in the history of life beginning around 541 million years ago that resulted in the appearance of most animal groups. A particular feature of their anatomy, the notochord, demonstrates that lancelets are in fact the sister group to all back-boned animals. This cartilaginous rod acts as a muscle-attachment organ, increasing the rigidity of the animal's body and at the same time allowing greater flexibility than the exoskeleton of invertebrates. The notochord was the precursor to a vertebral column, which first emerged in animals resembling modern lampreys. However, the subsequent evolution of jaws was the more profound evolutionary step, opening up a vast array of niches previously unattainable. Indeed, from these jawed ancestors have evolved several major fish lineages.

One lineage consists of the sharks and their relatives. These animals have a skeleton composed entirely of cartilage and are referred to as "cartilaginous fish." Although less dense than bone, cartilage is still heavier than water so cartilaginous fish must keep swimming to avoid sinking. For this reason, open water species such as the legendary great white shark (*Carcharodon carcharias*) never stop swimming for their entire lives. To facilitate this state of constant movement and to generate maximum dynamic lift, these sharks have also evolved a streamlined body and stiffened pectoral fins. In contrast, close relatives of sharks—the rays—have avoided all issues relating to buoyancy through the evolution of flattened bodies adapted for a lifestyle on the seafloor.

The cartilaginous fish are certainly an ancient branch of vertebrates, originating over 420 million years ago, but they are by no means the most diverse. As their name suggests, "bony fish" have retained the bony skeleton of their ancestors and contemporary species are divided into two clades. The extremely rare lobe-finned fish are one clade, with today's representatives including only two small groups: coelacanths and lungfish. However, the other clade, the ray-finned fish, are the most diverse of all extant vertebrates, with over 30,000 described species. Key to their success is their swim bladder, an internal gas-filled chamber used to overcome issues of buoyancy, which is lacking in the other major groups of fish. Without the need to preserve a streamlined body, ray-finned fish were free to diversify into an unbelievable range of shapes and forms. While some species such as

"Innovations in fishing technology in developed economies have resulted in highly efficient fleets capable of extracting many tons of fish from the ocean per catch."

swordfish and tuna have, like sharks, converged on a streamlined shape and pursuit predation, seahorses have a prehensile tail instead of a tail fin and swim upright, quite unlike any other fish.

The biggest threat facing today's fish species is undoubtedly rampant overfishing. Around 40 percent of the human population lives within close proximity to the coast, making seafood one of the most important sources of protein. However, innovations in fishing technology in developed economies have resulted in highly efficient fleets capable of extracting many tons of fish from the ocean per catch. Consequently, around 34 percent of the world's fisheries are overexploited and many have already collapsed. The overfishing crisis is epitomized by the state of the world's shark populations. Shark fin soup is a traditional dish in Southeast Asia and this highly wasteful trade has decimated shark populations. It is estimated that marine shark populations have declined

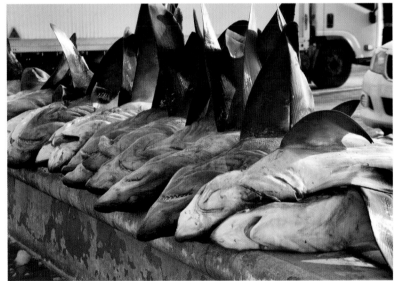

by over 70 percent since 1970. As ecological linchpins with a central role in stabilizing food webs, the decline in shark populations is very concerning for marine ecosystems and the people that rely on them.

The recent success of marine protected areas—places in which fishing or human exploitation of any kind is prohibited—provides a potential means of allowing the world's fish stocks to recover. However, there are other major threats to fish that may not easily be addressed with stricter fishing laws. For example, climate change is an immediate and existential threat to the world's coral reefs—habitats that harbor much of the world's fish biodiversity. As such, the loss of corals may trigger the secondary extinctions of many fish taxa.

Top: A great white shark (*Carcharodon carcharias*) spends its entire life swimming.

Bottom left: The lancelet is a distant relative to all vertebrates, owing to its notochord, an evolutionary forerunner of the spine.

Bottom right: Commercial shark fishing.

European Eel

Anguilla anguilla

Anguilla anguilla is a migratory species of eel that can reach a length of three feet (1 m). The eel makes a fascinating journey through its lifetime, starting life as larvae in the west Atlantic's warm Sargasso Sea, an area named for a free-floating seaweed of the genus *Sargassum*. They slowly drift on ocean currents toward Europe over around 300 days, by which time they have developed into juvenile "glass eels" and begin to enter Europe's river systems, effortlessly adapting to freshwater habitat. The process begins all over again in about 5 to 20 years when the eels are sexually mature and make the journey back to the Sargasso Sea to spawn.

Historically, European eels have been found across most of Europe, from the Mediterranean and Baltic Seas all the way to Russia's Black Sea. Yet today the species is on the brink of extinction as its population has decreased 98 percent since 1980. The eel has been eaten in Europe for centuries—think of East London's famous jellied eels—but now the demand has spread to Asia, partly in response to the protection of Japanese eel, which is now endangered.

Since 2010, trade of the European eel outside of Europe has been banned but illegal harvesting and selling of the species is still a major contributing factor in its significant decline. In Europe, an estimated 60 tons (54,430 kg) of glass eel are caught each year. Half are traded within the EU and the other half disappear into the black market. At its peak in 2018, some 350 million glass eels were illegally imported into Asia, where one pound (0.5 kg) can fetch a price of up to US$3,000. In 2020 a seafood salesman in the UK was convicted of smuggling US$70 million worth of glass eels from London to Hong Kong.

Added to the problem of illegal trade is the overall degradation of Europe's rivers due to pollution and development, including the turbine blades of hydropower plants that kill hundreds of thousands of eels annually. In 2019 alone 1,625 tons (1,474,175 kg) of eels were killed by hydropower plants in Europe. The black market also undermines conservation efforts in place at most European eel farms, which set aside a certain percentage of their eels to restock areas in Europe where it is decreasing in numbers. "It's like trying to fill the bath and someone pulled the plug out," said chairman of the Sustainable Eel Group, Andrew Kerr, highlighting the frustration of trying to save such a highly sought-after commodity nearing extinction.

Conservation Status

● Critically Endangered

European eels are described as "catadromous"—moving from freshwater to sea in order to spawn.

Estimated age of the Brantevik eel, an individual that lived in a well in the Swedish town of Brantevik and died in 2014

150 years

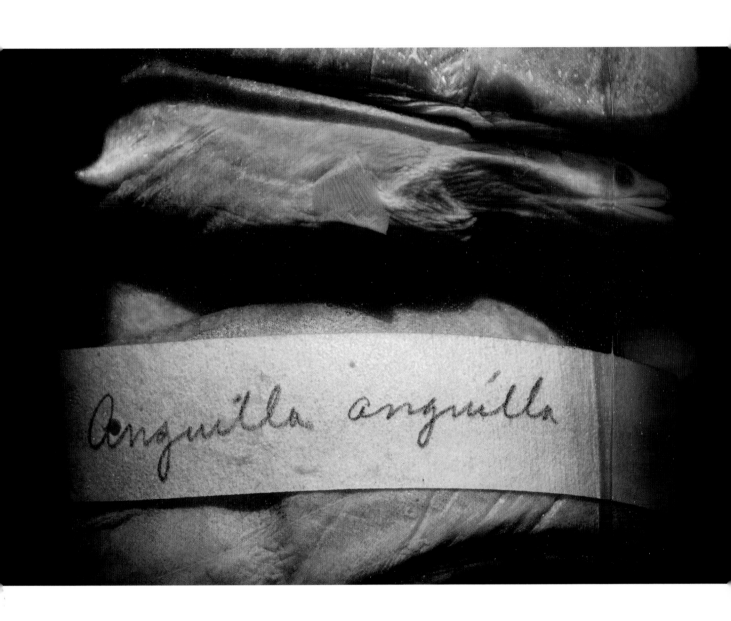

Atlantic Bluefin Tuna

Thunnus thynnus

The Atlantic bluefin tuna is one of the largest bony fish in the world—the average bluefin is 6 to 8 feet (1.8–2.5 m) long and weighs 500 pounds (226 kg). This warm-blooded fish can thrive in cold or warm water and can swim up to 60 miles per hour (96.5 km/h) when chasing potential prey (the name "tuna" comes from the Greek word meaning "to rush"). The lifespan of bluefins is up to 40 years. They migrate over vast distances in the Atlantic and the Mediterranean, from West Africa and Brazil to Norway.

Human demand for tuna meat, especially the Japanese appetite for sashimi, has made the fish particularly susceptible to the dangers of overfishing. The size and efficiency of commercial fishing operations have put bluefin numbers under huge pressure worldwide. Some estimates say the population size has halved since 1970.

The largest bluefins of breeding age are the most highly prized in fish markets around the world. A 612-pound (277 kg) tuna was sold at Tokyo's Toyosu fish market for US$3.1 million in 2019, the highest price for a single fish ever recorded.

The International Commission for the Conservation of Atlantic Tunas (ICCAT) was established in 1969 to set fishing quotas, recommending the appropriate and sustainable numbers of bluefin that can be caught each year. The process of arriving at quotas has been controversial due to the disputed accuracy of the commission's findings. As a result, since 2015 video monitoring is now required on all boats in the US Atlantic longline fleet—a concerted effort to put an end to illegal fishing.

Conservation Status

● Endangered

The fish farming industry has increased the supply of Atlantic bluefin tuna, which in turn has reduced the price of wild-caught fish such that fishermen must catch more to maintain their income.

Maximum depth in feet to which individuals are known to dive

3,280 (1,000 m)

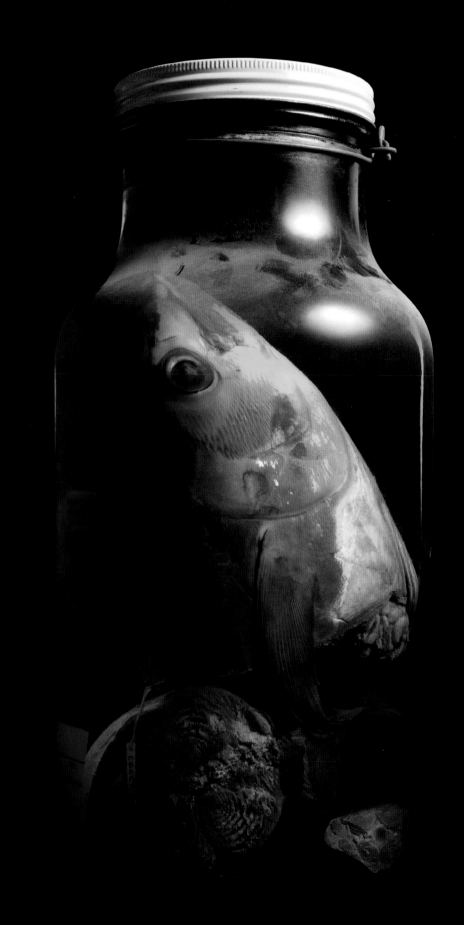

Atlantic Halibut

Hippoglossus hippoglossus

The Atlantic halibut is the largest flatfish in the world. Flatfish are uniquely adapted to living on the seabed by being flattened sideways—their eyes migrate to the right side of their heads during development, such that they lie on their left side. Atlantic halibut can reach up to 15 feet (4.5 m) in length and weigh as much as 700 pounds (317 kg). The fish is found in the northern Atlantic at depths of 160 to 6,500 feet (50–2,000 m), extending from the coasts of the northeast United States and Canada to Greenland, Scandinavia, and the United Kingdom.

The species has been classified as endangered by the IUCN since 1996. Due to the species' slow growth rate and late sexual maturity—males sexually mature at seven to eight years and females at 10 to 11 years—the Atlantic halibut is tremendously susceptible to overfishing. After decades of harvesting this popular eating fish, the population of Atlantic halibut now remains at less than 10 percent of what it was in the 1950s.

Due to extremely depleted stocks, commercial fishing of Atlantic halibut is limited—halibut sold to consumers is usually Pacific halibut or another species of large flatfish—although several fisheries have reported a significant increase of the species over recent years, demonstrating the need for more research on the fish. Some countries have started farming Atlantic halibut in an attempt to keep it on supermarket shelves and Sweden and Norway have now banned the fishing of wild halibut during their spawning season.

In 2004 the Atlantic Halibut Council was formed and with assistance from Canadian government funding, began to research and satellite tag the species in 2019. Researchers monitor movements and learn about spawning locations to obtain a better picture of the real state of Atlantic halibut stocks.

Conservation Status

● Endangered

Although occupying a high trophic level in the food chain, Atlantic halibut are important food items for seals, the Greenland shark, and orca.

Age of the oldest individual to have been caught

50

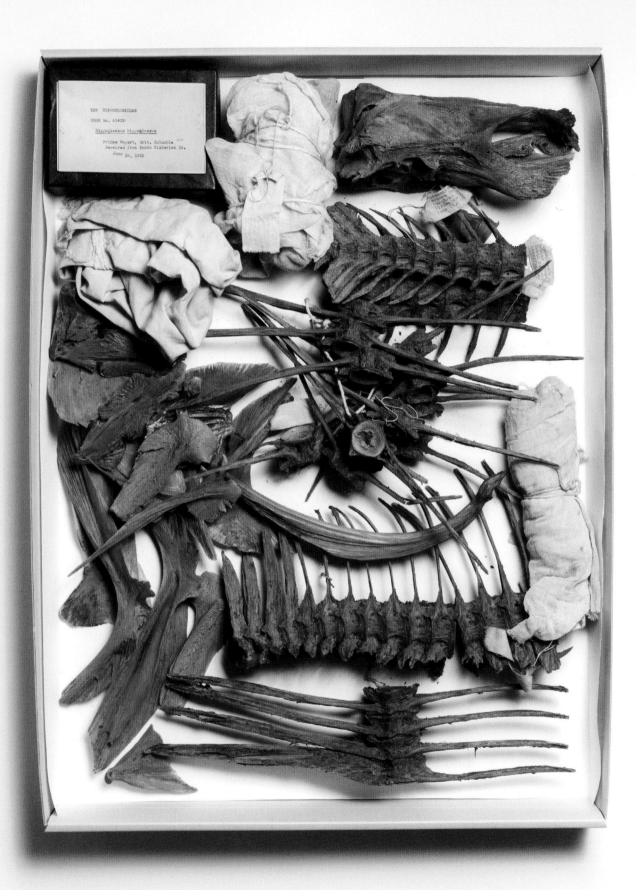

Deepwater Cisco

Coregonus johannae

There are eight species of North American cisco, ray-finned salmonid fishes, found in the Great Lakes and of those, three are now extinct. The deepwater cisco was observed only in Lake Huron and Lake Michigan and while there is some discrepancy in the taxonomy between the different species, it was one of the largest ciscoes. The fish was silvery in color with hints of pink and purple and with a green or blue back. Due to its size, it was overfished into extinction. The species was last seen in Lake Michigan in 1952.

The deepwater cisco population crashed and disappeared concurrently with many other Great Lakes fishes as they were collectively affected by two invasive species—predation by the parasitic sea lamprey and competition from the alewife, a herring species that bypassed Niagara Falls via Welland Canal in the mid-1900s. Without any predators in the Great Lakes—the lake trout population had been severely diminished by overfishing—sea lamprey and alewife became so abundant that they had to be controlled by the introduction of two species of Pacific salmon, coho and chinook salmon, a case of balancing the numbers of one predatory, invasive species with another.

Conservation Status

● Extinct

The deepwater cisco had a diet consisting of various aquatic invertebrates, including crustaceans and fingernail clams.

Year in which the Field Museum's three specimens were collected

1894

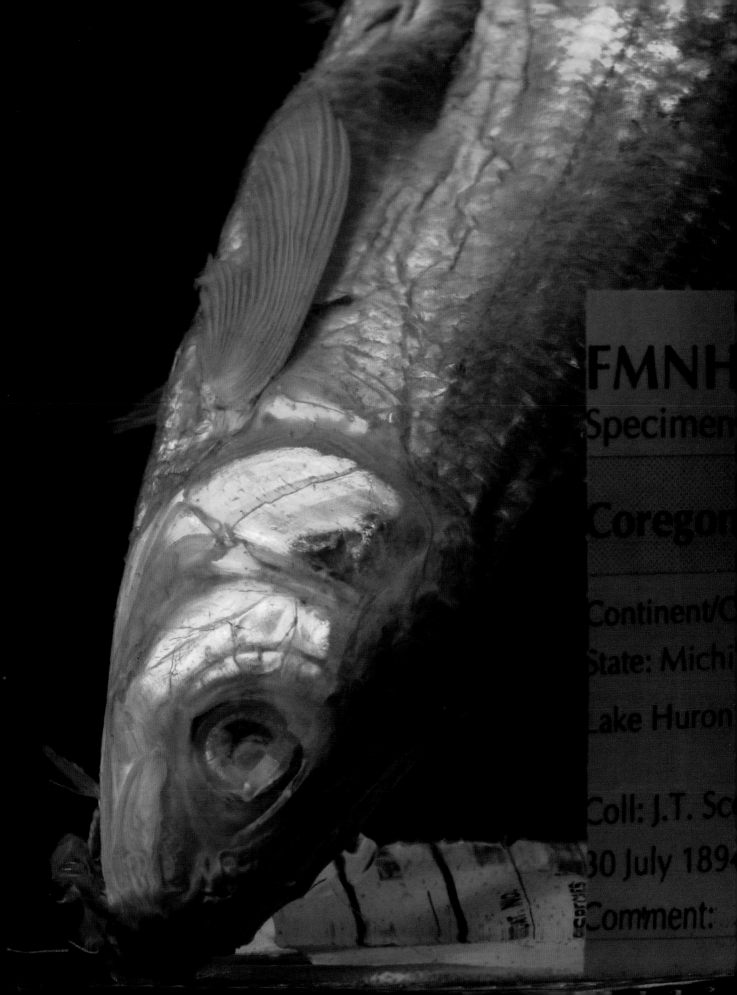

Chinese Paddlefish

Psephurus gladius

China's Yangtze River was once teeming with a particular species of "megafish," the Chinese paddlefish. The biggest specimen ever recorded was 23 feet (7 m) long and weighed 990 pounds (450 kg), making it one of the largest freshwater fish in the world. They had silvery bodies with a long snout shaped like a paddle, perfectly adapted for filtering water to find the zooplankton, insects, and small fish that sustained them.

Chinese paddlefish were historically prized for their plentiful flesh and eggs—even ancient emperors dined on the species. The fish were an easy target—they swam on the surface of the river in schools and were caught effortlessly by fishermen. Overfishing has contributed significantly to the fate of the Chinese paddlefish—some 25 tons (22,680 kg) were fished annually during the 1970s—but worse was the construction of the Gezhouba Dam in 1981, restricting the population's access to its spawning grounds and fragmenting its habitat.

From population estimates of around 10,000 in the 1970s, the last sighting of a juvenile Chinese paddlefish was in 1995 and no specimens have been observed in the wild since 2003. The species most likely became completely extinct in the wild between 2005 and 2010, according to researchers from the Chinese Academy of Fishery Sciences, ending this ancient fish's 200 million year-long existence. In 2017 to 2018 that same team of researchers conducted a thorough survey across the entire Yangtze River basin but failed to identify a single Chinese paddlefish. The species is survived by its relative, the American paddlefish (*Polyodon spathula*), now the only living species in the paddlefish family, Polyodontidae.

This specimen, pictured right, has been "cleared and stained" with a chemical process called diaphonization that reveals the skeleton. An enzyme is used to remove all tissues except bones and cartilage. Dyes are added to make bones blue and cartilage red. The fragile specimen is stored in glycerine. The process allows researchers to manipulate the skeleton to see how bones and cartilage move within the body.

Conservation Status

● Extinct

While formally classified as a ray-finned fish, in common with the American paddlefish, this species shared certain characteristics with pelagic sharks, such as a largely cartilaginous skeleton.

Maximum age at sexual maturity

8 years

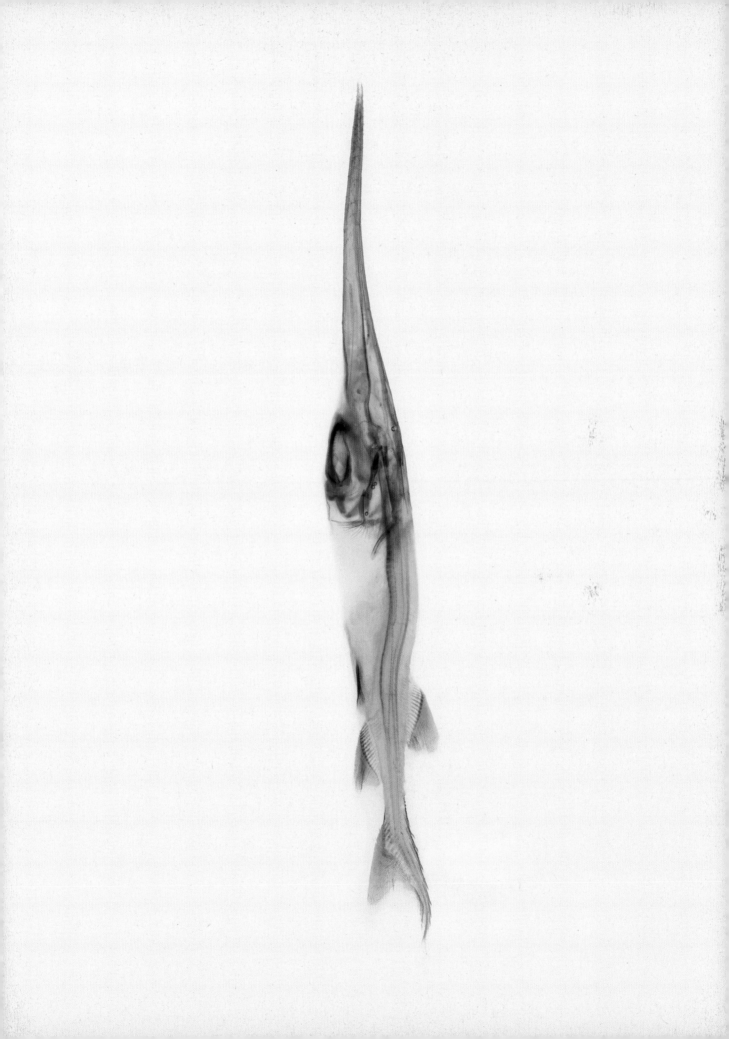

Atlantic Goliath Grouper

Epinephelus itajara

Reaching lengths of up to eight feet (2.5 m) and weighing as much as 790 pounds (358 kg), the Atlantic goliath grouper is a species that lives up to its name. This stocky fish is in the sea bass family, Lateolabracidae. It is mainly found in tropical waters around coral reefs at depths of 15 to 164 feet (4.5–50 m). It is distributed from Florida to Brazil in the western Atlantic Ocean and from Senegal to Democratic Republic of the Congo in the eastern Atlantic.

While they once numbered in the tens of thousands, the world population of Atlantic goliath grouper is said to have declined by at least 80 percent over the past 40 years, suffering most in the 1970s and 1980s. The species is extremely susceptible to commercial and recreational overfishing due to its size, slow growth, and reproduction rates. Fishing for the goliath grouper is thought to have begun in the late 1800s and spear fishing of the fish was especially popular in the Florida Keys. One fisherman quoted in *National Geographic Magazine* recalls fishing for goliath grouper 60 years ago: "The reefs were covered with them. There might be a hundred in one spot or a wall of them—something you don't forget! I'd shoot one or two, get eight cents a pound for them. Did that for 15 years or more."

Other threats to the species are increases in ocean temperature that can bring on harmful algal blooms such as red tides—one that occurred in 2005 off the southwest coast of Florida resulted in the death of an estimated 120 Atlantic goliath grouper—and loss of mangrove habitat where goliath groupers live for the first five years of their lives.

Fishing for Atlantic goliath grouper has been prohibited in the US since 1990 and the species has since experienced some recovery in the Florida region, leading the IUCN to downgrade the species from critically endangered to vulnerable. Fishermen now insist that goliath grouper are so abundant that they interfere with their catches, eating fish right off their lines, and as such are calling for the ban to be renegotiated. Conservationists argue that such claims are exaggerated and that withdrawing the ban would be detrimental to the widespread, long-term recovery of the species.

As of 2021, Florida Fish and Wildlife Conservation officials are considering lifting the complete ban on goliath grouper fishing by issuing US$300 per week licenses that allow for the catching and killing of one grouper—even though nearly all mature adults recently tested for mercury concentration exceeded safe human consumption limits. If this measure is passed, all proceeds would go toward research of the species. In addition, a growing dive ecotourism industry, providing the opportunity to see and photograph these massive fish aggregating on reefs, has the potential to offset the loss of the commercial value of fishing for the goliath grouper.

Conservation Status

● Vulnerable

For several weeks each year, hundreds of grouper aggregate in particular locations to reproduce, traveling up to 100 miles (160 km) to reach aggregation sites.

Oldest verified lifespan

37 years

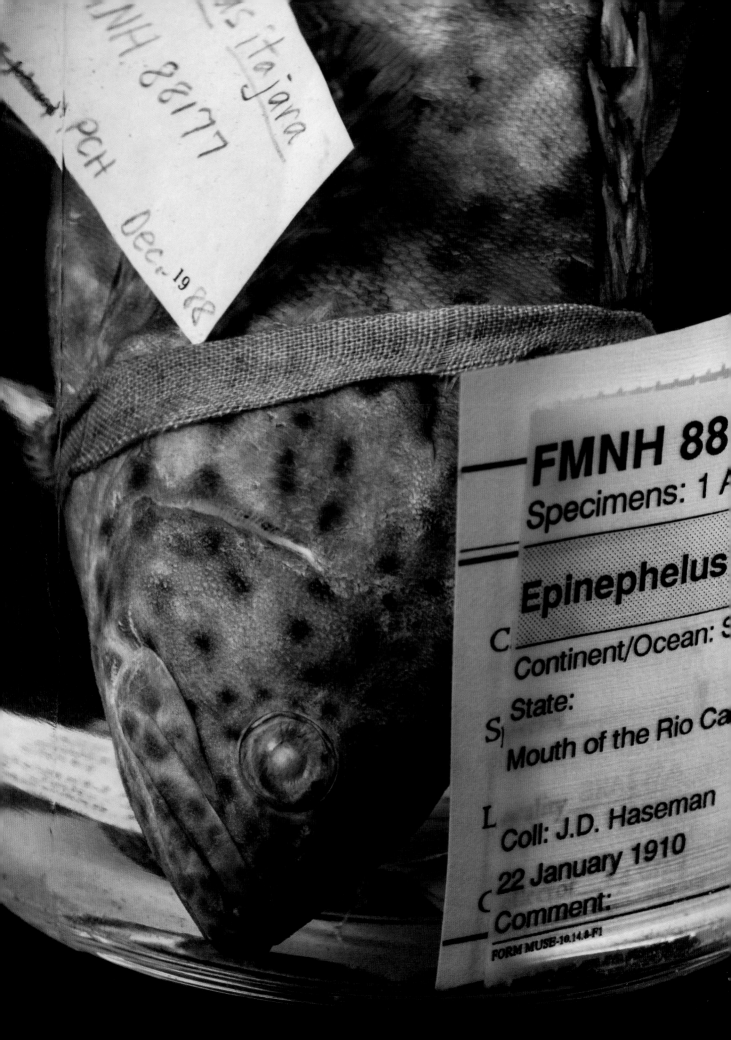

West Indian Ocean Coelacanth

Latimeria chalumnae

In 1938 a fisherman off the coast of South Africa brought up his haul to find a prehistoric-looking, dark blue, scaly, oily fish. After alerting a local expert, it was determined that the specimen was a coelacanth, a fish that was previously thought to have been extinct for over 65 million years. The discovery of this creature was widely hailed as the "most important zoological find of the twentieth century." This specimen was a West Indian Ocean coelacanth, one of only two known extant coelacanth species, with a second, the Indonesian coelacanth (*L. menadoensis*) having been discovered in the 1990s under very similar circumstances.

As members of the lobe-finned fish, coelacanths are actually more closely related to the other classes of animals (amphibians, reptiles, birds, and mammals) in this book than they are to ray-finned fish. Their antiquity is illustrated by coelacanth fossils found in rocks dating over 40 million years before the first trees emerged, around 370 million years ago. Coelacanths are therefore described as "living fossils." Living at a depth of up to 2,300 feet (700 m), a coelacanth can grow to around 6½ feet (2 m) long and weigh as much as 200 pounds (90 kg). In 2021 a French research team examined coelacanth scales with polarized light, revealing five times more annual growth rings, or circuli, than were previously observed under regular light. The researchers determined that they can live for nearly 100 years (it was previously thought to be closer to 50 years) and do not sexually mature until age 40. The new information means that the species is more threatened than previously thought and has enormous consequences for the continued survival of the species.

Although population figures are hard to discern given its deepwater habitat, the coelacanth is now categorized as critically endangered, with a steep population decline in effect since the 1990s and an estimated 1,000 individuals left in the wild. Although international trade of coelacanths is banned, they are often incidentally caught by fishermen trawling deep waters. Further threatening coelacanth numbers is the degradation of their ocean habitats by oil drilling off the coast of South Africa and by the proposed oil pipeline from Uganda to Tanzania's port of Tanga, which borders the protected Coelacanth Marine Park reserve.

Conservation Status

● Critically
Endangered

A study found that a single clutch of coelacanth embryos had shared paternity, an indication of females mating with only a single male during each breeding attempt.

Coelacanth gestation period

5 years

Endorheic Chub

Evarra tlahuacensis

Evarra tlahuacensis was a ray-finned fish in the family Cyprinidae, native to Mexico. It was listed as extinct in 1986—along with *E. eigenmanni* and *E. bustamantei*—most likely due to degradation of its habitat as a result of urbanization. This specimen from the Field Museum is the only one in existence. It was collected in 1901 outside of Mexico City by Dr. Seth Meek, one of the museum's first fish curators. *Evarra eigenmanni* shares a very similar story to *E. tlahuacensis* and the museum also has just one specimen of *E. eigenmanni*.

"This jar with this little minnow in it, which looks like just a fairly dried-out, shriveled-up brown fish, is actually, in my opinion, one of the cooler stories in the fish collection," explains Dr. Caleb McMahan, Fishes Collections Manager at the Field Museum. "Seth Meek worked all across Mexico and was really one of the earliest people to start doing large-scale collections in that region. And he collected this little minnow in 1901, brought it back, and then a year or so later described this as a new species. This little brown fish in this jar is our only record that this species ever lived on the planet… So, if one's interested in trying to figure out why this thing went extinct, they would have to come here and look at this specimen to start the quest of figuring it out."

McMahan and his colleagues are currently working on a project to return to *E. tlahuacensis'* original habitat to compare Meek's findings with the current status of other, similar species in the area.

Conservation Status

● Extinct

Endorheic, the first word of the species' common name, (endorheic chub), is used to describe a closed drainage basin with no outflow to other bodies of water.

Estimated number of species in the largest vertebrate family, Cyprinidae (carps and minnows), of which only half are extant

3,000

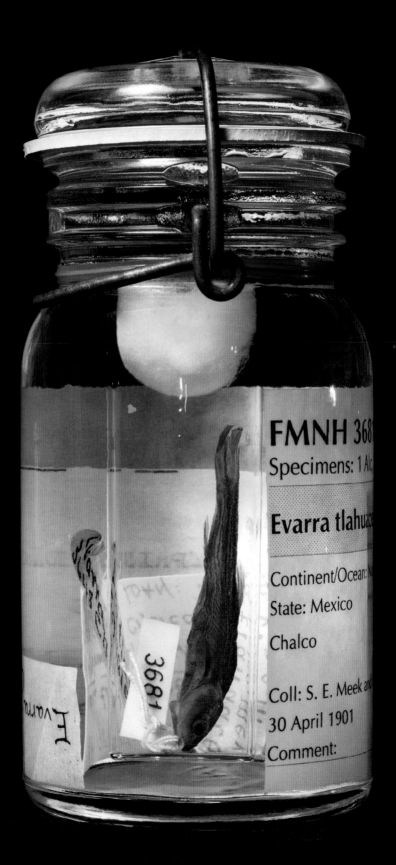

FMNH 368[...]
Specimens: 1 Alc[...]

Evarra tlahua[...]

Continent/Ocean: N[...]
State: Mexico
Chalco

Coll: S. E. Meek and[...]
30 April 1901
Comment:

Galapagos Damsel

Azurina eupalama

The Galapagos damsel is a six-inch (15 cm) long, silvery fish that was once abundant in the waters surrounding the Galapagos Islands. *Azurina eupalama* is from the Pomacentridae family of damselfishes and clownfishes and was first described in 1903. Up until 1976, the species was occasionally recorded but it has not been observed since 1983. Another damselfish, the swallow damsel (*Azurina hirundo*), occurs in the waters around Baja California, Mexico.

The reason for the fish's disappearance is thought to be the El Niño event of 1982 to 1983, which caused an unprecedented increase in water temperature around the Galapagos Islands. The Galapagos damsel survives on plankton which were severely in decline—the warmer the surface water, where plankton grow, the less nutrients there are for them to thrive on. Despite extensive searches, the fish has not been observed since this event and although considered critically endangered by the IUCN, it is highly likely that it is now extinct.

This specimen, pictured right, has been "cleared and stained" with a chemical process called diaphonization that reveals the skeleton. An enzyme is used to remove all tissues except bones and cartilage. Dyes are added to make bones blue and cartilage red. The fragile specimen is stored in glycerine. The process allows researchers to manipulate the skeleton to see how bones and cartilage move within the body.

Conservation Status

● Critically Endangered

Also known as the blackspot chromis for the black spot that it bears at the base of its pectoral fins.

Number of species in the genus *Azurina*

2

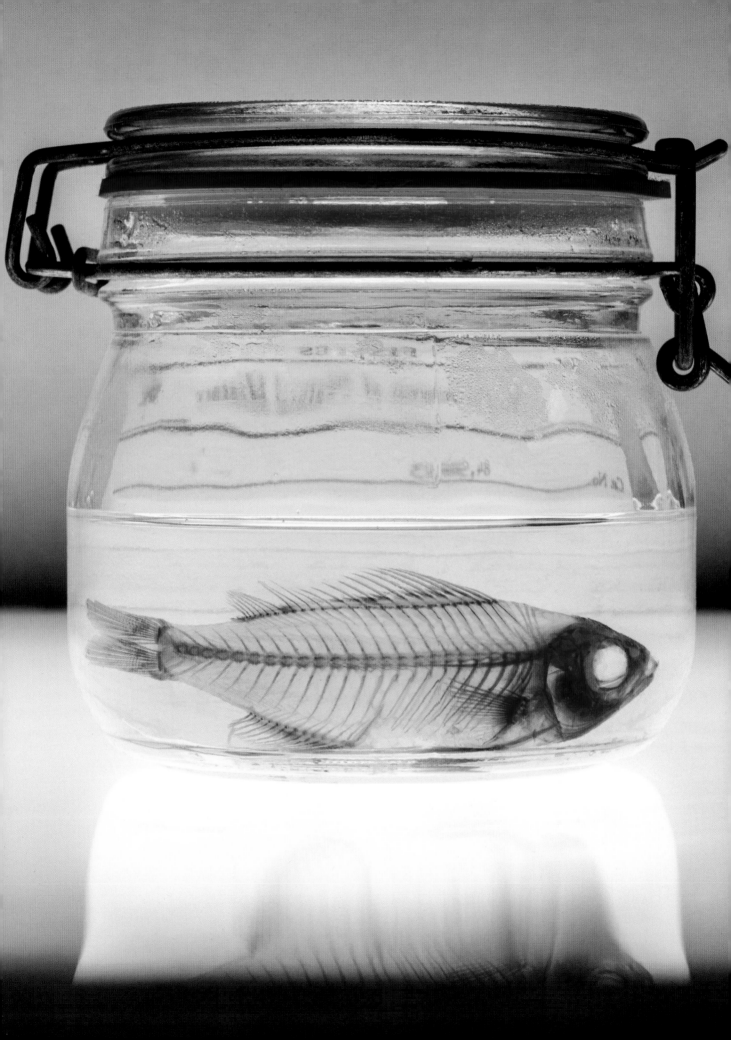

Fountain Darter

Etheostoma fonticola

The fountain darter is a small, one-inch (25 mm) long species of freshwater fish from the perch family and is found only in the headwaters of two rivers in South Central Texas between the cities of Austin and San Antonio—the Comal River and the San Marcos River. The species' lifespan is one to two years, and it feeds on small invertebrates. They lack a swim bladder, which means they dart along the bottom of their clear spring habitats, helping them contend with strong currents.

Fountain darters have been listed as endangered since 1986 and are primarily threatened by decreasing water levels from drought and increased use of groundwater as the human population expands. General destruction of habitat caused by human activities and invasive species has also contributed to the species' decline. One highly competitive species of snail from Asia now found in the Comal River, *Melanoides tubercaluaus*, is the sole host for another non-native species, a parasitic flatworm (*Haplorchis pumilio*), that is known to attack the gills of native fish species such as the fountain darter. Both invasive species were most likely introduced to the river by people dumping their aquariums. However, the fish has maintained its endangered conservation status since the 1980s without moving closer to extinction, indicating that positive steps are being made to maintain its population.

The fountain darter, along with several other species in the San Antonio area, is protected under the US Endangered Species Act. The city's only source of water—the Edwards Aquifer—was directly linked to the livelihoods of these species and the city was legally forced to rethink its water management policy in the 1990s. The city's efforts at diversifying and creating sustainable practices for its water use have now made it a model for water conservation worldwide, demonstrating the unexpected influence one tiny fish can have on an entire city.

Conservation Status

● Endangered

In 2018, a novel aquareovirus was identified from the San Marcos River population, introducing another threat to this species and raising calls for increased biosecurity measures in the area.

Estimated number of individuals the entire Comal River population descended from

49

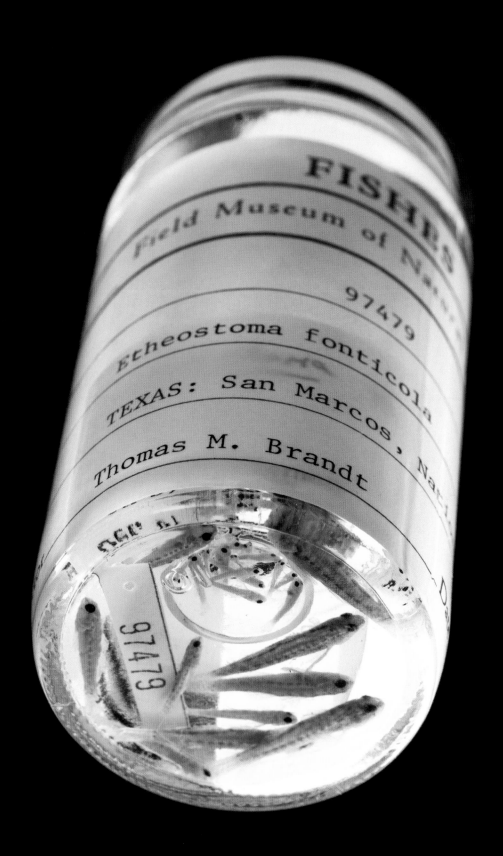

Titicaca Orestias

Orestias cuvieri

Orestias cuvieri is a species of pupfish endemic to Lake Titicaca, South America's largest lake, situated in Bolivia and Peru. Its genus, *Orestias*, is composed of 45 species, all of which inhabit waters in the Andean highlands. The Titicaca orestias, referred to locally as umanto, averages 8½ inches (21.5 cm) long and is characterized by its upturned mouth, flat head, and greenish-yellow coloring. The species is thought to be as old as five million years and therefore specifically adapted to its closed lake ecosystem.

Umanto were first observed in the 1930s and while the IUCN lists the species as data deficient, many believe that the fish has been extinct for decades. Its possible extinction can be linked to a decision in 1936 to populate the lake with lake trout from North America. Hoping to reap the perceived economic benefits of Lake Titicaca, Peru and Bolivia asked the US Fish and Wildlife Service for their advice. After a short survey of the area, it was recommended that lake trout be introduced to improve commercial fishing and to serve as another food source for the human population.

In 1937, 500,000 trout eggs were sent to Lake Titicaca, irreversibly altering the ecosystem. The trout flourished and became the top predator in the lake, eating smaller umanto and competing for food with the larger individuals. Umanto also suffered from the introduction of another non-native species in the 1950s, the Argentinean silverside, with which it also had to compete for food. Not a single individual umanto has been collected since 1960.

There are still over 20 species of *Orestias* in Lake Titicaca, many suffering population declines due to the introduction of invasive species and rampant pollution in the lake. In 2015, a program was developed between Bolivia and Peru to address the lake's environmental problems. However, as the cost of adequately cleaning the lake is estimated to be tens of millions of US dollars, financial considerations may yet again affect the management of the Lake Titicaca ecosystem.

Conservation Status

● Extinct

The genus *Orestias* is named after the Greek mythological character, Orestes. It is loosely translated as "stands on a mountain."

Percentage of species within the *Orestias* genus that are endemic to the Titicaca basin

51%

1 specimen

Field Number 86

Lake Titicaca, near
Bay Chiquito

Nov., 1941

Coll. Harry Tschopp

C. C. Sanborn

F. M. N. H.

Lake Sturgeon

Acipenser fulvescens

The history of the lake sturgeon is an example of the successful recovery of a species. Known as a "living fossil," the lake sturgeon is from a family of fish that have existed for around 135 million years. This freshwater fish is found in lakes and rivers in North America and can grow to be six feet long (1.8 m) and 200 pounds (90 kg) in weight.

In the early nineteenth century, lake sturgeons were considered pests by commercial fishermen in the Great Lakes because they had a tendency to rip up fishing nets. As such, lake sturgeons were routinely slaughtered and left rotting on shores, their carcasses used as fertilizer. It did not take long, however, for the economic value of the species to be realized—their bodies were burned as fuel to power steam ships, their swim bladders were used to make wine and beer, and their roe was sold as caviar. From 1879 to 1900 fishing of lake sturgeon reached an unprecedented high, averaging around three million pounds (1,360,777 kg) a year and in 1885, a staggering 8.6 million pounds (3,900,894 kg) were harvested.

From then on, the number of lake sturgeon declined dramatically. Not only were they affected by overfishing—not helped by their slow growth rate and late age of sexual maturity—but also by pollution and the damming of several tributaries of the Great Lakes, preventing access to their historical spawning grounds.

Commercial fishing of lake sturgeon collapsed in the 1970s and today it is banned in the US and heavily restricted in Canada. In a twist of fate for the species, commercial fishermen have played a vital role in the fish's recovery by trap-netting individuals for tagging and research, followed by their release. A vast amount of money has also been invested into restoring the Great Lakes, further assisting the recovery of the species. Rivers and lakes around the country are now being restocked with hatchery-grown lake sturgeon and the species is thriving thanks to lower levels of pollution, tighter fishing limits, the destruction of dams, and the proliferation of invasive species upon which the fish now feeds (zebra and quagga mussels and round goby, a fish). As journalist Ted Williams has written, "All who feel a sense of hopelessness about humanity's future and the future of the natural world need to contrast what we used to do to lake sturgeon with what we're doing for them now."

Conservation Status

● Least
 Concern

DNA studies of predator gut contents correlated with time have shown that young lake sturgeon are preyed upon more when the lunar light is at its maximum.

Distance traveled per day in miles during winter months

0.1–0.5
(0.2–0.8 km)

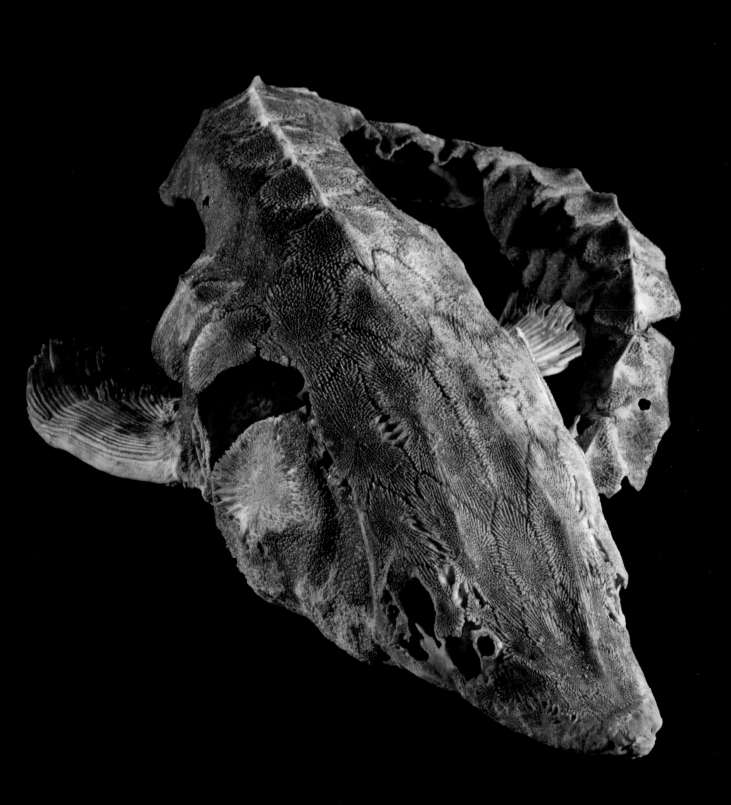

Spotted Darter

Etheostoma maculatum

Typically around two inches (50 mm) long, the freshwater spotted darter's traditional range spanned several Midwest and eastern US states within the Ohio River basin. It is now considered a vulnerable species as its numbers have decreased throughout this range. Currently, it is only found in 19 fragmented locations, and it is primarily limited to Ohio.

The fish was first described in 1840 and is characterized by a pointed snout, with males possessing small, bright-red spots. The spotted darter is a member of the perch family and typically inhabits medium-size rivers and streams where there are large rocks and boulders providing cover for hunting prey. The presence of spotted darters is widely considered to be an indicator of high-quality, clean water, as it is very sensitive to the effects of pollution and siltation.

Although the species' habitat is gradually declining, in 2011 the US Fish and Wildlife Service decided against listing the spotted darter under the Endangered Species Act, stating, "Our review of the best available scientific and commercial information… does not indicate that there are threats of sufficient imminence, intensity, or magnitude that would cause substantial losses of population distribution or viability of spotted darters." However, as Tierra Curry, Senior Scientist at the Center for Biological Diversity commented, "We're losing freshwater animals to extinction at 1,000 times the natural rate and that's really scary when you consider that the health of humans is directly linked to the health of our rivers. Endangered Species Act protection will protect not only these special freshwater species but also the healthy water quality that people need."

Conservation Status

● Vulnerable

A study analyzing other members of the *Etheostoma* genus found that male color patterns tend to correlate with their environment; it is thought that this makes them more detectable to females.

Maximum length in inches

3½ (90 mm)

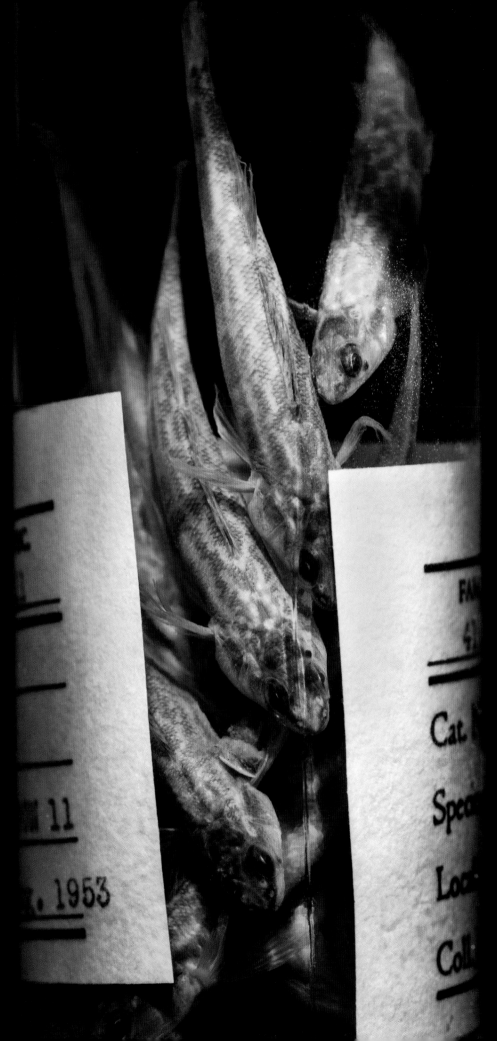

Maryland Darter

Etheostoma sellare

The tiny, three-inch (75 mm) long Maryland darter was native only to a small number of creeks and tributaries of the Susquehanna River in Harford County, Maryland. The IUCN lists the species as extinct. However, the US Fish and Wildlife Service considers the fish as only endangered and continues to search for remnant populations.

The Maryland darter has managed to evade biologists and conservationists for over 100 years. After its discovery in 1912, the fish was not observed again until 1962. Three years later, over 70 individuals were collected but then sightings became rare and irregular, with the last sighting in 1988. Its rarity contributes to the lack of information on its life history. The species is believed to be scarce due to its incredibly specific habitat requirements, making it particularly sensitive to habitat degradation due to residential development.

After a five-year review of the Maryland darter implemented by state and federal wildlife services, it was concluded that more data was needed, motivating researchers to begin using techniques such as electro-trawling—a process of sending harmless electric pulses through the water, bringing fish to the surface—to survey the population. The research also called for the necessary improvement of agricultural and forestry practices in the watershed to limit chemical runoff and erosion that degrades the water clarity that the species requires.

Conservation Status

● Extinct

While spawning was assumed to occur during the latter part of April (in common with other darters), the species was never observed during reproduction.

Average lifespan

3 years

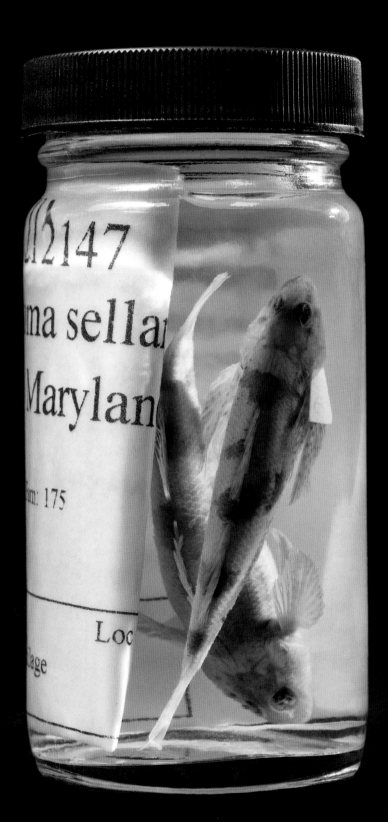

Snail Darter

Percina tanasi

The Tennessee River system has a huge diversity of fish in the family Percidae and many are threatened. One of those, the snail darter, is a 2¼ to 3½-inch (55 to 90 mm) long fish that was discovered in the eastern region of Tennessee in 1973 and was almost immediately listed as endangered. In that same year, this diminutive fish became the subject of a controversial and important legal proceeding, one that would come to have a significant impact on numerous endangered species in the United States.

The Endangered Species Act was passed in 1973 to protect already threatened species from the "consequence of economic growth and development untempered by adequate concern and conservation." The act was invoked by the Environmental Protection Agency (EPA) in their 1978 lawsuit against the Tennessee Valley Authority (Tennessee Valley Authority v. Hill) to stop the construction of the Tellico Dam. The EPA argued that continuing with the proposed dam on the Little Tennessee River would propel the snail darter to extinction by blocking its migratory route. The case made it all the way to the Supreme Court where the justices ruled 6–3 to halt construction of the dam.

Congress was furious that such a huge project could be thwarted by a "minnow" and eventually made the Tellico Dam exempt from the act. They voted on amendments to create the Endangered Species Act Committee, also known as the "God Squad," to consider the economic implications of future projects in order to grant exemptions. Nonetheless, the suit was considered a success as it was the first major test of the courts' willingness to enforce the ESA, protecting endangered species regardless of cost. The dam was completed in 1979 but not before the snail darter was introduced to or colonized seven rivers in the region. In August 2021 the US Fish and Wildlife Service proposed to delist the snail darter, indicating the species has recovered, and it can now be found in Tennessee, Alabama, Georgia, and Mississippi.

Conservation Status

● Vulnerable

As the name suggests, the snail darter feeds on river snails present in medium-size rivers it occupies but also insect larvae and nymphs.

Number of eggs in an average size litter

600

American Paddlefish

Polyodon spathula

The American paddlefish is an ancient species that is physically similar to its ancestors of 120 million years ago and is therefore often referred to as a "fossil fish." The only other species in the American paddlefish family Polyodontidae is the extinct Chinese paddlefish. The American paddlefish is closely related to the sturgeon and averages five feet (1.5 m) long with a weight of 60 pounds (27 kg). Unusual for a freshwater fish, it uses its long snout, called a rostrum, to filter feed on plankton. This photograph shows the extremely intricate bone structure of the rostrum, which can take up to a third of its length. The species is found in the 22 states in the US that are part of the Mississippi River basin. It inhabits slow-flowing, large rivers at depths of four feet (1.2 m) or more.

The American paddlefish has reached vulnerable status because it is highly prized for its meat and eggs. Expensive caviar is traditionally sourced from eggs of the beluga sturgeon (*Huso huso*), native to the Caspian and Black Seas. Access to the Caspian Sea has been extremely limited since Iran's revolution in 1979, diverting attention to the American paddlefish as the next best substitute. Consequently, the species was exploited for roe in the 1980s, at a time when the commercial fishing of American paddlefish was still legal.

Fishing of the American paddlefish is now extremely regulated, as is the international trade of its eggs, but the demand and potential profit from selling American paddlefish eggs is huge. At its height in 2007, one pound (0.5 kg) of roe could fetch as much as US$300 wholesale (it is now valued at closer to US$120). Many states, including Oklahoma, Montana, and North Dakota, have implemented programs whereby fishermen bring caught American paddlefish to a facility where the data is logged and any eggs are sold and exported, mainly to Japan, with 100 percent of the profits used to fund conservation efforts.

Overleaf: Close-up of the skeleton of an American paddlefish rostrum.

Conservation Status

● Vulnerable

American paddlefish are believed to rely on electroreception rather than vision for detecting their prey, which is primarily zooplankton.

Maximum home range in which individuals have been observed to travel in miles

2,000 (3,220 km)

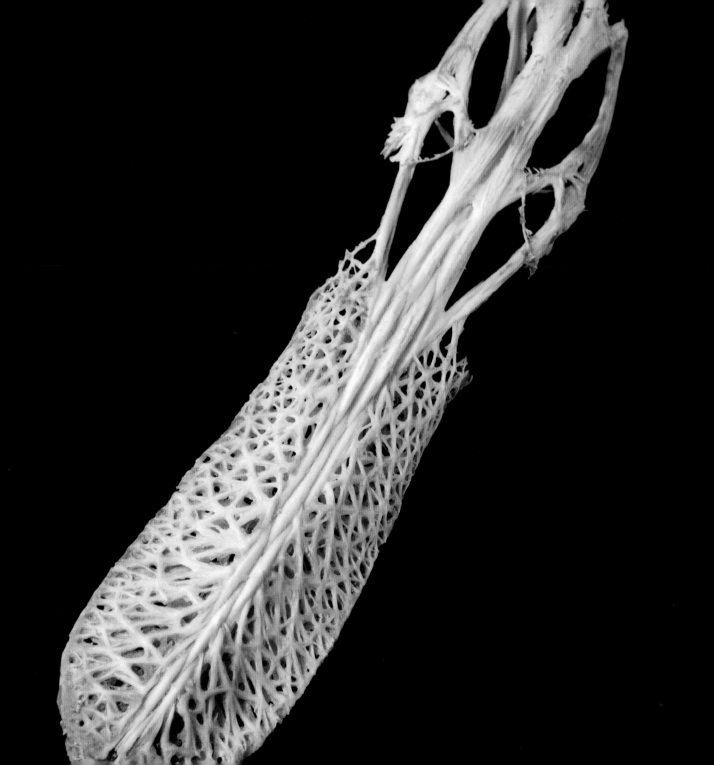

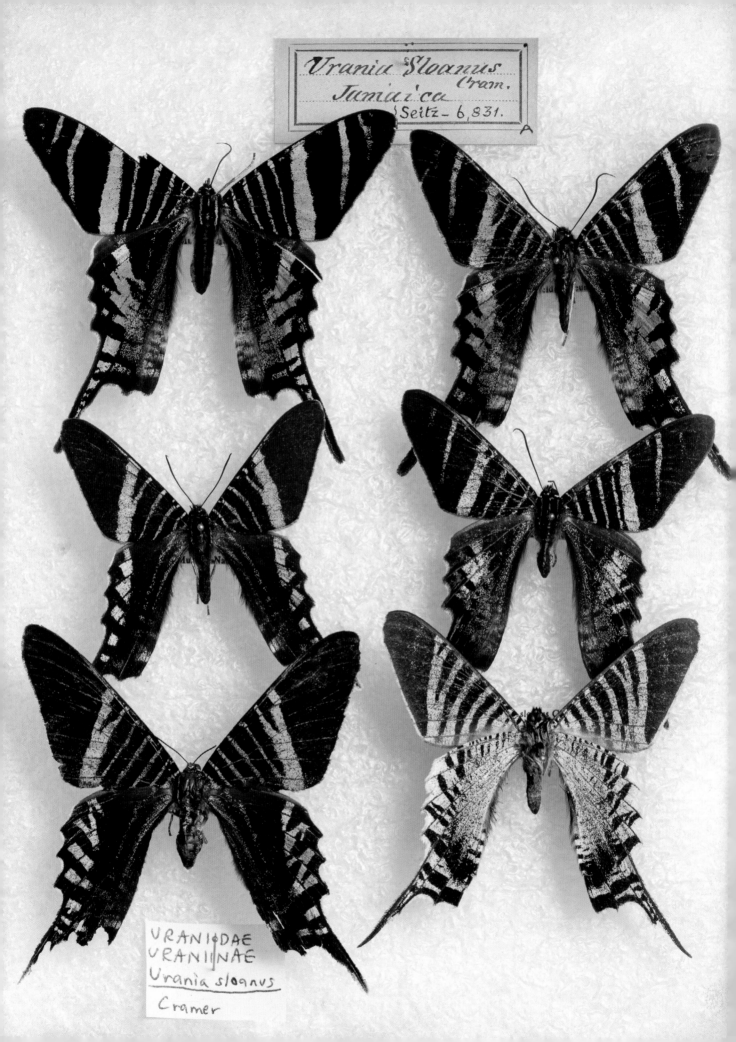

URANIODAE
URANIINAE
Urania sloanus
Cramer

4 Insects

"From the small size of insects, we are apt to undervalue their appearance. If we could imagine a male *Chalcosoma* [beetle] with its polished, bronzed coat of mail, and vast complex horns, magnified to the size of a horse or even of a dog, it would be one of the most imposing animals in the world."

Charles Darwin

Opposite: Sloane's urania (*Urania sloanus*).

Within invertebrates, the group known as arthropods have a distinct and divergent solution to the problem of maintaining an animal's rigidity; where vertebrates have developed a backbone, arthropods have an exoskeleton. They possess segmented bodies that enable the rigid exoskeleton to achieve a range of motion. In arthropods, the exoskeleton is constructed from chitin, a molecule derived from long chains of sugars, which has the useful characteristic of facilitating fossilization. This is famously embodied in one of the earliest known classes of arthropods, trilobites, which have appeared in the fossil record since around 530 million years ago. From this point on, arthropods survived numerous mass extinction events to become one of the most successful phyla of animals, with about 84 percent of all known species included in this lineage. The most successful group of arthropods are undoubtedly the insects, with an estimated 10 million extant species.

In addition to their high speciosity, a feature of modern insects is their universally small body sizes. Indeed, without the support provided by an internal skeleton, the upper limit of their body size is set at a lower level compared to that of vertebrates. However, larger insects are known from the fossil record, suggesting that other variables are also important. The largest insect ever recorded was a dragonfly, *Meganeuropsis permiana*, which had a wingspan of over 2¼ feet (0.7 m), roughly equivalent to a medium-size bird. This huge insect existed around 300 million years ago during the Carboniferous, a period defined by higher levels of atmospheric oxygen than present, which facilitated large body size given their relatively inefficient respiratory systems. The absence of predators is also likely to have been an important factor—it is notable that the size of insects declined markedly following the evolution of birds, around 150 million years ago.

Despite their diminutive nature, insects have nevertheless adopted a distinguished variety of complex life histories and social structures. For example, bees, ants, and wasps commonly display a social hierarchy known as eusociality, involving cooperative care of young and a caste-based, colonial social structure that works to benefit some, if not just one reproducing member of the group, such as a queen. Beyond their success in the wild, insects have further proven their value and success in the lab as model organisms, given their fast rate of reproduction and ease of rearing in a laboratory. The common fruit fly (*Drosophila melanogaster*) has become one of the most studied species of any animal phylum and has been the

"If all mankind were to disappear, the world would regenerate back to the rich state of equilibrium that existed ten thousand years ago. If insects were to vanish, the environment would collapse into chaos."

E. O. Wilson

source of troves of information about genetics, animal development in the womb, and how microbes cause disease. In the process, six Nobel Prizes have been awarded to researchers working with the common fruit fly.

In comparison to vertebrates, data on insect population trends are very scarce and geographically biased in favor of North American and European regions. However, that which does exist makes for grim reading. In 2017, one of the only long-term studies to investigate insect abundance through time, led by the Entomological Society Krefeld, reported a decline in total flying insect biomass of over 75 percent in three decades. What is particularly disturbing about these findings is that the locations from which the data were compiled were all designated protected areas in Germany—places that should be relatively sheltered from the impacts of human activity. The first major review of the state of insect

Above left: Over 20,000 trilobite species have been described in the fossil record and they were distributed worldwide.

Top right: Fruit flies, genus *Drosophila*, are one of the most studied animals in the history of science.

Bottom right: There are estimated to be at least 1,000,000 ants for every human being.

biodiversity, published in 2019, estimated that, globally, around 40 percent of insect species are in decline, which is double that of vertebrates. However, in common with vertebrates, the major driver of species decline was found to be habitat destruction, with pollution (through the use of fertilizers and pesticides), invasive species, and climate change also making substantial contributions.

The degree to which ecosystems are resilient to this level of insect biodiversity loss is unclear. Given the key roles insects play within communities as conduits of energy to higher trophic levels, losses of the magnitudes reported have raised serious concerns of a so-called "ecological armageddon." As the prominent entomologist E. O. Wilson has said, "If all mankind were to disappear, the world would regenerate back to the rich state of equilibrium that existed ten thousand years ago. If insects were to vanish, the environment would collapse into chaos." The authors of the 2019 insect biodiversity review advocate for a multifaceted approach in reversing current trends. In particular, habitat restoration will be key to allow insects to recover in areas that have been intensively farmed. They also suggest that biological control strategies, in which a natural enemy of an insect pest is used to suppress their abundance, have been underutilized and may serve as a much more sustainable solution than the use of traditional agrochemicals.

Narrow-Headed Ant

Formica exsecta

The narrow-headed ant is a species of wood ant native to the British Isles, distinguished from other species by a deep notch on the back of its head. It is around half an inch (12 mm) long, is dark, reddish-brown in color, and is thought to play an integral role in seed dispersal. The ant is highly territorial and when attacked or threatened it can accurately fire formic acid up to four inches (10 cm) from an abdominal gland. The narrow-headed ant once inhabited heathland and moorland in England and pine forests in Scotland but now the species is found only in South Devon and in scattered forests in Scotland as well as a patchy distribution throughout Europe.

Though not listed on the IUCN Red List, the narrow-headed ant is considered endangered in the UK and it is projected to become extinct in England in the near future. The primary threat to the species is loss of habitat. In England, heathland has largely been cultivated for agriculture and developed or degraded as a result of human activity and mismanagement. Pine forest habitats in Scotland have suffered much the same fate.

As narrow-headed ants cannot travel across unsuitable habitat to establish new colonies, inbreeding—resulting in a lack of genetic diversity within populations—further threatens their survival. Consequently, the species is recognized as a priority for conservation under the UK Biodiversity Action Plan. The only remaining population in England occurs on Chudleigh Knighton Heath at the roadside of the A38 trunk road on a small nature reserve managed by Highways England partnering with conservation organizations. Road verges are now recognized as good habitats because they are relatively free from human activity.

In 2018, a three-year project began—led by volunteers and wildlife charities Buglife and Devon Wildlife Trust—to create, restore, maintain, and link up heathland habitats across 200 of the ants' nest structures at the site in Devon. Nests were also moved to former sites that are now protected. "I've been engaged with the plight of *Formica exsecta* for 18 years," said Buglife's Stephen Carroll in 2021. "I saw the last nest succumb and die out at its penultimate site in 2004. It's great to see the first significant steps to recovery, which might have been our last chance, and just in time."

Conservation Status

● Endangered

A substantial portion of their diet consists of honeydew, an excretion of "milk" from aphids.

Number of sites at which *Formica exsecta* occurs in England

1

American Burying Beetle

Nicrophorus americanus

The American burying beetle is 1½ inches (40 mm) long with a distinctive pattern of orange patches on its black body. The beetle is nocturnal, can fly distances of up to half a mile (almost 1 km) each night, and, unusually for beetles, both the male and female look after their young. It is a carrion beetle, meaning that it relies on dead or decaying carcasses for food and for breeding. The male waits for a female if he finds a carcass first. When they have buried the carcass, they mate, and the female lays approximately 30 eggs inside the carcass. The process turns and enriches the soil and is thought to encourage decomposition.

The species' range once extended over 35 states in the US and into southern Canada, yet by the 1920s it had all but disappeared—it is now only found in six states and in the Canadian province of Ontario. Scientists think that the decline of American burying beetles is linked to several factors: the extinction of the passenger pigeon (which was the perfect size food for the beetle), the widespread use of insecticides, an increase in mammal scavengers, and light pollution, which disrupts their circadian rhythm.

The American burying beetle was listed as endangered in the US Endangered Species Act in 1989, resulting in a conflict between beetle conservationists and oil and gas companies in Oklahoma—one of the species' only remaining habitats, but also home to people that rely on these industries to make a living. Protection by the Act meant that any drilling or pipe laying in the species' habitat was strictly forbidden without first having to bait, trap, and relocate the beetles. Lobbying by the petroleum industry led to these requirements being dropped in 2012.

In September 2020, the conservation status of American burying beetle was downgraded from endangered to near threatened under the administration that also rolled back numerous wildlife and environment protections across the country. It is listed as critically endangered on the IUCN Red List. As of early 2021, The Center for Biological Diversity filed a lawsuit to fight for the reinstatement of the beetle's endangered status because of continued threats to its survival. "The Trump administration didn't strip this beautiful orange-and-black beetle of protection because it was recovered, but as a gift to the oil and gas industry," said Kristine Akland, staff attorney for The Center. "Far from having recovered, the American Burying Beetle is even more endangered than it was when it was first protected in 1989 because of the linked effects of massively expanding oil and gas development and climate change."

Conservation Status

● Critically
 Endangered

Nicrophorus americanus is the largest carrion beetle.

Distance in miles at which chemical receptors on their antennae can detect decaying flesh

2 (3.2 km)

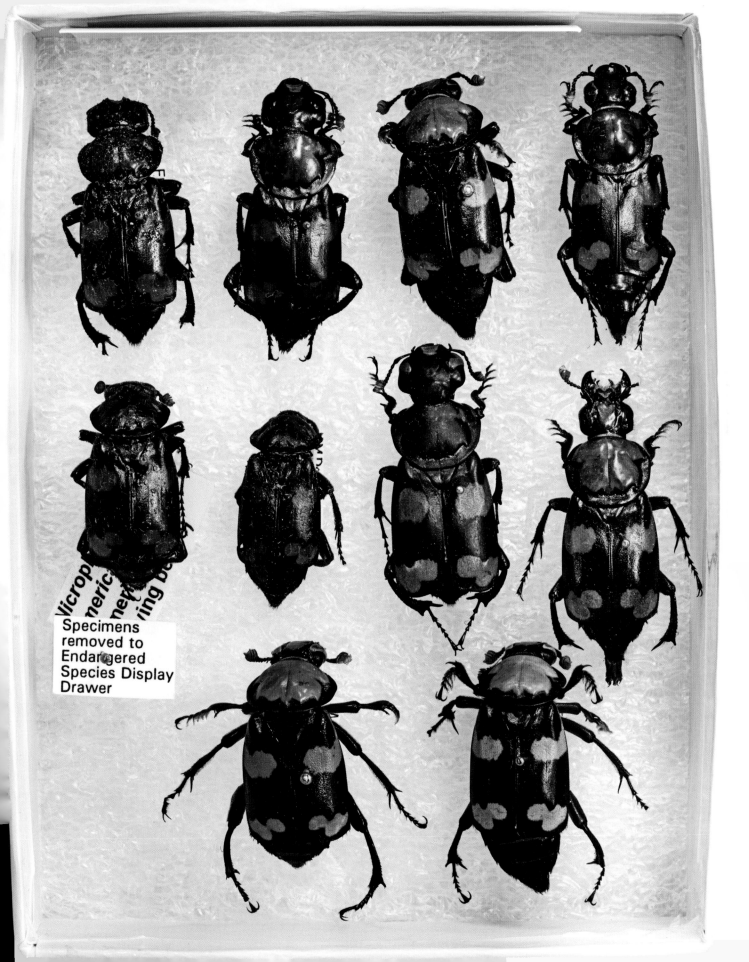

Columbia River Tiger Beetle

Cicindela columbica

The endangered Columbia River tiger beetle is around half an inch (12 mm) long, characterized by its black body with light-colored, wavy markings. It has very specific habitat requirements—living in sandbars, dunes, and river beaches—and was once found in the US states of Washington, Oregon, and Idaho on the Columbia, Salmon, and Snake Rivers before damming of its Columbia River habitat extirpated the species from much of its range. It is now only found in the Lower Salmon River system in Idaho.

Tiger beetles pursue their prey in a stop-and-go chase pattern. The insect accelerates so quickly that for an instant, it cannot see. Professor Cole Gilbert of Cornell University explains, "It just means that at their speed during the chase, they're not getting enough photons reflected from the prey to make an image and locate the prey. That is why they have to stop, look around, and go. Although it is temporary, they go blind." Despite the stops, a tiger beetle is still fast enough to catch its prey.

Affected by fluctuating water levels due to damming, the Columbia River tiger beetle is also threatened by other human activities such as recreational use of its waters and over-collecting—given its newfound rarity, the beetle is very popular with collectors. Currently, it is not protected by the US Fish and Wildlife Service and there are no efforts to monitor or manage its habitat. Fortunately, there are organizations fighting for the survival of often overlooked invertebrates, like the Xerces Society, which works to bring awareness to the plight of the Columbia River tiger beetle. In a published species profile, they outline what is needed to save this species and many other endangered species from extinction: "Necessary actions include monitoring known populations and searching for new ones, and protecting habitat in regions where the species is known to occur."

Conservation Status

● Endangered

Measured for speed relative to body size, an Australian species, *Cicindela hudsoni*, is 20 times faster than Usain Bolt and 7.5 times faster than a cheetah.

Speed of *Cicindela hudsoni*, the fastest insect on land, in miles per hour

5.6 (9 km/h)

Rusty Patched Bumble Bee

Bombus affinis

The rusty patched bumble bee was once endemic to the east and upper Midwest of the United States and in southern Ontario and Quebec, Canada. Distinguishable from other bumble bees by the rust-colored marking on its abdomen, it has experienced the most serious decline of any bee species in North America, disappearing from an estimated 87 percent of its historic range and suffering a 95 percent decline in its population in the last few decades. Since 2003, only very small numbers have been recorded.

In the past decade, unprecedented numbers of bees have been dying off; about 30 percent of them are lost each year. Bees pollinate well over half of the world's crop species—they are particularly crucial to fruit and nut crops—posing a huge threat to the future of agriculture and nutrition for humans. Despite this, humans are responsible for their looming extinction.

Scientists studying bees have identified the use of certain insecticides, known as neonicotinoids and widely used in commercial agriculture, as particularly lethal to bees. Added to this are deadly parasites—such as the microsporidian parasite *Nosema bombi*, recently reclassified as a fungus—carried by commercial bees shipped around the country to pollinate farms but in the process infecting populations of wild bees. Climate change also plays a role—as the Earth's temperature warms, many species of plants and animals head north but it has been found that bees don't follow this trend, remaining in the south where their habitat is gradually diminishing.

Thanks to efforts by the Xerces Society and a process begun in 2013 by the US Fish and Wildlife Service, the rusty patched bumble bee was declared endangered in March 2017, the first species of bee to be protected under the US Endangered Species Act. The IUCN lists the species as critically endangered. Alongside this work to list the species, population assessments are increasingly assisted by surveys carried out by expert and nonexpert volunteers—for instance, the website Bumble Bee Watch exists for people to record new sightings, verified by experts who then advise conservation methods—harnessing the power of citizen scientists around the world.

A 2021 survey of native bees and the plants they are attracted to also offers a targeted way for people to help conserve struggling species of bees by selecting certain plants to grow in their gardens. "These are very small animals; you don't need 100 acres to make an impact. A tiny bee can do well in a small residential setting," said Matthew Sarver, a consulting ecologist in Wilmington, Delaware, and instigator of the survey. "It's a great opportunity for conserving biodiversity, but enough of us have to do it."

Conservation Status

● Critically Endangered

Bumble bees have very fast metabolisms, and they eat continuously: "A bumble bee with a full stomach is only ever about 40 minutes from starvation," says Professor of Biology Dave Goulson of the University of Sussex, UK.

Frequency of bumble bee wings beating in Hz (beats per second)

200

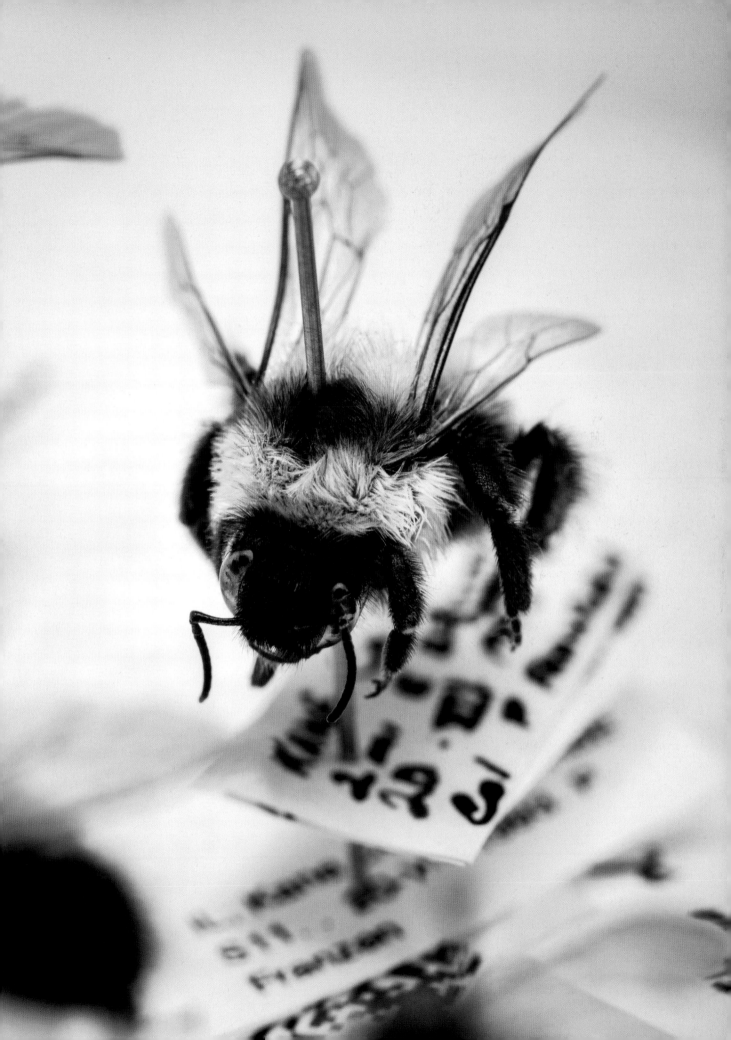

Western Bumble Bee

Bombus occidentalis

There are approximately 30 bumble bee species in the Pacific Northwest region of the United States and the western bumble bee was once the most common of these—its historic range spanned 14 states and into western Canada. This species is considered to be a generalist pollinator, benefiting numerous agricultural crops. In the 1990s the species was bred to commercially pollinate crops, eventually contracting *Nosema bombi*, a deadly fungal parasite affecting many bee species. As a result, wild populations of the species were also infected and numerous commercial bumble bee operations collapsed.

Over the past two decades, numbers of western bumble bee have dropped more than 90 percent and its range has decreased by 20 percent. The species has nearly disappeared from southern British Columbia down to Central California; however, the bee is yet to be listed under the Endangered Species Act in the US. The threats to the western bumble bee are shared by other species of bee: the spread of disease by the commercial bee industry, habitat destruction, pesticides, invasive plants that compete with the bee's native sources of nectar and pollen, and the spread of parasitic insects, such as the small hive beetle (*Aethina tumida*). As the overall population becomes more fragmented, they are also threatened by inbreeding, resulting in sterile males that cannot reproduce or serve as workers.

In 2016, small populations of western bumble bee were discovered in locations in Washington and Idaho where they had previously not been documented, offering a glimmer of hope for the species. One hypothesis regarding this reemergence is that they have developed a resistance to *Nosema bombi* or that the parasite has become less virulent. However, researchers warn against being too positive about their slight resurgence. "It's not clear if we caught them on a good year or a bad year," said Paul Rhoades, graduate research fellow at the University of Idaho. "We need to see if these populations are sustainable."

Conservation Status

● Vulnerable

The western bumble bee exhibits different colors in the various regions it occurs in western North America.

Number of species of bumble bee worldwide

249

Bombus (Bombias) nevadensis nevadensis Cresson, 1874

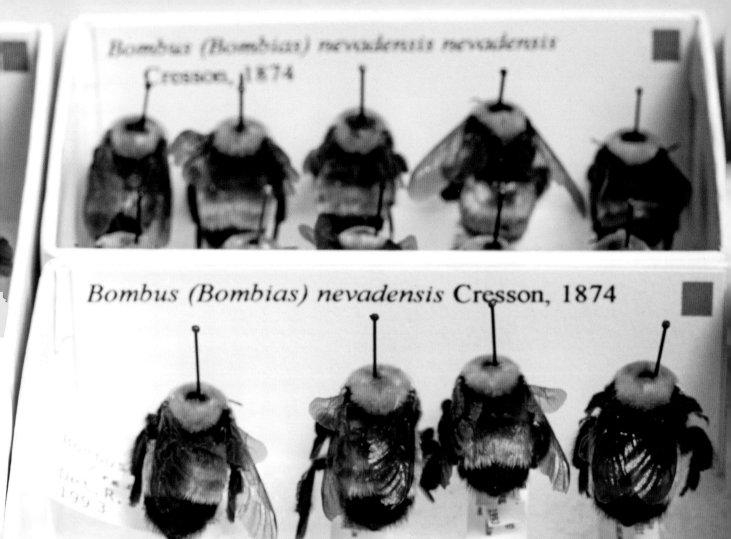

Bombus (Bombias) nevadensis Cresson, 1874

Bombus (Bombias) occidentalis Greene, 1858

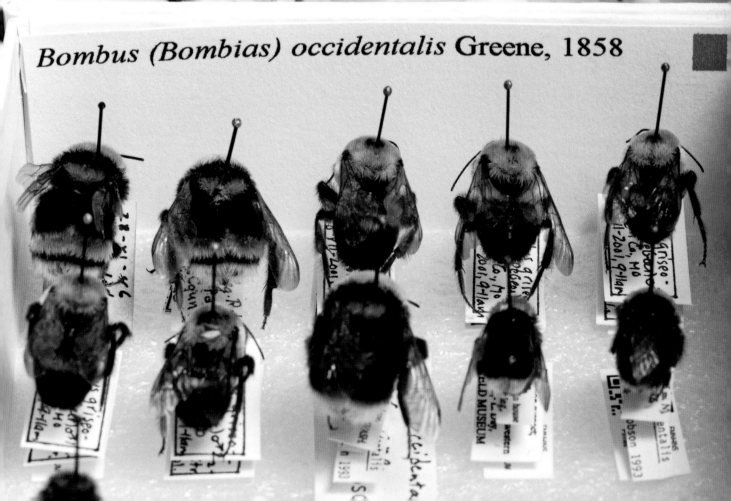

Monarch Butterfly

Danaus plexippus

The unmistakable monarch butterfly, with its bright orange wings, striped in black and dotted in white, is arguably the most iconic species of butterfly in the United States. Monarchs are found all over the country (as well as in Southeast Asia and Oceania) and they migrate during the winter months, west to California and south to Mexico, flying over 2,400 miles (3,900 km).

As of March 2020, monarchs overwintering in Mexico—roughly 99 percent of the total North American population—had decreased by 53 percent from the previous year, while the western population crashed by 99 percent to a historic low of 30,000 individuals (down from 1.2 million in the 1990s). As the monarch's larvae feed exclusively on milkweed, their survival is inextricably linked to the abundance of this plant. Milkweed, however, has systematically been eradicated around the American Midwest by the widespread use of herbicides. It is estimated that 120 to 150 million acres (48–60 million ha) of milkweed habitat in the Midwest is now completely gone. Deforestation in their overwintering habitats is another major obstacle for the monarch.

Current numbers of monarchs are below the threshold at which many researchers believe migrations could collapse. An increase in volatile environmental conditions has also had a substantial effect on monarch populations. A study published in the journal *Science* in 2021 found that butterfly numbers in the western US dropped an average of 1.6 percent over 40 years in areas where fall temperatures had risen significantly compared to summer temperatures, possibly disrupting breeding cycles and negatively affecting food sources. The difficulty in pinning down an exact population number of the butterfly is emphasized by Robin Delapena, Collections Assistant in the Insects Division at the Field Museum: "The monarch is a tough one. It depends on who you talk to. Some believe it's endangered; others believe it's a very cyclical species and populations are hard to calculate."

Being such a beloved species means that monarchs have federal, local, and state governments along with several organizations petitioning to have the butterfly protected under the US Endangered Species Act. In 2020 more than 100 organizations banded together to call for an increase in federal funding to US$100 million per year to conserve the species. Conservationists are lobbying to stop the widespread use of pesticides, and efforts are in place to plant species preferred by the monarch along its migration route. In 2021, California began planting nearly 620 acres (251 ha) of milkweed statewide, thanks to a US$1 million initiative to restore the monarch's habitat. Small changes on a local level are even said to make a difference, as people are encouraged to plant their own "butterfly gardens" to entice monarchs to return each year.

Conservation Status

● Endangered

Monarchs flap their wings five to 12 times per second, whereas other butterflies on average flap 20 times per second.

Number of American states for which the monarch is the state insect

7

Atala

Eumaeus atala

The atala butterfly, with its black wings dotted in iridescent blue and vivid orange abdomen, is native to southeastern Florida, the Bahamas, Cuba, and the Cayman Islands. Its larvae feed exclusively on the coontie plant (*Zamia integrifolia*), a species of cycad, and in doing so ingest a toxic chemical that remains in its body its entire life, making the butterfly distasteful to potential predators.

The atala was once so abundant in South Florida that in 1888 it was regarded as "the most conspicuous insect" in the area. The significant abundance of coontie plants quickly changed once the plant started being harvested for its roots as a source of starch. By the 1920s the plants were extremely scarce and by the 1950s the atala was thought to be extinct.

In 1979, a colony of atala butterflies was discovered living on a barrier island off Florida's east coast near Miami. With the combined efforts of scientists and the general public, the species is now thriving. Thanks to a renewed appreciation for Florida's native plants, coontie plants are now commonly found in botanical landscapes and gardens. The return of the atala is considered a nuisance by some because they feed on these expensive plants. However, many residents regard the recovery of this attractive species as outweighing the potential damage to their gardens.

Since 2019 the state of Florida has ranked the butterfly as "apparently secure globally" yet the population continues to fluctuate. "Atala butterflies are en masse right now in St. Lucie County [on the east coast of Florida]," said Ken Gioeli, author at the University of Florida's Institute of Food and Agricultural Sciences. "I refer to them as ephemeral. We have a lot right now in coastal areas but they are likely to completely disappear soon. So basically, we enjoy them when we have them."

Conservation Status

● Endangered

During winter, conservation colonies are fed freeze-dried coontie plant due to the unavailability of fresh coontie.

Maximum adult lifespan

3 months

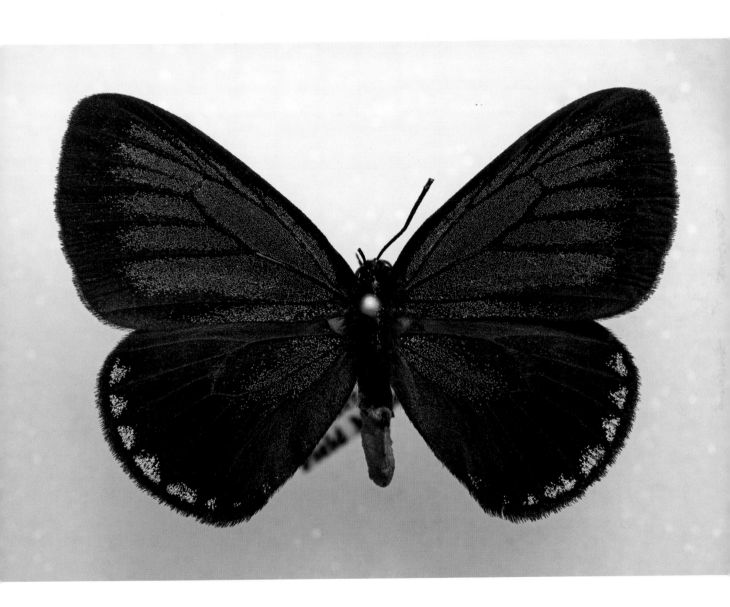

Xerces Blue Butterfly

Glaucopsyche xerces

Writing in 1998 about the sadness associated with extinction, veterinarian and author Dr. Mark Jermone Walters remarked, "When the tiny wings of the last Xerces blue butterfly ceased to flutter, our world grew quieter by a whisper and duller by a hue." The Xerces blue was last observed in the wild in 1941.

The species was first described in 1852 and was of great interest to butterfly experts because individuals exhibited incredible variation in their wing patterns. The small, periwinkle-blue butterfly was native to the coastal sand dunes of San Francisco before being driven to extinction by habitat loss due to urbanization. It was the first North American butterfly to become extinct as the result of human action.

The Xerces blue today lives on, lending its name to the Xerces Society, a nonprofit organization that is focused on the conservation of at-risk invertebrates and their habitats. The society works closely with lawmakers and government agencies as well as producing educational programs and publications. Dr. Robert Michael Pyle, who founded the Xerces Society, also spearheaded a Xerces blue de-extinction effort starting in 2000. However, critics of de-extinction maintain that reintroduction could negatively affect ecosystems that have adapted to the loss of a species and that de-extinction is exploitation of a species mankind has killed off, with possible unforeseen negative consequences. For now, the focus of the Xerces Society remains firmly in generating awareness and preventing the extinctions of other often-overlooked, less charismatic, but incredibly vital invertebrates.

Pyle has hypothesized that if a butterfly species with a similar genome to that of the Xerces blue—such as the silvery blue (*Glaucopsyche lygdamus*)—was introduced to the newly restored patch of sand dunes in San Francisco's Presidio area, it might evolve into something more closely resembling Xerces blue. "Assisted migration is an important solution to climate change," said Lewis Stringer, Associate Director of Natural Resources at Presidio Trust. "In order for an individual species to be able to adapt to climate change, humans will have to step in and bring them to the places that they wouldn't otherwise be able to bring themselves."

Some scientists have questioned whether Xerces blue was a distinct species or an isolated population of silvery blue. However, in 2021 researchers extracted DNA from a 93-year-old specimen in the Field Museum and using the latest genome sequencing technology, they concluded that it is indeed a distinct species, highlighting the importance of preserving collections for future analysis using tools not previously available.

Conservation Status

● Extinct

An endangered subspecies of silvery blue, *Glaucopsyche lygdamus palosverdesensis*, native to coastal Los Angeles, has been reared in captivity since 1995.

Number of species worldwide in the genus *Glaucopysche*

20

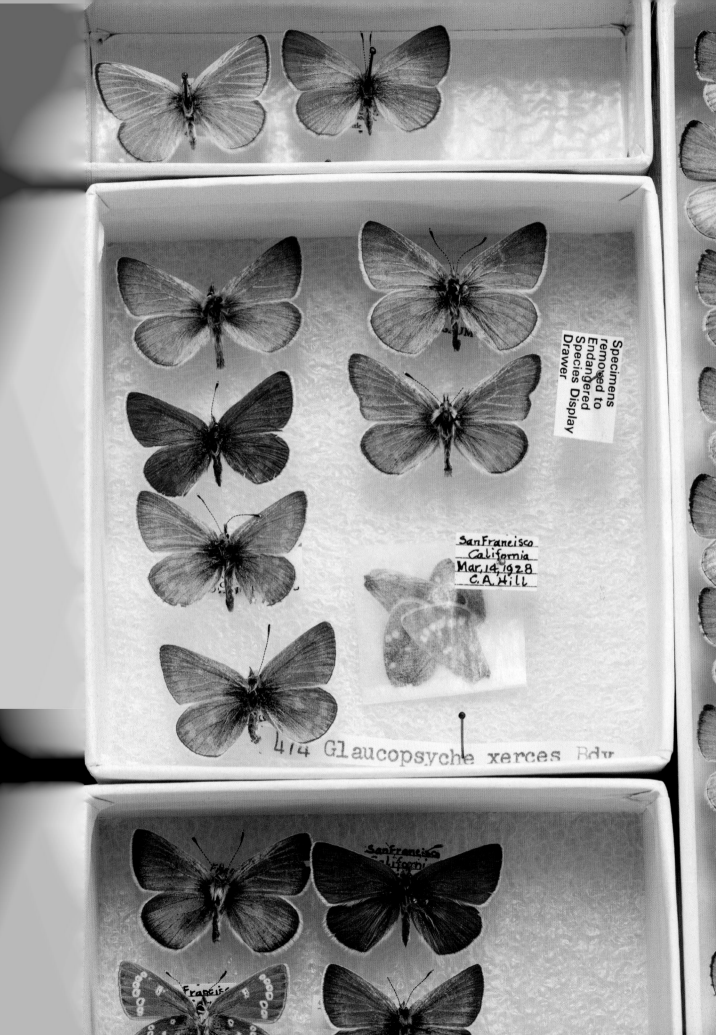

SanFrancisco
California
Mar. 14, 1928
C.A. Hill

474 Glaucopsyche xerces Bdv

Sloane's Urania

Urania sloanus

Upon his death in 1753, British physician, collector, and naturalist Sir Hans Sloane bequeathed his numerous collections—everything from flora and fauna to coins and manuscripts—to the British Museum in London. The plants, animals, and insects he collected later became the core collection of London's Natural History Museum. His legacy, however, is not without controversy as his wealth was derived from the work of slaves on his plantations in Jamaica. This history was acknowledged by the British Museum in 2020 when they removed his bust from a prominent position to a display case, with text explaining his connection to slavery and imperialism.

The species was described in 1779 by Pieter Cramer and he honored Sloane with the common name. The *Urania* genus includes only six species of large, day-flying moths (most moths are nocturnal), mainly found in Central and South America. Sloane's urania was endemic to Jamaica and was black with iridescent, metallic markings in orange, blue, and green along its wings. Just over 100 years after Sloane presented his illustrations of *U. sloanus* to the world, the moth became extinct, most likely caused by loss of habitat, including a plant of the genus *Omphalea* that was its main source of food, as land was cleared for agriculture. Its last sighting was in the 1890s.

Conservation Status

● Extinct

Sloane's urania was also known as the Jamaican sunset moth.

Number of specimens of *Urania sloanus* in the collections of the Field Museum

8

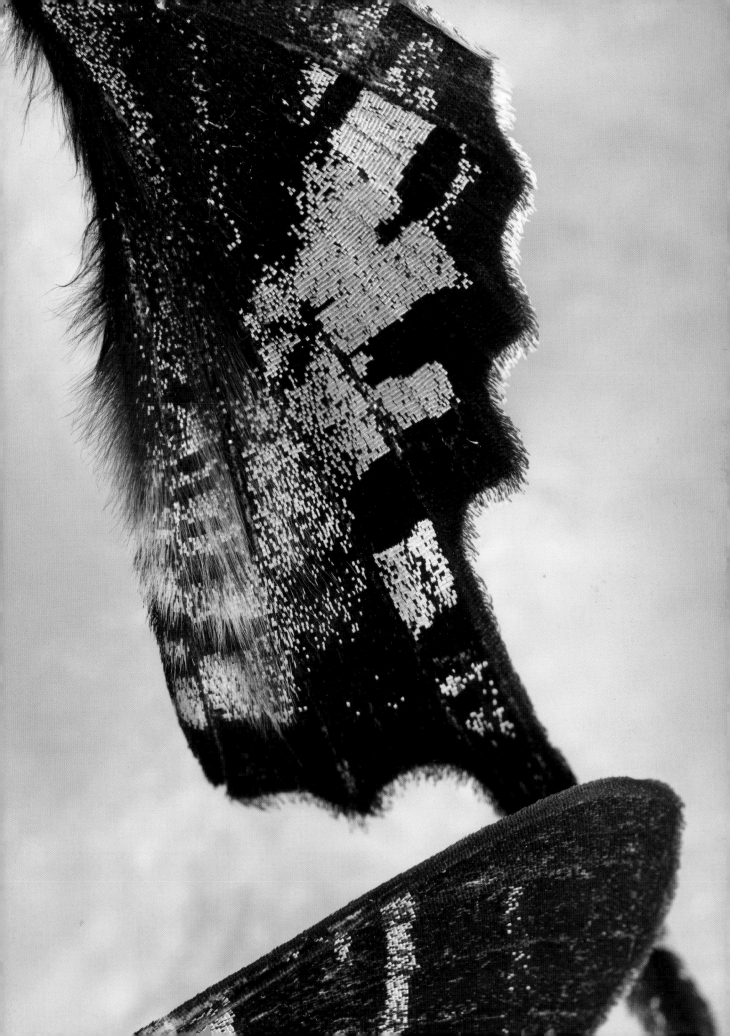

5 Invertebrates

"We don't even know what species are out there, for the most part, particularly when you get down to the microbes and very small invertebrates. They make up the mass of the organisms around us, including the soil we depend on, the soil of cornfields as well as hardwood forests."

E. O. Wilson

Opposite: Land snail
(*Cyclosurus mariei*).

nvertebrates include all lineages of the animal kingdom that do not possess a backbone, which accounts for the vast majority of animals, with estimated numbers of species ranging from 10 to 30 million. The diversity of invertebrates began with the origin of animals themselves when sea sponges appeared around 580 million years ago in the fossil record, but with DNA analyses suggesting an earlier origin around 750 million years ago. This is followed by the divergence of the phyla Ctenophora (comb jellies) and Cnidaria (corals and jellyfish). More advanced invertebrate groups possess bilateral symmetry, such as arthropods, mollusks, and annelid worms. In this chapter, corals and mollusks are highlighted, given the sheer size and diversity within the Field Museum's Invertebrates Collection.

Despite the invertebrate dominance of the animal tree of life, with their variety of marine and terrestrial habitats, lifestyles, and morphologies, animal biodiversity research is significantly biased toward the study of vertebrates in temperate climates. In fact, although representing only five percent of all animal species, vertebrate biodiversity research accounts for approximately half of all research output in the last 20 years. This is particularly unfortunate for corals (class Anthozoa), invertebrate reef building colonies of polyps that exclusively inhabit shallow tropical oceans. Building complex calcium carbonate structures called coral reefs, they establish marine ecosystems that house an amazing abundance of marine species; indeed, housing this level of diversity means that corals are considered as keystone species. Corals are excellent sentinels of general ocean health, as they are particularly sensitive to environmental change, and for humans, represent opportunities for tourism, jobs, and natural products.

With rising sea temperatures, coral bleaching has become an imminent threat to the future biodiversity and range of corals. This phenomenon occurs when the symbiotic algae living in coral tissue, generating 90 percent of a coral's metabolic energy, are expelled due to severe heat stress associated with rising sea temperatures. Climate change also drives increased carbon dioxide (CO_2) concentrations in the atmosphere, leading to more CO_2 absorbed by the oceans, otherwise known as ocean acidification. This directly reduces the availability of calcium compounds corals use to construct their great reefs.

"With rising sea temperatures, coral bleaching has become an imminent threat to the future biodiversity and range of corals."

According to climate models, if carbon emissions continue as they are, 90 percent of corals will undergo annual bleaching in the next 30 years. Overall, around 33 percent of all coral species are currently at risk of extinction, with this figure predicted to rise to 75 percent by 2050. Nevertheless, while corals are on a severe decline, hope remains that their sheer number and diversity may save them from absolute extinction, according to a recent survey of half a trillion Pacific colonies. Even if losses remain around 90 percent, this may not be enough to cause an outright loss of species diversity, with small pockets of colonies enduring, giving humans time to reign in climate change, preserving the diversity of 450 million years of evolutionary history.

Among the variety of habitats provided by coral reefs lives a small bivalve creature called *Lithophaga curta*, composed of two calcium-derived shells, burrowing directly into and colonizing living corals. It is a member of the mollusks, the second largest phylum of invertebrates, comprising over 85,000 species, more than all the vertebrates combined. In common with other invertebrates, research on them is more limited than other groups of animals; it is estimated that there are 50,000 to 200,000

undescribed species of mollusks globally. The phylum is hugely diverse, housing everything from snails, octopuses, and clams to more exotic and less understood forms such as nudibranchs and the giant squid. Mollusks account for a quarter of all described marine fauna, with equal amounts of success on land.

The calcareous shells of mollusks fossilize easily so they are therefore particularly suited for biodiversity studies. They are strong indicators of past habitat conditions and industrial pollutant runoffs. The IUCN currently lists 26 percent of all mollusk species as at risk, with 80 percent of these species either terrestrial or inhabiting inland freshwater. The majority of mollusk extinctions are driven by human expansion of agriculture and urbanization, with water pollution contaminating freshwater habitats and deforestation fragmenting terrestrial habitats. Efforts to control terrestrial snail populations have included the introduction of alien species without proper screening of ecosystem level effects, resulting in extinctions and infestations, particularly on Pacific islands. Invertebrates have a huge range of life histories and survival strategies to contend with nature's challenges, yet they face the twofold risk of rising extinction rates and under-representation in scientific research, presenting obstacles to their future conservation.

Blue Coral

Heliopora coerulea

Coral reefs cover less than one percent of the Earth's surface yet nearly a quarter of the ocean's species are dependent on them for food and shelter. They are one of the most diverse ecosystems on Earth. They occur most frequently in warm, shallow waters and due to the diversity of life they support, are often referred to as the rainforests of the ocean.

Blue coral is one of only two species in the genus *Heliopora*. It produces a massive internal skeleton, populated with individual polyps. It is most commonly found in the shallow waters of the Indo-Western Pacific and is named after its distinctive bright blue skeleton. A second species of blue coral, *H. hiberniana*, was formally named in 2018 and remarkably, it has a white skeleton.

It is no secret that coral reefs are under threat, primarily from human action, with an estimated 20 percent already destroyed. The ubiquitous threat of climate change is a major factor, which causes ocean acidification and increasing water temperatures. Even a one-degree Celsius difference in temperature affects the delicate symbiotic relationship between coral polyps and the algae inhabiting them. This process is referred to as coral bleaching, which occurs when coral polyps expel their temperature-sensitive algae and become almost transparent, revealing their white skeleton. If stressed by warm temperatures for too long, the coral will die from starvation or disease. Sea temperatures across the Great Barrier Reef in Australia hit a record high in February 2020 and there is concern the resulting bleaching could become an annual event.

Added to bleaching is a long list of other threats to coral: overfishing, the use of cyanide or dynamite in fishing, exploitation for the aquarium trade, urban and industrial pollution, the introduction of invasive species, outbreaks of predatory starfish, careless tourism, sedimentation from land erosion, and damage from natural disasters.

There are, however, glimmers of hope as scientists continue to study reefs that are referred to as "bright spots"—areas with far more fish than expected. One such example is Indonesia's Raja Ampat archipelago. While bleaching has been widespread throughout the reefs in Indonesia's waters, Raja Ampat is thriving. Scientists have concluded that the extreme temperature variations it experiences—fluctuating between 66 and 96 degrees Fahrenheit (18–35°C)—has resulted in a more temperature-tolerant species of algae inhabiting the coral, helping the reef bounce back from bleaching. As such, the Raja Ampat reef, if properly conserved, could serve as a "seed-bank" and be the key to the long-term viability of what remains of the world's reefs. However, an unfortunate incident put that hope in jeopardy in March 2017 when a cruise ship ran aground and damaged more than 200,000 square feet (18,500 m²) of Raja Ampat's pristine reef, highlighting again the effect careless tourism can have on the environment.

Conservation Status

● Vulnerable

The pigment that gives the coral its blue tone is from the same family of pigments responsible for the green color sometimes seen in human bruises.

Oldest example in fossil record

120 million years ago

Arcuate Pearly Mussel

Epioblasma flexuosa

North America is home to more than one third of the world's freshwater mussel species, the highest diversity of bivalves anywhere. Of the approximately 300 species of freshwater mussel in the United States and Canada, over 70 percent are at risk and 38 species are presumed extinct, making freshwater mussels one of the most endangered organisms in North America. In comparison, less than 20 percent of birds and mammals respectively are currently at risk.

The arcuate pearly mussel was first described in 1820 and was found in the US states of Alabama, Illinois, Indiana, Kentucky, Ohio, and Tennessee. Little information is recorded on this species and despite extensive surveys the last living individual was observed around 1900. *Epioblasma flexuosa's* natural habitat was flowing water in rivers, so it can only be assumed that the species' extinction is linked to extreme habitat alteration and degradation. This is most likely a result of damming, channelization, draining, and pollution from agriculture and industry that plagued American rivers, affecting the countless aquatic species inhabiting them. In addition, freshwater mussels are dependent on fish for reproduction—parasitic glochidia, a larval stage, attach themselves to the gills of host fish and metamorphose over several weeks into free-living juveniles, making freshwater mussels particularly vulnerable to the general decline of their ecosystem.

Conservation Status

● Extinct

All freshwater mussel species rely on fish to host their larvae, except one. The salamander mussel (*Simpsonaias ambigua*) relies on aquatic salamanders, known as mudpuppies, as hosts.

Number of specimens of *Epioblasma flexuosa* in the Field Museum

13

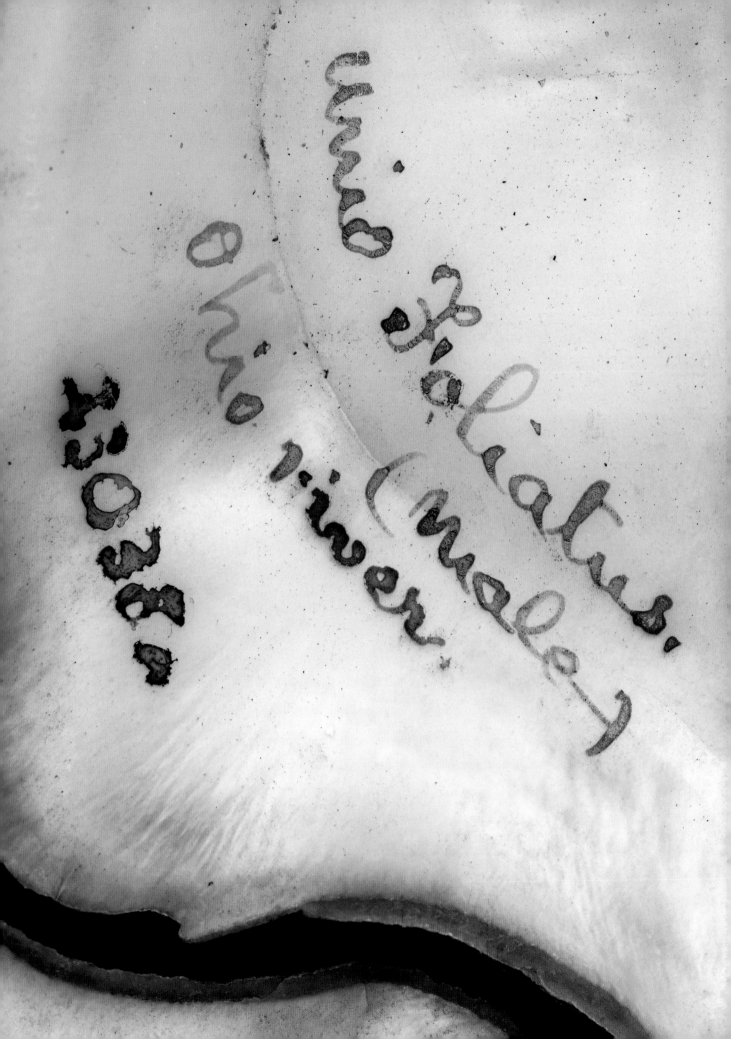

Spengler's Freshwater Mussel

Pseudunio auricularius

Named after Lorenz Spengler, the Danish naturalist who discovered it in 1793, Spengler's freshwater mussel is a large species of mollusk with a shell that can reach a length of up to eight inches (20 cm). It exclusively inhabits large, slow-moving rivers with clean and oxygen-dense water, relying on a host fish species for reproduction like other mussels in its family. *Pseudunio auricularius* was once widespread throughout Europe but it is now believed to be one of the most threatened invertebrate species in the world, decreasing 90 percent over the past 90 years.

The population of Spengler's freshwater mussels suffered a dramatic decline beginning in the early twentieth century. It was thought that the last live specimens were collected in 1933, although 63 years later approximately 2,000 *P. auricularius* were discovered in a channel in Spain's Ebro River basin. Today, the mollusk occurs only in four locations in Spain and France.

Trade in the mussel's nacre, its mother-of-pearl inner shell, began over two centuries ago and was used to produce items such as buttons and knife hilts. However, the species now faces more modern threats: loss of habitat due to the construction of dams, riverbed dredging, water extraction, and pollution from pesticides. All of these factors also greatly impact the fish species it relies on for reproduction, primarily the critically endangered European sturgeon (*Acipenser sturio*).

The species is now protected in France and Spain and part of its Ebro Delta River basin habitat has been declared a national park. Yet without captive breeding measures, the smaller and fragmented populations of Spengler's freshwater mussel that exist in France could disappear within the next 15 to 45 years.

Conservation Status

● Critically
 Endangered

A *Pseudunio* archaeological shell specimen from 7,000 years ago was identified in 2020 by analyzing crystalline structures found between proteins.

Estimated life span

50–80 years

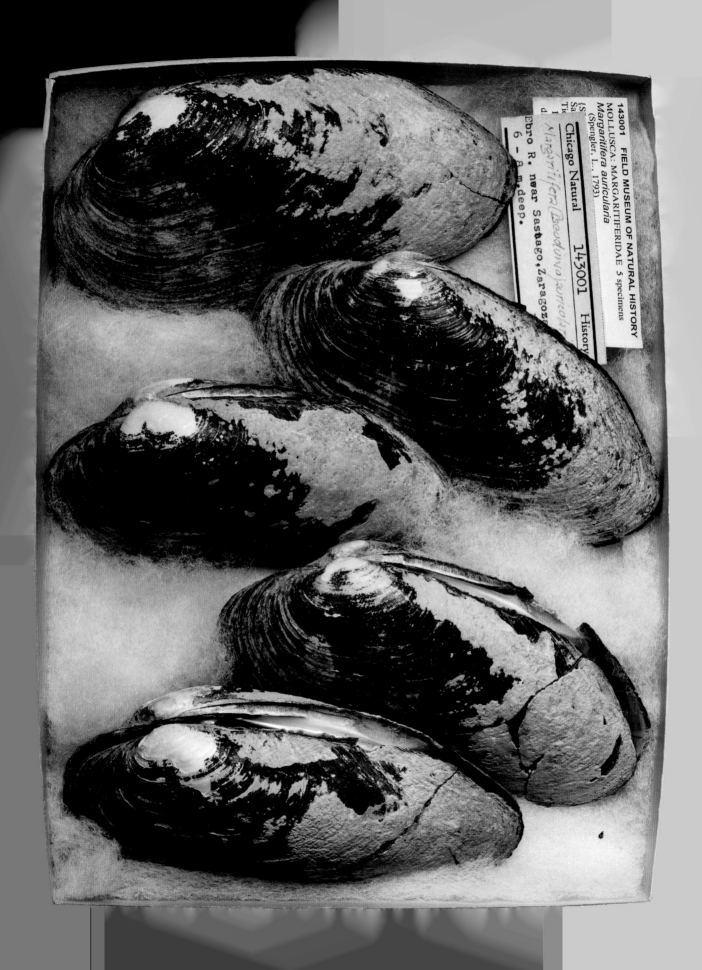

Freshwater Pearl Mussel

Margaritifera margaritifera

The freshwater pearl mussel is one of the longest living species of invertebrates, living up to 200 years. It is distributed throughout the Holarctic, the ecozone comprising the globe's northern continents, making it one of the most widely distributed mollusks in the world, although it is not abundant within its range. The species inhabits fast-flowing rivers and streams where it requires clean water and sediment in which to bury itself.

Numbers of freshwater pearl mussels are now declining, and they have become extinct in some countries, suffering an overall global loss of 61.5 percent and an 81.5 percent loss in Europe since 1920. The main threat to the species is the degradation of its habitat from human activity, such as overfishing, construction, water pollution, drainage, and dredging. Siltation of its freshwater habitats as a result of these practices means that freshwater pearl mussels are unable to get the amount of oxygen they need to survive. The mussels are also the victims of pearl fishing, which is now illegal throughout Europe, as their pearls have been prized and exploited since Roman times.

Further adding to its plight, the species grows very slowly, reaching reproductive maturity at around 15 to 20 years old, meaning it is slow to recover from any population decline. They are dependent on host fish—salmon and trout—where they begin their lives as glochidia, a larval form with minuscule shells that stay open until they snap shut on the gills of the host fish without harming it. They then drop off after several months but must land on clean sandy or gravel substrates to successfully burrow and grow.

Conservation efforts offer some hope for the freshwater pearl mussel and include habitat restoration, captive breeding, and repopulation in areas where the species has been eradicated. It is protected by almost all European countries, but a parallel effort needs to be made to conserve the salmon and trout that are crucial to the freshwater pearl mussel's continued survival.

Conservation Status

● Endangered

Hydropower plants on rivers significantly impact the distribution of these mussels, with 97 percent more individuals found upstream of these plants compared to downstream.

Maximum age reached (one of the longest living invertebrates)

280 years

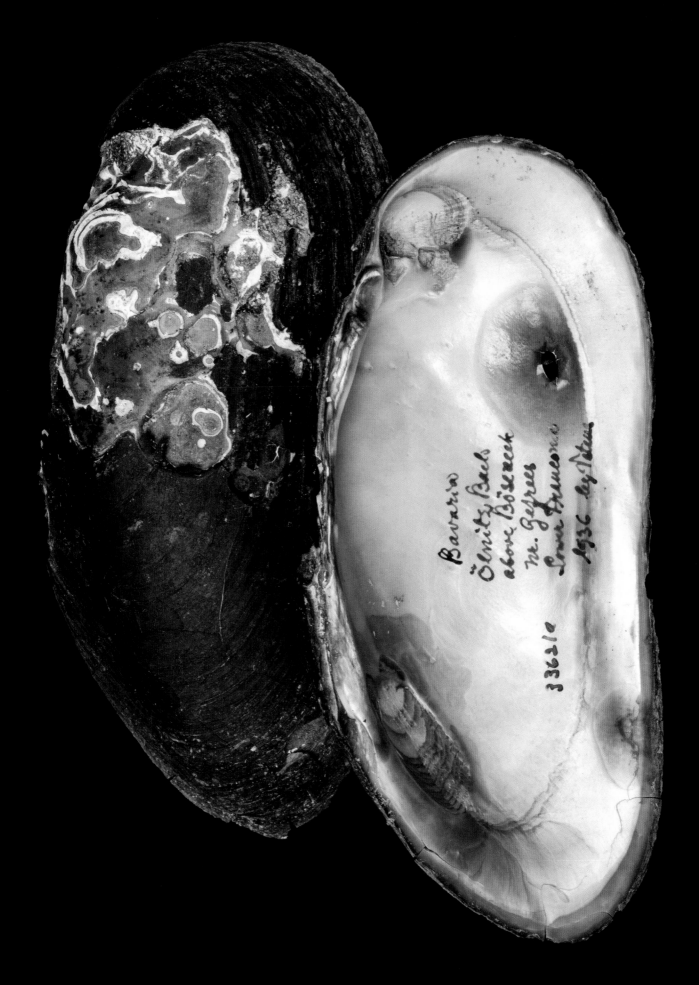

Yellow Blossom Pearly Mussel

Epioblasma florentina florentina

The *Epioblasma* genus is made up of around 27 species of North American freshwater river mussels. It is believed that more than half of the species and subspecies found in this genus are extinct and others are endangered. Almost all extant species are now protected under US federal law.

Far from being a passive resident of the riverbed, this species employs a remarkable reproductive strategy. They have adapted their anatomy and behavior to capture specific host fish in the family Percidae, temporarily clamping onto the fish's head without killing it and infesting its gills and fins with glochidia, its larval form. The parasitic glochidia attach themselves to the fish, mature in a few weeks and then drop off as juveniles. The strategy allows *Epioblasma* to exploit upstream habitat unavailable without the mobility of the host fish.

The yellow blossom pearly mussel was first described in 1857 and the last known specimen was collected in 1967. In September 2021 the US Fish and Wildlife Service proposed that this species be declared extinct and removed from the endangered species list, based on the inability to find any individuals in the wild for such a long time. The species originally inhabited the once clean, shallow, and rapid streams of the Tennessee River basin and the Cumberland River, primarily in the states of Tennessee and Kentucky. Extinction resulted from the destruction of its habitat through damming, recreation, and hydroelectric power production. It is thought that all species of *Epioblasma* are particularly sensitive to degradation of water quality. With increased pollution and sedimentation from mining, farming, logging, and construction, numbers of yellow blossom pearly mussels suffered immediate and drastic declines. Further threats to the genus come from invasive species: the zebra mussel (*Dreissena polymorpha*) competes for food and swarms *Epioblasma* by attaching and smothering; and the round goby (*Neogobius melanostomus*) competes with the perch that *Epioblasma* relies on as a host fish.

Conservation Status

● Extinct

Some species of freshwater mussel have a lifespan of over 100 years.

Number of known freshwater mussel species worldwide

958

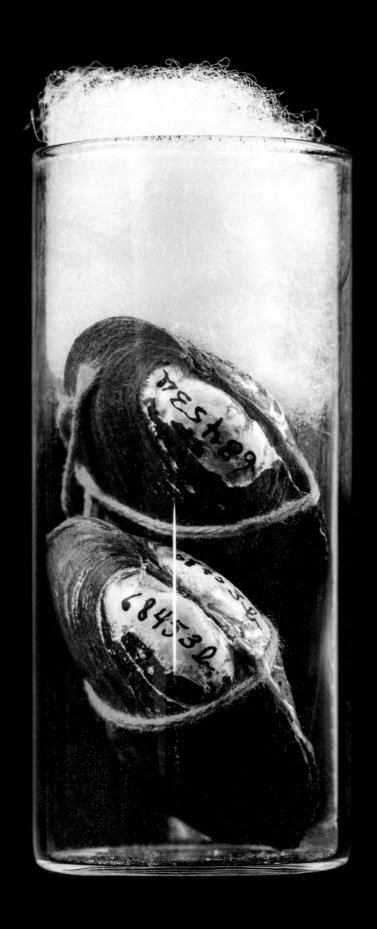

Black Abalone

Haliotis cracherodii

Black abalone is a species of edible mollusk, widely considered to be a delicacy. Its shell is a dark blue, green, or brown with an iridescent pinkish or greenish interior. Black abalone can grow up to eight inches (20 cm) and is mainly found on the southern coast of California, extending down to northern Mexico. It is thought to live between 25 and 75 years. Moving slowly across rocks and hard surfaces using its foot, it feeds primarily on algae and kelp.

The species was once among the most abundant marine mollusks on North America's west coast. However, in 1985, numbers of black abalone suffered an 80 percent decline attributed to a disease called withering syndrome, caused by bacteria that attack the abalone's digestive tract. This leads to atrophy and eventually starvation. It is believed that increasing water temperatures allow the bacteria to flourish.

Haliotis cracherodii also suffers greatly from being overharvested for food since the 1800s and for trade in its shell, used in making decorative items or jewelry. There are now laws in California restricting how abalone may be harvested—only by skin diving and without any scuba gear, only in certain seasons, and only once they reach a particular size. Yet illegal poaching continues, and the species remains threatened by commercial harvesting in Mexico.

Wildfires on California's Central Coast in 2020 were aligned with the Big Sur coastal area where 75 percent of the black abalone population remained. Harsh winter rains in early 2021 washed debris and loose earth into the ocean, burying the abalone's habitat with sediment, tree trunks, and boulders. Scientists estimate that tens of thousands of abalone died from this event. Around 200 surviving individuals were rescued and taken to a holding facility, which is not the preferred conservation method for many scientists. "We've been of the mindset that if we leave them alone, then they will recover. And that is true for most things," said Dr. Peter Raimondi, a marine ecologist and evolutionary biologist at the University of California, Santa Cruz. "But now, there's an impetus to start a different approach, which is more interventionist."

Conservation Status

● Critically Endangered

Archaeological past abundances of black abalone along California's coast have been used to identify four optimal future locations for restoration of the species' population.

Number of species in genus *Haliotis*

56

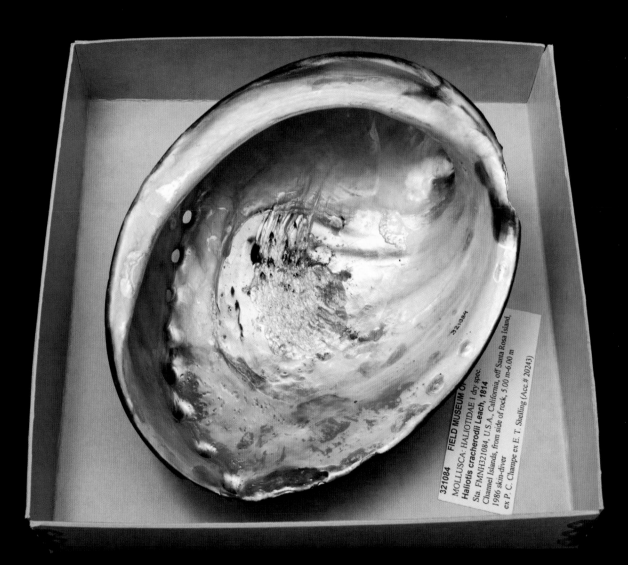

Ribbed Elimia (pictured top)

Elimia laeta

Tulotoma Snail (pictured middle)

Tulotoma magnifica

Pyramid Slitshell (pictured bottom)

Gyrotoma pyramidata

First described in 1834 and native to the Alabama-Coosa River system in the Alabama, US, the tulotoma snail inhabits the underside of large rocks in fast-flowing water. The species gives birth to live young, rather than eggs or larvae as most other snails do, and is considered large in comparison with other freshwater snails—its shell, ornamented with knobs and spirals, grows up to one inch (25 mm) in height.

The ribbed elimia and pyramid slitshell freshwater snails, also endemic to the Alabama, were listed by the IUCN as critically endangered in 1996 before being declared extinct in 2020 due to lack of survey data.

The tulotoma snail was once found in great numbers but by the 1950s it had essentially disappeared from the Alabama River and only small, fragmented populations existed in just three creeks. The major contributing factor to the species' decline was the construction of six dams on the Alabama and Coosa Rivers between 1914 and 1966, effectively draining 90 percent of the snail's habitat in a river system that had an extremely rich diversity of freshwater fauna.

The US Fish and Wildlife Service (USFWS) protected the snail in 1991 under the Endangered Species Act by listing it as endangered, which has led to a strong recovery. The Alabama Power Company, advised by USFWS, began to time its water-release schedules to coincide with the species' reproductive cycle, which also improved the habitat by increasing oxygen levels. Existing populations flourished and six further populations of the snail were discovered. Although still considered endangered by the IUCN since an assessment in 2000, USFWS downlisted the species' status from endangered to threatened in July 2011.

Conservation Status

- Ribbed elimia: Extinct
- Tulotoma snail: Endangered
- Pyramid slitshell: Extinct

Tulotoma snails seem to prefer river water flowing at speeds of below 8 inches per second (20 cm/s).

Number of freshwater snail species that were endemic to the Coosa River

80

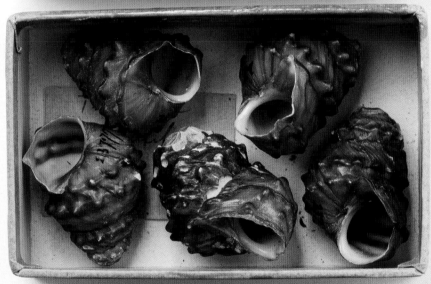

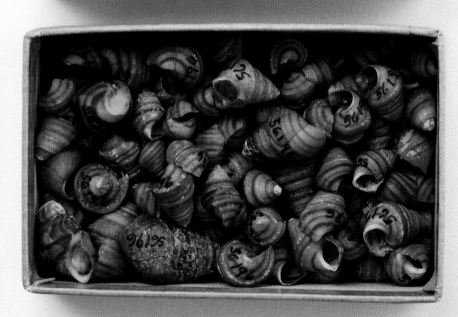

O´ahu Tree Snails

Achatinella

Of the 41 species of O´ahu tree snails that are endemic to the third largest Hawaiian island, all are now believed to be extinct or near extinction. These tree-dwelling snails are found in forests at altitudes above 1,600 feet (487 m). They are nocturnal and feed on fungus that grows on the leaves of some native Hawaiian plants. Averaging just under one inch (25 mm) in length, this genus of snails includes species that are diverse in colors, shapes, and patterns. Due to their low growth and fertility rate—as opposed to other snails, they give birth to one live young at a time, rather than laying eggs—the number of *Achatinella* snails is easily threatened.

The most recognized culprit behind the extinction of the Hawaiian tree snails has been the introduction of the invasive, aggressive, and carnivorous *Euglandina rosea*, the rosy wolfsnail. Native to the southeastern United States, the rosy wolfsnail was introduced to Hawaii in an attempt to control the population of another snail, the giant African land snail, which was causing damage to crops and plants. Other introduced predators included rats and chameleons. *Achatinella* demonstrates the susceptibility of animals that evolved via island speciation, where their specialized slow reproductive strategy was successful in the absence of outside predation but became a huge disadvantage with the arrival of the rosy wolfsnail.

Legitimate efforts are underway to conserve the 10 or so species of *Achatinella* that are not yet extinct. Biologists at the University of Hawaii have been breeding them in captivity in situ and then relocating them to a predator-proof enclosure in the Waianae Mountains, constructed by the US Army.

On January 4, 2019, the Hawaii Department of Land and Natural Resources reported that George, the last known *Achatinella apexfulva*, died on New Year's Day 2019. According to Dr. David Sischo, wildlife biologist with the Hawaii Invertebrate Program, George was approximately 14 years old. George was named after Lonesome George, the last of the now extinct species Pinta Island tortoise (*Chelonoidis abingdonii*) in the Galapagos Islands of Ecuador.

Overleaf: Various species of Hawaiian snails of the genera *Achatinella* and *Carelia*.

Conservation Status

● Critically
 Endangered or
● Extinct

Achatinella snails' trails contain pheromones that may serve a social or reproductive function between individuals.

Number of offspring per year

0–7

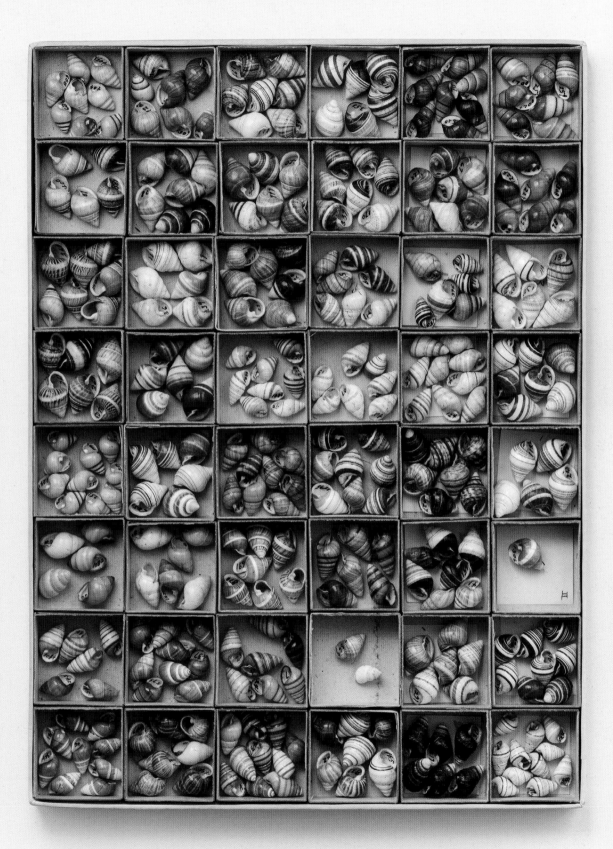

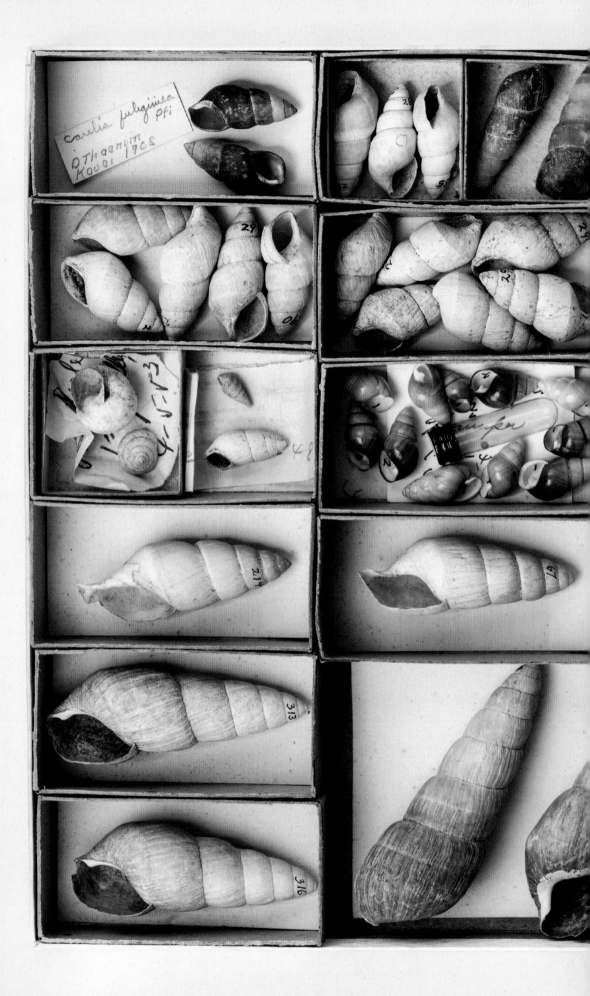

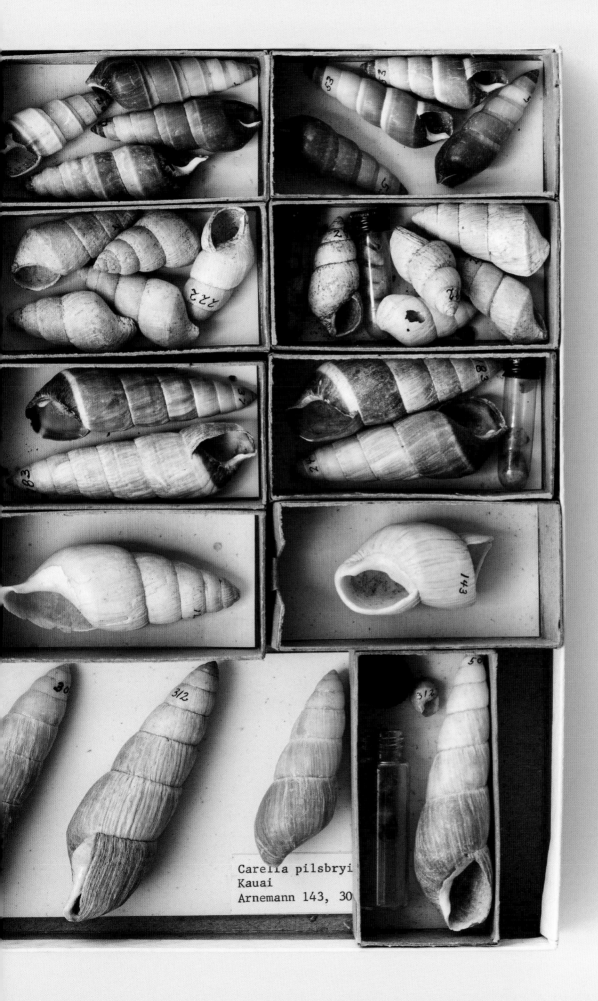

Carella pilsbryi
Kauai
Arnemann 143, 30

597373

=Dryopteris acutidens CChr.

Phegopteris spinulosa, Hillebr.
Hawaii & Maui.

6 Botany

"Destroying rainforest for economic
gain is like burning a Renaissance
painting to cook a meal."

E. O. Wilson

Opposite: Fern
(Dryopteris acutidens).

Plants are the foundations of terrestrial ecosystems. They regulate the air we breathe, the water we drink, and, as the primary producers of food webs via photosynthesis, they sustain us as a food source. The natural fibers they produce are used to manufacture everything from clothing to shelter, and compounds within their cells are the raw materials for medicines that treat our illnesses and prolong our lives. Simply put, without plants, life on land would not be possible. It is unsurprising then that the origin of land plants, over 475 million years ago, precedes the emergence of all land-based animals.

In common with terrestrial animals, the ancestry of land plants can be traced to the marine environment. Similarly, the most basic forms of land plants, the liverworts and mosses, are confined to damp places because they lack adaptations to overcome a relative scarcity of water. More derived land plants, such as clubmosses and ferns, show a higher degree of anatomical complexity with the presence of roots to access the rich store of nutrients and water held below ground, as well as vascularized stems providing structural support against gravity, allowing them to grow taller and compete with one another for access to light. It is these groups that formed the primordial forests of the Carboniferous period. However, given that their method of reproduction requires sperm to actively swim toward the female gamete to complete fertilization, even these plants were not entirely emancipated from water; modern ferns are still only found in moist environments.

Seed plants, which first appeared some 350 million years ago, were able to overcome some of the limitations of their precursors. They produce tiny packets of sperm, known as pollen, with a tough outer cuticle to increase resistance to desiccation. Instead of relying on water to achieve fertilization, the earliest seed plants utilized the wind to carry their pollen grains through the air to female reproductive structures called ovules where fertilization happens and the developing embryo becomes a seed. Seed plants have come to dominate global floras, such is the advantage gained from an increased separation from water. Nevertheless, while wind pollination is clearly effective, it is notable that pollen grains must be produced in vast amounts to ensure the fertilization of a female egg.

A more recent group of seed plants, the angiosperms, devised a far more efficient mode of transport for their pollen, by enlisting the help of the insects. Flowers are the primary evolutionary novelty of the angiosperms,

"The origin of land plants, over 475 million years ago, precedes the emergence of all land-based animals."

analogous to advertisement billboards, enticing insects to land on them with an assortment of colors, patterns, and pheromones. By means of a reward, usually in the form of a sugary solution called nectar, insects learn to positively associate flowers with a source of food. As such, they are encouraged to carry pollen from one flower to another in quantities just about sufficient for fertilization, thereby minimizing wasted energy allocated toward the production of gametes. Around 90 percent of living plant species are angiosperms, demonstrating how successful an innovation the flower truly is.

In a world in which humans are leaving an indelible impact, recent analyses suggest plants are faring particularly poorly. Overall, an estimated 40 percent of plant species are threatened with extinction, putting them on a par with amphibians in terms of the degree of threat. Over the past few hundred years, we have raised the rate of plant extinctions by an estimated 500 times compared to background extinction levels, although this figure is probably too low—many

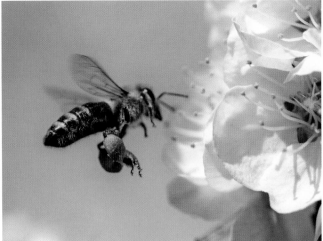

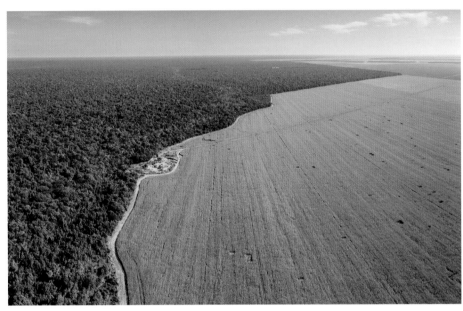

Top left: Ferns are one of the oldest plants in the fossil record and there are over 10,000 extant species.

Top right: Approximately 90 percent of wild plants and approximately 75 percent of global crops depend on animal pollination.

Bottom right: Deforestation at the boundary of Xingu Indigenous Park in Brazil to grow soybeans.

extinctions in this time are likely to have gone unrecorded and some extant species may have been pushed below thresholds of population viability and habitat availability, such that extinction is inevitable. Agriculture and overexploitation are the predominant reasons for the decline of plants, with the impact of climate change likely to increase over the coming decades. Moreover, extinction risk is not evenly spaced across the plant tree of life; of all the plant families, the cycads are considered the most imperiled due to the combined effects of relatively slow rates of reproduction and high rates of deforestation across their predominantly tropical geographic range. As one of the oldest plant lineages, the loss of cycads will inflict a regrettable loss of evolutionary history. In general, the loss of floral diversity will diminish the quality of human life, making the current status of global plant life highly unsettling.

Albany Cycad

Encephalartos latifrons

Cycads are the oldest living species of seed plants in the world. They date back 340 million years and have survived three mass extinctions. There are approximately 300 species of cycad left today and while many thrive in areas that are free from development, cycads are one of the most threatened plant families in the world.

The Albany cycad is one of the rarest species of cycad and is native to South Africa's Eastern Cape, found at altitudes between 650 and 1,900 feet (200–580 m). Its stems grow up to 14 feet (4 m) high and its leaves are a glossy, dark green and are very broad compared to other cycads, making it one of the most visually attractive species.

Encephalartos latifrons is listed as critically endangered because it is estimated that fewer than 100 mature individuals are alive in the wild, the result of an 80 percent decline in its population over the past 100 years. The plants that do persist in the wild are often more than half a mile (0.8 km) apart, making reproduction impossible without hand pollination by humans.

Due to their attractiveness and value to plant collectors, the biggest threat to the Albany cycad is criminal poaching. The species is now protected under CITES, which prohibits its trade, and is housed in several botanic garden collections. However, controlling the theft of Albany cycad continues to be a challenge for conservationists.

In August 2014, 24 cycads worth an estimated US$54,000 were stolen from Kirstenbosch National Botanical Garden in Cape Town; 22 of those were Albany cycads, some of which had been housed there since 1913. The garden has now implemented microdot technology, so that the source of stolen plants can be identified, in one last attempt to save what remains of the Albany cycad.

Conservation Status

● Critically
 Endangered

In 2013, a new population of Albany cycads was discovered in South Africa that seemingly persisted without human assistance. This has allowed scientists to study the species' life history, population structure, and response to environmental stressors.

Approximate number of undescribed species, based on rate of discovery

100

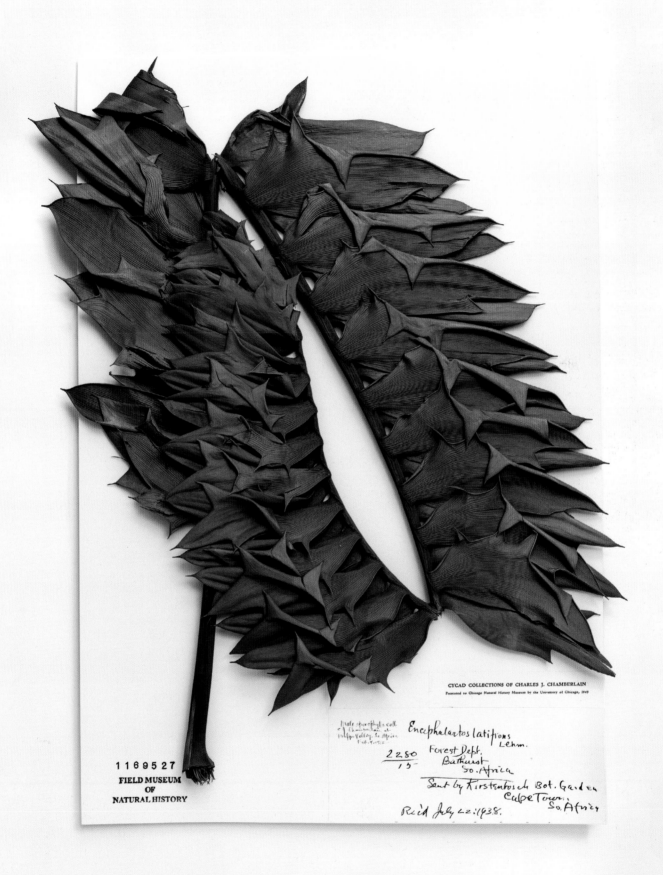

CYCAD COLLECTIONS OF CHARLES J. CHAMBERLAIN

Presented to Chicago Natural History Museum by the University of Chicago, 1949

Encephalartos latifrons
Lehm.

Forest Dept.
Bathurst
So. Africa

2280
15

Sent by Kirstenbosch Bot. Garden
Cape Town,
So. Africa

Rec'd July 22: 1938.

Male sporophylls coll.
 by Chamberlain at
Tulpa Valley, So. Africa
Feb. 9. 1922.

Banded Trinity

Thismia americana

In 1912, botany PhD student Norma Pfeiffer made a very unusual discovery near a lake in an area south of Chicago. She happened upon a small bluish-white flower, no bigger than a fingernail, growing in a prairie. After extensive research, it was determined that the plant was a new species, whose closest relatives are found in Asia, Australia, and New Zealand. It was named *Thismia americana* and it became the rarest plant ever to be found in the Chicago area. Four years later it completely disappeared and has not been found in Illinois or the United States since.

Banded trinity grows mostly underground and is only visible above ground when it is flowering. The plant lacks chlorophyll—it does not require sunlight to grow but instead maintains a symbiotic relationship with the fungi on its roots for food.

No one knows how or why banded trinity came to grow next to Lake Calumet in Illinois. Unproven theories include being brought in by imported sheep from New Zealand or by migratory birds carrying seeds. Today, it has almost rock-star status among botany enthusiasts and annual hunts are held around Chicago each year attempting to locate the species again. Botanists are not ready to give up on *T. americana* yet and as Robb Telfer, former Calumet Outreach Coordinator at the Field Museum, explains, "It seems to be a powerful and enduring symbol of the fragility of our native ecosystems, and the prospect of perhaps rediscovering it is a perfect stand-in for all that we have yet to discover."

Conservation Status

● Extinct

The species has been found only from early July to mid-September when it flowers and fruits; it is underground the rest of the year.

Number of specimens in the Field Museum

2

Illinois

Thismia americana Pfeiffer
Drawn by Marion Pahl from
material in liquid. Used
in Museum Bulletin Feb. 1973.

Plant, X 4; dissected flower, X 4;
filament to show anthers; tepals
spread to show ring made
on summit of ovary

Big-Leaf Mahogany

Swietenia macrophylla

A big-leaf mahogany tree can grow up to 195 feet (60 m) high and produces leaves up to 20 inches (50 cm) long. The trees are very slow growers and can live for over 350 years. The former range of the big-leaf mahogany was southern Mexico through Central America and into Bolivia and Brazil.

The beautiful, deep-reddish hardwood timber of the big-leaf mahogany has been sought after for centuries and trade of its wood began with the Spanish in the 1500s. The two other species in the genus *Swietenia*, the Caribbean mahogany and Honduras mahogany, are now regarded as commercially extinct from overexploitation, leaving *S. macrophylla* as the remaining species of "genuine" mahogany. As the wood is so valuable, foresters commonly build roads into dense forests to access the trees. It is estimated that numbers of big-leaf mahogany have declined up to 70 percent since the 1950s and they have experienced a 60 percent reduction in their range in Central America.

Swietenia macrophylla has been protected under Appendix II of CITES since 2002, restricting its trade and encouraging future sustainable management of the species. However, "wood pirates" continue to be an ongoing problem in places such as Bolivia, where the export of big-leaf mahogany has been prohibited since 2011. These are not isolated individuals but vast criminal networks aided by corrupt authorities, leading Interpol to start categorizing illegal logging as organized crime starting in 2019. A UN Environment Program and Interpol report from 2016 estimated the global value of forestry crimes at US$50 billion to US$152 billion per year and that up to 30 percent of the global wood trade could be illegal. In Bolivia, 638,000 acres (258,000 ha) of land were deforested in 2017 alone, 52 percent of which was done illegally.

Conservation Status

● Vulnerable

Swietine, a molecule isolated from the big-leaf mahogany, has been shown to have an anti-inflammatory effect and remain stable within human, rat, and mouse livers.

Age at which it starts to regularly produce fruit

15

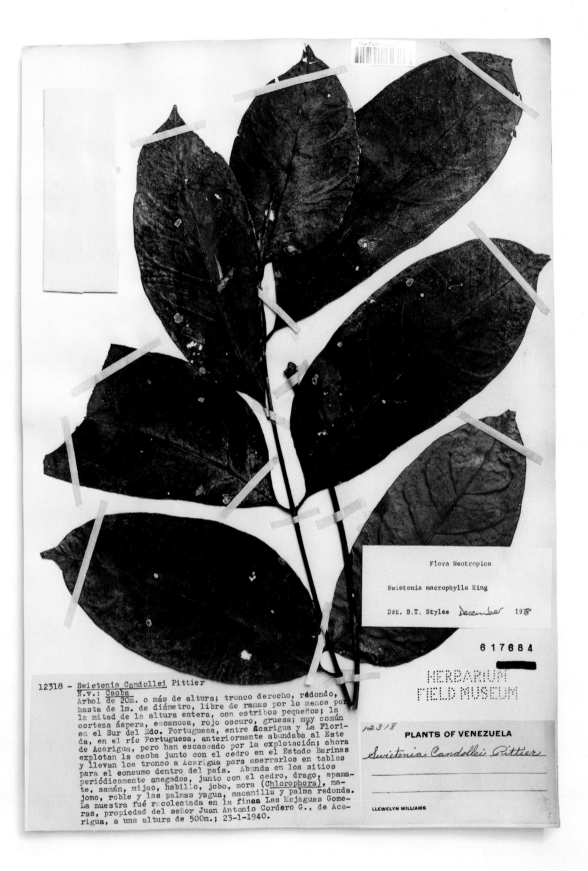

6 17684

12318 - Swietenia Candollei Pittier
N.v.: Caoba
Arbol de 20m. o más de altura; tronco derecho, redondo,
hasta de 1m. de diámetro, libre de ramas por lo menos por
la mitad de la altura entera, con estribos pequeños; la
corteza áspera, escamosa, rojo oscuro, gruesa; muy común
en el Sur del Edo. Portuguesa, entre Acarigua y La Flori-
da, en el río Portuguesa, anteriormente abundaba al Este
de Acarigua, pero han escaseado por la explotación; ahora
explotan la caoba junto con el cedro en el Estado Barinas
y llevan los tronco a Acarigua para aserrarlos en tablas
para el consumo dentro del país. Abunda en los sitios
periódicamente anegados, junto con el cedro, drago, apama-
te, samán, mijao, habillo, jobo, mora (Chlorophora), ma-
jomo, roble y las palmas yagua, macanilla y palma redonda.
La muestra fué recolectada en la finca Las Majaguas Gome-
ras, propiedad del señor Juan Antonio Cordero G., de Aca-
rigua, a una altura de 500m.; 23-1-1940.

Clover Grass

Halophila baillonii

Clover grass is a type of seagrass found mainly in the Caribbean region. In some areas, *H. baillonii* forms dense underwater meadows, such as off the coast of Belize. Yet elsewhere the species is rare and sparse, limited to seven locations and continuing to decline, despite once being recorded in high numbers, resulting in it being listed as vulnerable.

Little is known about the biology of clover grass. It is a main food source for the threatened West Indian manatee and it provides shelter for some species of mussels and fish. Clover grass is highly susceptible to the effects of polluted water and heavy storms—a previously thriving bed of *H. baillonii* near Costa Rica was eliminated by a harsh storm in 1996 and it has not been observed there since. A large meadow in Belize is in rapid decline due to both the growing tourist industry and eutrophication—when fertilizer, mineral, or nutrient runoff causes an overgrowth of algae, blocking sunlight and causing plants to die. The resulting decomposition reduces oxygen levels, making the area unsuitable for fish and aquatic insects, in addition to manatees.

Seagrasses worldwide are contaminated by microplastic particles, which are then consumed by fish and marine invertebrates. In a study published in 2020 in *Marine Pollution Bulletin*, researchers from Heriot-Watt University in Edinburgh found that every blade of seagrass examined in a bed in the Orkney Islands had an average of four microplastic particles stuck on its surface, while sea snails collected from the bed contained an average of 4.5 particles.

Conservation Status

● Vulnerable

There are 10 seagrass species in the tropical Atlantic region and five are from the *Halophila* genus.

Lowest depth in feet at which it occurs

50 (15 m)

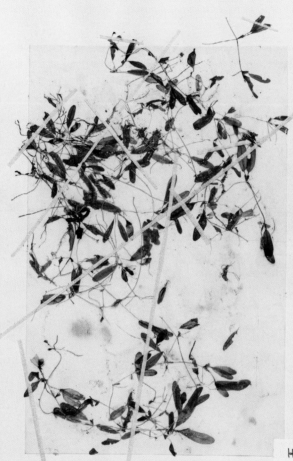

Florida Perforate Reindeer Lichen

Cladonia perforata

The humble lichen may not be the most charismatic of species, but they play a very specific and crucial ecological role and are often the first species in an environment that is new or regenerating, known as a pioneer species. Lichens can absorb nitrogen from the atmosphere and break down rock, creating nutrient-dense soil in the process, which in turn leads to colonization by plants and animals. Lichens are not plants—they are a symbiosis of algae and fungi but are held in the Botanical Collections of the Field Museum.

The Florida perforate reindeer lichen occurs only in the state of Florida and is characterized by its yellow-gray, complex branching pattern. Its branches are 1½ to 2 inches (35–50 mm) long and are tipped with red spore-producing structures. It grows only in a specific scrubland habitat that is found in isolated areas around the state, with around 30 populations of *C. perforata* recorded in total.

In 1992 only 15 percent of *C. perforata*'s habitat remained due to degradation from residential and agricultural development, pollution, tourism, and environmental disturbances such as fires and hurricanes. A single hurricane or fire can significantly reduce a subpopulation or decimate it entirely. One hurricane in 1995 resulted in at least two subpopulations of *C. perforata* being destroyed.

The future of *C. perforata* is now carefully guarded. It was listed on the US Endangered Species List in 1993, the first species of lichen to be protected in this way. As a result, about 16 populations are currently on protected land and all federal landowners with *C. perforata* are responsible for its conservation and protection under the Endangered Species Act. Concerted efforts are made to remove them from habitats before heavy storms or hurricanes and to rescue damaged lichen afterward, unburying them from sand or plucking them from trees to be replanted. The state of Florida also has robust conservation and natural heritage programs, tracking listed species and working to conserve them via land acquisition and management.

Conservation Status

● Endangered

Lichens are not a single species themselves, but a composite organism of algae or cyanobacteria living on a substrate of fungi, each benefitting the other.

Proportion of Earth's land surface covered by lichens

8%

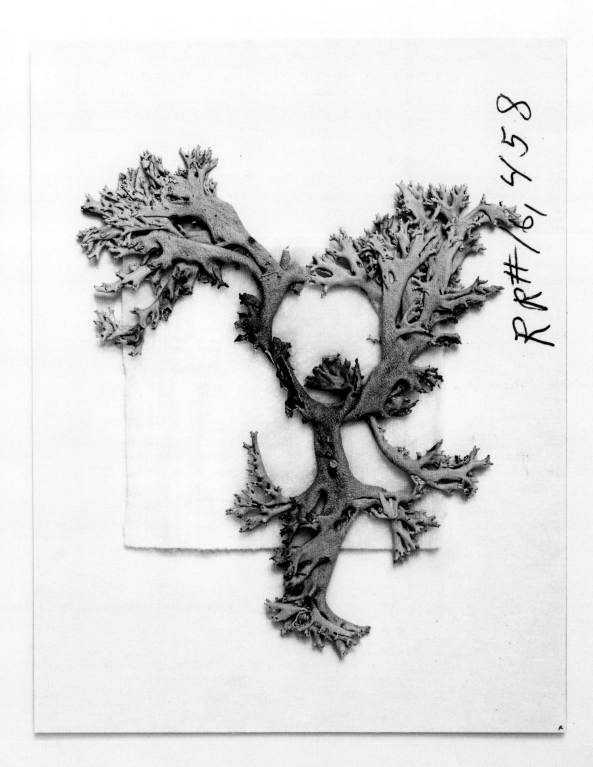

RR#161458

Patagonian Cypress

Fitzroya cupressoides

The giant and majestic conifer tree, Patagonian cypress, can reach heights of up to 197 feet (60 m) with a trunk diameter of 16 feet (5 m) in native forests. Some specimens are estimated to be as old as 3,600 years. It is the world's second oldest living tree species, after the bristlecone pine (*Pinus longaeva*). It occurs only in southern Chile and Argentina's Patagonia region in temperate rainforests. Also known by the common name *alerce* (or "larch" in English), it was originally named by Charles Darwin. The tree grows in a wet environment but it depends on forest fires for regeneration. Fire suppression by humans may be contributing to the current decline of remnant populations.

Historically, the wood from *F. cupressoides* has been prized—it is very resilient and lightweight—and has been harvested in Chile since the end of the sixteenth century. By the early 1900s, a third of the Patagonian cypress population had been decimated and due to its slow regeneration, the species has not significantly recovered.

In 1976, Chile declared *F. cupressoides* a national monument, immediately banning any further logging. However, trees still standing that died before 1976 are exempt from this law, resulting in a gray area as some logging continues. Long-term conservation of the species will require coordinated efforts from private landowners, logging companies, indigenous communities, and the governments of Argentina and Chile.

In 2019, a huge swathe of land that had been purchased by philanthropist Doug Tompkins, founder of The North Face, outdoor equipment manufacturer, was bequeathed to the Chilean government. Tompkins purchased the 642,000 acres (260,000 ha) in southern Chile, now called Patagonia National Park, as a conservation project to save it from human development and to "rewild" what had previously been overharvested. An estimated 25 percent of what remains of the Patagonian cypress population is located in the park, whose future is now in the hands of the Chilean government.

Conservation Status

● Endangered

The species is known as the "redwood of the south."

Proportion of conifers threatened with extinction globally

34%

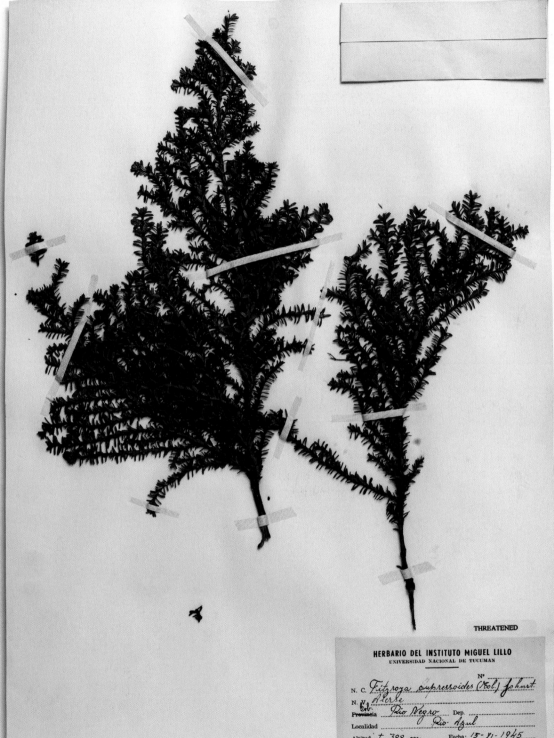

THREATENED

Pau Brasil

Paubrasilia echinata

Paubrasilia echinata has an important place in Brazil's history and culture. The tree is endemic to the Mata Atlântica, the moist forest ecosystem on Brazil's Atlantic coast that has suffered historical losses of over 90 percent due to deforestation and urbanization. In the 1500s Portuguese explorers arrived in what is now Brazil and recognized the trees as similar to those in Europe that produced a red dye, called *pau brasil* in Portuguese; the people who collected it were called *brasileiros*. Pau brasil was exported in such great numbers that the country was named after it.

Pau brasil can reach up to 50 feet (15 m) high and is characterized by a flaked bark that reveals a blood-red wood underneath, fragrant yellow flowers, and compound leaves with many small leathery leaflets. It is believed that the tree's bark may have medicinal properties and has even been tested as a possible treatment for cancer.

Exploitation of pau brasil began in 1501. The dye from the trees was regarded as far superior to the European version and its timber was almost indestructible. It was used in construction and to make bows for string instruments and hunting tools. By the time synthetic dyes became readily available in the late nineteenth century, the pau brasil population had suffered immensely.

Today, pau brasil continues to be threatened by deforestation of the Mata Atlântica. It is the main source of high-quality violin bows. Two pounds (1 kg) of wood is needed to manufacture one bow, which can cost hundreds to tens of thousands of US dollars (a bow was sold at auction in 2017 for US$690,000) with 70 to 80 percent of that wood wasted in the process. The bow industry is estimated to be worth millions of US dollars a year and illegal cutting and exportation continues. Along with other organizations, the Global Trees Campaign works to build awareness in local communities and to support conservation and forest restoration efforts.

Conservation Status

● Endangered

Bow makers prefer the less dense heartwood (pernambuco) at the tree's core; bows can also be made from the denser sap wood (brazilwood).

Average weight in pounds of a violin bow

0.13 (60 g)

1073460

POLLEN MATERIAL REMOVED
FOR PREPARATION OF SLIDES.
DATE AUG 2 4 1961
NO. F-58

Herbarium, Field Museum of Natural History

Caesalpinia echinata
"Pau Brasil"
S. Salvador, Bahia
COLL. B.E. Dahlgren. Aug. 1940

Confirmavit G.P. Lewis 1993 !

Phycolepidozia exigua

Phycolepidozia exigua

Phycolepidozia exigua is a microscopic liverwort, a division of plants that physically resemble mosses. Along with hornworts and mosses, they make up a group known as bryophytes. Liverworts are a very primitive plant—they are found over 300 million years earlier in the fossil record than flowering plants. They reproduce via spores instead of seeds.

Endemic to the island of Dominica in the Caribbean Sea, *P. exigua* is the only species in its family. It has a fiber-like stem, around a quarter of an inch (6 mm) long. The extreme reduction of its leaves means that the plant is essentially leafless. It inhabits the bark of trees in humid rainforests at an altitude of 1,400 feet (425 m).

The species was collected only once, in 1966, in an area that has since been destroyed by a hurricane. Relocation efforts were not successful. It is listed as critically endangered because there are hopes that in finding suitable habitat on the island, *P. exigua* may be discovered again but many regard the species as extinct.

Conservation Status

● Critically Endangered

The species is unique as a leafy liverwort (order Jungermanniales) due to the extreme reduction of its lateral leaves.

Number of cells the leaves consist of at maturity

2

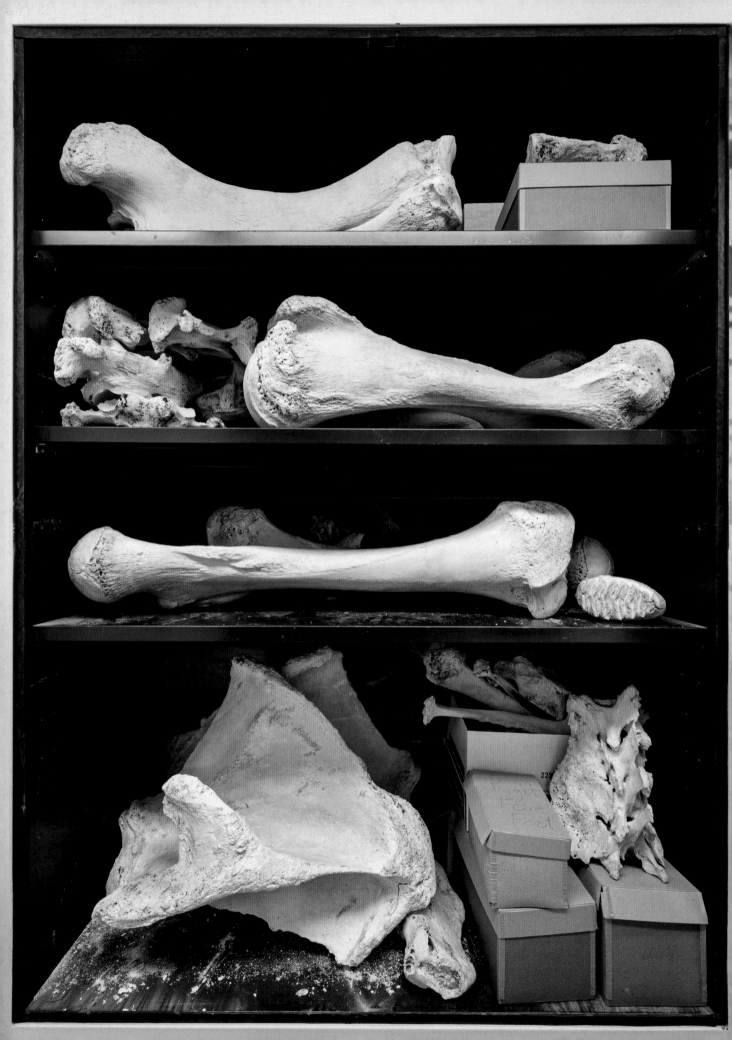

7 Mammals

Opposite: Asian elephant
(*Elephas maximus*).

"No one in the world needs
a rhino horn but a rhino."

Paul Oxton

The mammals are a highly charismatic group of vertebrates, descended from one of the two lineages of reptiles that diverged over 300 million years ago. Surprisingly, the branch of reptilians that led to the mammals includes *Dimetrodon*, illustrations of which are unmistakable given the distinctive sail carried on its back. Some argue this part of its anatomy acted somewhat like a radiator, allowing the creature to dissipate and absorb heat at different times of day, while others believe it was used primarily in communicating with other members of its own species. However, the ability to regulate body temperature is a hallmark of mammals, a feat partly achieved in many modern species by a dense covering of hair. In fact, although their name is derived from the Latin word for "breast," it is their hair as well as the production of milk that distinguishes them from all other animals.

The Cretaceous-Tertiary mass extinction event, triggered by the impact of a large asteroid around 66 million years ago, set in motion the so-called "Age of Mammals." The disappearance of the non-avian dinosaurs, marine reptiles, and pterosaurs left a chasm of unoccupied niches that would be rapidly filled by mammals, a process evolutionary biologists refer to as an "adaptive radiation." In the present day, over 6,000 species of mammals are found across all parts of the world, occupying marine, freshwater, and terrestrial environments. Their success is also reflected by the extraordinary range of body sizes and forms observed across mammalian species: some weighing scarcely more than a coin, others believed to be the largest animals that have ever lived; some capable of powered flight, others spending their lives burrowing in tunnels and rarely coming above ground.

Taxonomists recognize three main divisions of mammals. The monotremes are especially peculiar among mammals, as they are the only group to lay eggs instead of bearing live young, an attribute retained from their reptilian ancestors. A mere two types of monotremes are still extant, both of which are endemic to Australasia: a lone species of duck-billed platypus (*Ornithorhynchus anatinus*) and four species of echidna. Another major division of modern mammals also native to Australasia (as well as the Americas), are the marsupials, containing several well-known species such as kangaroos, koalas, and wombats. The most striking characteristic of marsupials is their pouch ("marsupium" is Latin for "pouch"), within which juveniles develop. However, far and away the most common and familiar of all mammals are the placentals,

"The disappearance of the non-avian dinosaurs, marine reptiles, and pterosaurs left a chasm of unoccupied niches that would be rapidly filled by mammals."

a group in which our own species belongs. Compared to marsupials, the offspring of placentals continue developing inside their mother until much later in development, nourished by an organ called the placenta.

The conservation status of mammals varies dramatically between species, with clear biological differences between winners and losers. Many mammals display remarkable adaptability and, using their high levels of intelligence and ingenuity, species such as the red fox (*Vulpes vulpes*) have thrived alongside humans, exploiting the warmth and abundance of food sources provided by contemporary towns and cities. Nevertheless, an estimated 26 percent of mammals are at risk of extinction, with rampant overexploitation for human consumption, ornaments, and the pet trade being the primary sources of threat for many species. Throughout history, the heaviest mammals (megafauna) appear to be those most negatively affected by the presence of humans. Their demands for larger territories

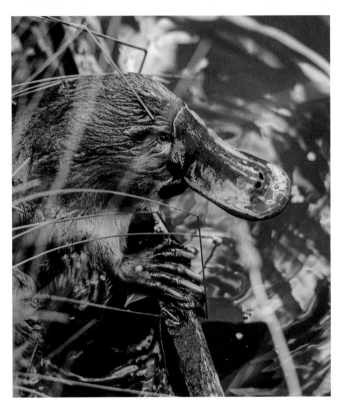

Above left: *Dimetrodon* means "two measures of teeth," referring to its large canine teeth with smaller shearing teeth behind the canines.

Top right: Pangolins are the only mammal with scales.

Bottom right: A spur on the hind limb of the male duck-billed platypus (*Ornithorhyncus anatinus*) secretes venom, thought to be used against rival males during mating season.

and greater amounts of food compared to smaller-bodied counterparts bring them into direct competition with humans. Furthermore, their slow rates of reproduction reduce their ability to respond to elevated levels of mortality, meaning their populations are particularly susceptible to overhunting. Indeed, the megafaunal extinction events during the last tens of thousands of years coincide with the arrival of humans following their migration out of Africa.

Despite their precarious status as of the twenty-first century, mammalian megafauna such as rhinoceroses, elephants, tigers, and pandas generally receive disproportionate attention from targeted conservation campaigns, which may ultimately secure their future. The fate of lesser-known species is perhaps more uncertain. For example, as one of the most trafficked animals on the planet, pangolins are being hunted at an incredibly alarming rate across Africa and Asia for their scales, which are used in traditional Chinese medicines, notwithstanding the complete lack of evidence for medicinal value. In fact, their scales are composed of the same structural protein as our own hair and fingernails—keratin. Without a major change in attitude and more effective law enforcement against this senseless trade, the pangolin, and other species, appear to be heading toward extinction.

Mexican Gray Wolf

Canis lupus baileyi

The Mexican gray wolf is the rarest, most endangered subspecies of gray wolf in North America. They once roamed the forested mountains and grasslands of the southwestern United States and northern Mexico. They are slightly smaller than the gray wolves that live further north, no larger than five feet (1.5 m) long, just under three feet (1 m) high, and weighing 50 to 80 pounds (22–36 kg).

In the early 1900s, Mexican gray wolves began attacking livestock, resulting in huge financial losses for farmers. This led to a concerted effort from both the US government and private citizens to eradicate the species with whatever means necessary: hunting, poisoning, trapping, and stealing pups from their dens. By 1918 their population in the US had crashed to 45 individuals in the wild. These same tactics were then used in Mexico, resulting in another rapid decline in numbers. By 1950, the Mexican gray wolf no longer existed in the wild in the US and fewer than 50 individuals remained in Mexico. The wolf was listed on the US Endangered Species Act in 1976, barely in time to help save it from extinction.

Canis lupus baileyi survives today due to joint conservation efforts between the US and Mexican governments. Five individuals were captured in Mexico between 1977 and 1980 to initiate a captive breeding program and by 1998, 100 wolves were released back into the wild in "recovery areas" across Arizona and New Mexico. The population of the Mexican gray wolf has since fluctuated but has nearly doubled since 2015. A survey of the population in early 2021 concluded that there are 186 Mexican gray wolves in the wild. When pups are located, they are vaccinated against rabies and other viruses and GPS tagged to ensure careful monitoring of the population.

Unfortunately, shooting and poaching of the wolves continues and livestock is once again threatened by the growing population. Bryan Bird, director of the southwest program for Defenders of Wildlife said, "While it is encouraging to see an increase in wolves, limited genetic diversity and high rates of illegal killing continue to slow recovery efforts. There is still work to be done to establish a self-sustaining Mexican gray wolf population."

Conservation Status

● Endangered

Over 80 percent of the Mexican gray wolf's diet in summer consists of elk (*Cervus elaphus*).

Proportion of wolf fatalities attributed to illegal shooting and trapping (1998–2015)

53%

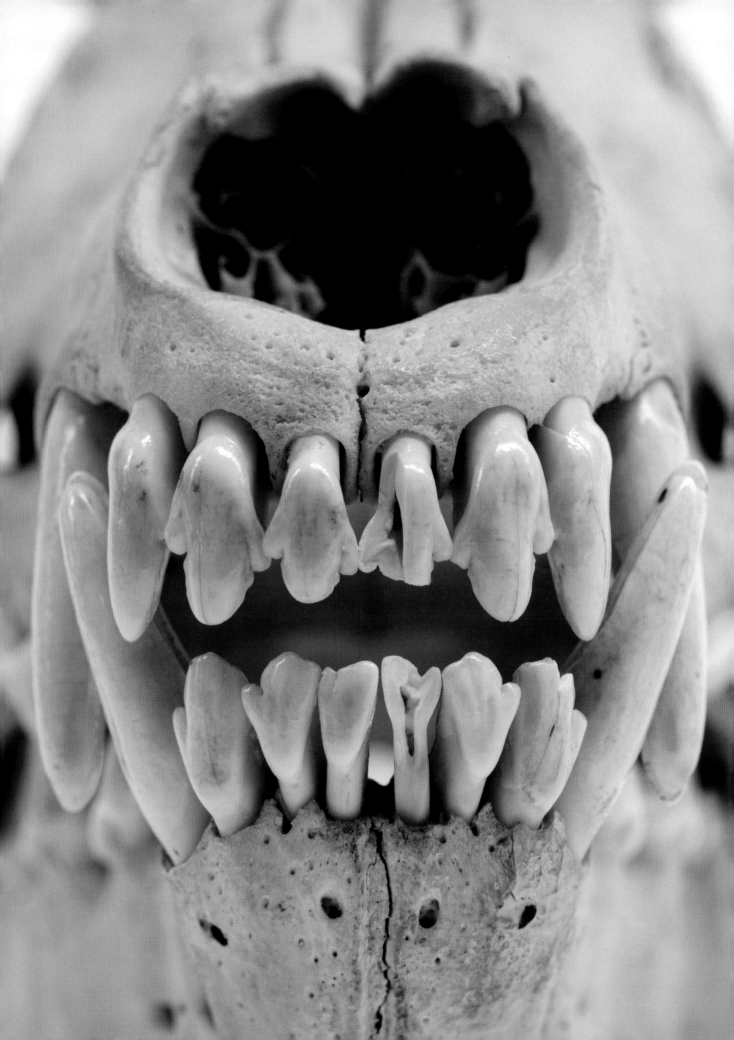

Asian Elephant

Elephas maximus

Elephas maximus is the largest land mammal on the Asian continent. It is slightly smaller than its African relatives and has different physical traits, such as smaller ears and only one finger-like structure on the base of its trunk (as opposed to the African elephant's two). The Asian elephant's range extends throughout the continent, from India to Borneo, including three subspecies in Sri Lanka, Borneo, and Sumatra. The elephant plays an integral role in its ecosystems and is known as a "keystone" species—one on which other species heavily depend and one whose disappearance would have a drastic impact on their ecosystem. By eating an average of 330 pounds (150 kg) of vegetation every day and then defecating around 18 times per day, the Asian elephant opens up forest clearings and distributes the seeds of several plant species.

The population of Asian elephants has become increasingly fragmented and isolated throughout most of its range. It is estimated that their numbers have decreased at least 50 percent over the past 75 years, with only 50,000 individuals remaining in the wild as of 2018. One of the main threats to the continued viability of the Asian elephant is habitat loss. As human populations across the continent continue to steadily grow, the elephant's habitat is encroached upon to make way for development, leaving the particularly fragile species confused and stressed. This also means they have contact with humans more frequently, often resulting in violence. In India, elephants kill about 500 people a year—as well as destroying about US$2–3 million in crops annually—and they are usually killed in retaliation.

Male Asian elephants can grow to almost double the size of females, and, unlike females, they possess large tusks. Males are targeted by poachers much more frequently, leading to a disproportionately high number of females, affecting a herd's ability to breed successfully. In one reserve in India, Periyar Tiger Reserve, the male to female sex ratio between 1969 and 1998 changed from 1:6 to 1:101 due to illegal poaching. Wild populations are also threatened in some countries by capture for domestication and use in the tourism industry, where they are violently "broken" into submission. Nearly 15,000 Asian elephants, around one in three, live in captivity.

The IUCN has identified three areas of immediate concern to save the Asian elephant: conserving and maintaining their habitat (as well as designating protected corridors of land between fragmented habitats to allow populations to intersperse, a concept known as connectivity), managing human/elephant conflicts, and improving legislation and enforcement. The World Wildlife Fund (WWF) established the Asian Rhino and Elephant Action Strategy in 1998 to address these concerns. The group also works with local communities to educate people on the links between economic development and elephant conservation, demonstrating that the two are not mutually exclusive. With the implementation of these strategies there may yet be hope for the Asian elephant.

Conservation Status	*Elephas maximus* is the only surviving species of its genus. The other two extant African elephant species fall into genus *Loxodonta*. The genera diverged 7.6 million years ago.	**Average length of sleep for adults**	
● Endangered		3 hours	

Southern White Rhinoceros

Ceratotherium simum simum

Conservation Success

The southern white rhinoceros is one of two subspecies of white rhinoceros and is native to southern Africa (with 93 percent of their population located in South Africa). In 1900 they were the most endangered out of the five species of rhino in the world, with less than 20 individuals remaining on a reserve in South Africa. Over the decades their numbers gradually increased, assisted by successful protection and management measures. Today, there are an estimated 18,000 individuals in the wild, making the southern white rhinoceros the most abundant of all rhinos. In contrast, only two female northern white rhinos are left in the world, living in captivity.

In the nineteenth century, Dutch and English settlers in southern Africa killed rhinos for meat and sport. They hunted them near to extinction before governments began to take action to protect the remaining rhinos. Ironically, it was the market for legal white rhino trophy hunting that contributed to the species' recovery—South Africa has permitted trophy hunting since 1968. Quotas are set by owners of private game ranches with a vested financial interest in maintaining a viable breeding population. While the southern white rhino is generally thriving, the black rhino, which occurs in countries with less economic stability, has dramatically declined over the years and is now critically endangered.

Nonetheless, the southern white rhino is not free from all threats. Illegal poaching for its horns continues—ground-up rhino horn is still in demand in Asian traditional medicine and carved horns are popularly used to make ceremonial daggers in Yemen. They also still face persistent habitat loss as human populations spread and more land is developed. However, the southern white rhino, protected by both the state and the private sector, has become a poster child for effective conservation of Africa's wildlife. Pure economics, fueled by human greed, was cleverly used as a powerful incentive to keep the southern white rhino from extinction.

Conservation Status

● Near Threatened

All three calls of the white rhino (grunt, hiss, and snort) have an acoustic structure capable of encoding individual-specific characteristics.

Reproductive age of females in captive breeding programs

7 years

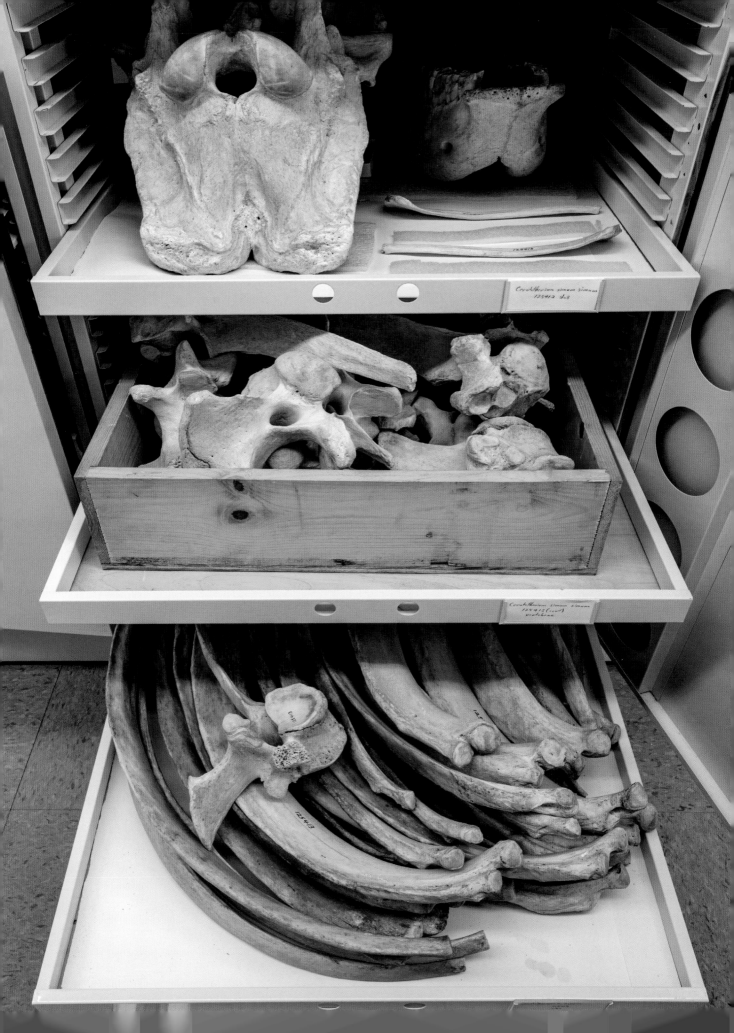

Black Rhinoceros

Diceros bicornis

Rhinoceros are one of the oldest groups of mammals alive today and all five species are threatened or near threatened. Native to eastern and southern Africa, the black rhino is differentiated by its pointed lip, contrasting the square lip of the white rhino. It can weigh up to 3,000 pounds (1,360 kg) and has two prominent horns, the longest of which can reach up to 22 inches (55 cm).

Diceros bicornis has experienced a huge decline in numbers since the first European settlers arrived in Africa—they viewed the rhinoceros as pests and were determined to exterminate the species. Rhinos have since become victims of poaching and their horns—shaved or ground to a powder and dissolved in boiling water—are coveted in traditional Asian medicine. Between 1960 and 1995, 98 percent of black rhinos were killed. Due to conservation efforts, the species began to recover by 2008 and by the end of 2017 its numbers had doubled. However, this still represents an overall 85 percent decline over 44 years and poaching continues as a result of political instability, severe poverty, and black market demand. In 2014, 21 percent more rhinos were poached in South Africa than the previous year. As of 2018, there were an estimated 5,500 black rhinos left in the world.

A study published in April 2020 analyzed how the relationship between black rhino and the red-billed oxpecker (*Buphagus erythrorhynchus*)—a bird that feeds on rhino ectoparasites such as ticks—could be having a positive symbiotic effect on the black rhino. One theory is that oxpeckers are effectively guarding their food source—the rhinos hear the birds' alarm calls, helping them detect and evade poachers. In the study, oxpeckers enabled 40 to 50 percent of rhinos to avoid approaching humans.

In a highly controversial move, since 2012 the government of Namibia has been auctioning off the "opportunity" to shoot and kill a black rhino in the wild—in 2018 a game hunter paid US$400,000 for the privilege. Namibian authorities claim to allow the highest bidder to shoot only an old rhino and that the money raised goes toward rhino conservation efforts and protection against poaching.

New technology may help provide a lifeline to the critically endangered black rhino, with the launch of smartphone software in 2020 that uses a footprint-identification technique (FIT) to analyze their movements and keep them safe from poachers. Utilizing the knowledge of local trackers, an individual rhino's footprints are identified, photographs are uploaded to a global database, and software analysis pinpoints the individual's age and sex with 99 percent accuracy. This information is then used to monitor populations of black rhinos.

Conservation Status

● Critically Endangered

Mitochondrial genetic diversity has decreased in the black rhino by 69 percent, in part because of the recent 98 percent reduction in population size.

Fastest recorded running speed in miles per hour

34 (55 km/h)

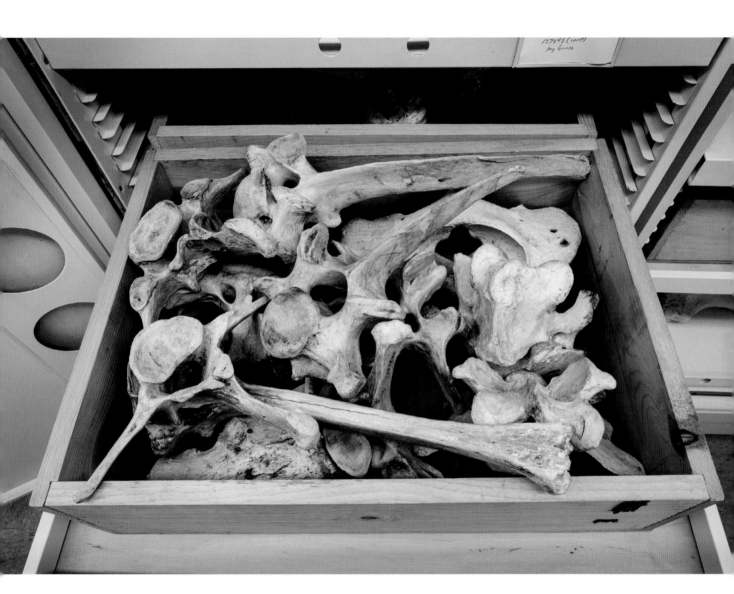

Chinese Pangolin

Manis pentadactyla

Pangolins are a group of mammals that once barely registered in the public consciousness; however, they are now by far the most heavily trafficked animals in the world. A pangolin most resembles an anteater with scales—the only group of mammals that possess this method of protection from predation. These ancient-looking creatures have long tongues that can stretch almost their entire body length, facilitating their hunting of ants. Pangolins have no teeth, and they roll into a tight armored ball when confronted. Wildlife photographer Suzi Eszterhas, who spent time with pangolins in a reserve in Vietnam, remarked, "Some animals you can't help thinking just seem too innocent for this world. The pangolin is one of those creatures."

The taxonomy of pangolins is not well known and there is debate as to whether there are just eight extant species worldwide or, as research indicates, a potential fifth Asian species and possibly a total of six African species. The critically endangered Indian pangolin is native to the Indian subcontinent; the Chinese pangolin is distributed across southern China, Southeast Asia, and into Nepal and Bangladesh; and the Sunda pangolin's range extends further south into Indonesia, Malaysia, and Singapore. The Indian and Sunda pangolins are slightly larger than the Chinese pangolin, but they all share many similarities, including a preference for forested habitat and sleeping in burrows or tree hollows during the day, before emerging at night to hunt for ants or termites.

The Chinese and Sunda pangolin species have suffered more than any others due to their location in the world. Their meat and blood are prized as a delicacy and their scales are used in traditional medicines, said to have aphrodisiac properties and to cure skin problems (they consist of keratin, the same structural protein in human hair and nails). A live pangolin can be sold on the black market for several hundred dollars, a price that continues to rise because of the ban on trade and the lack of enforcement. It is estimated that one million pangolins have been trafficked in the past decade—and nearly 200,000 were trafficked in 2019 for their scales alone—resulting in an 80 percent decline in their numbers and leaving them disturbingly close to extinction.

The plight of the pangolin continues to gather more and more attention and many organizations are taking action. Pangolins rescued from poachers are released back into the wild or placed in reserves for captive breeding. Public education is another major hurdle—many people are not aware that it is illegal to eat pangolins and many fear them because of their appearance. Raising awareness is a focus of organizations such as Save Pangolins and Pangolin Conservation. However, changing the mentality of an entire continent—enough to put an end to illegal poaching—is a colossal task. In 2020, pangolin scales were withdrawn from the official list of approved traditional medicine ingredients in China. Although this is a positive move, many medicines and companies still regularly feature them. Without immediate conservation and education, it may be too late for the innocent pangolin.

Overleaf: Indian pangolin (*Manis crassicaudata*), skin with claw.

Conservation Status		Number of scales on a Chinese pangolin	
● Critically Endangered	The Indian pangolin's ancestor split from the Chinese and Sunda pangolin's ancestor around 16.7 million years ago.	527–581	

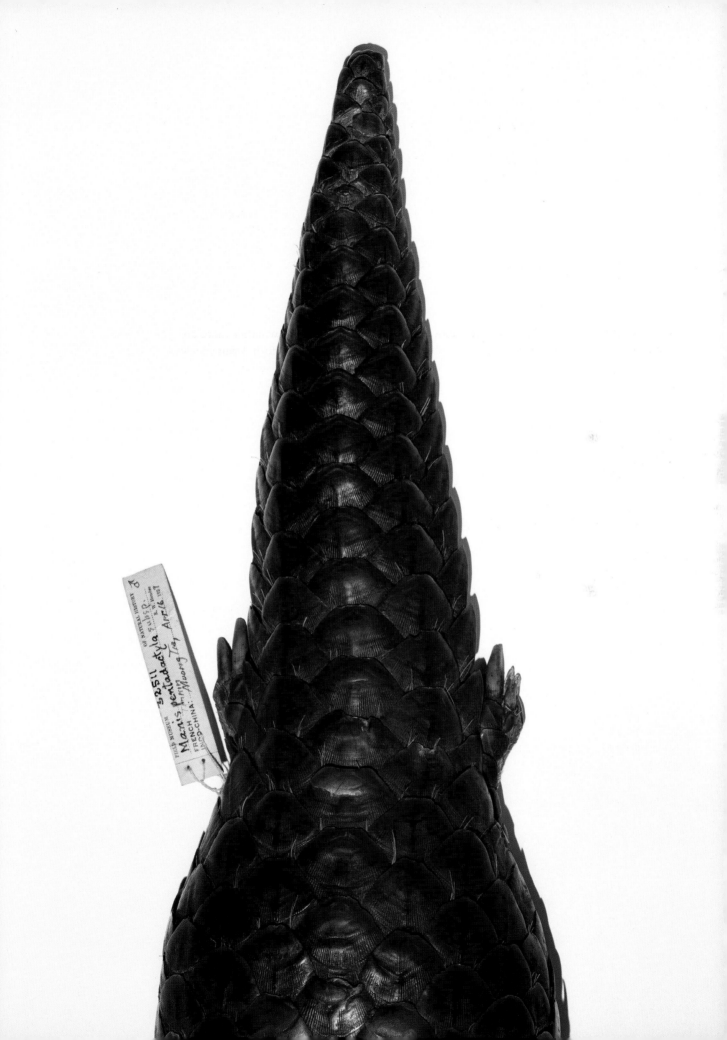

CHICAGO NATURAL HISTORY MUSEUM
BROOKFIELD ZOO, CHICAGO
Manis crassicaudata
41353 160
1122

eum
1950
♂
ast

Chicago Na
No. 68743
Manis
Locality N. Born
Sandaken Di
Collector D. D
SPK-Skin

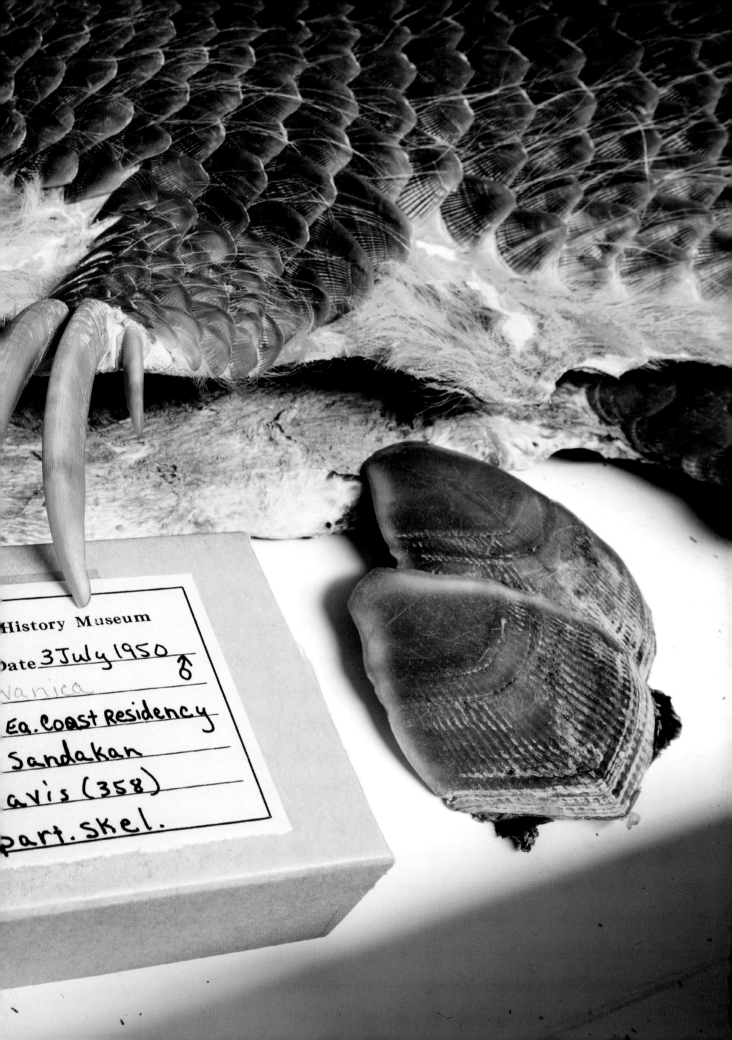

History Museum
Date 3 July 1950 ♂
vanica
Ea. Coast Residency
Sandakan
avis (358)
part. Skel.

Giant Armadillo

Priodontes maximus

With its hard shell made from bony plates and its long, thick claws, the giant armadillo is the largest armadillo species, growing up to four feet long (1.2 m) and weighing around 60 pounds (27 kg). This species is also unique in that it has between 80 and 100 peg-like teeth, the most of any land mammal.

The habitat of giant armadillos covers a wide range in South America where they live solitary and nocturnal lives, spending the entire day in their burrows. They prefer to live in undisturbed forests that are close to water sources but can also be found in grassland. Their six-inch (15 cm) long front claws are perfectly adapted for digging in the ground to hunt for their preferred food source of ants and termites. Given that this species is so unique in several ways, it is surprising that there has been very little scientific study on giant armadillos in the wild. They are increasingly rare and their low population density over a large range hinders research.

It is estimated that the species has declined by 30 percent over 25 years. Along with the commonly cited threat of habitat loss from deforestation, the biggest threat to the continued survival of the giant armadillo is hunting because their meat is an important source of protein for many indigenous peoples. Despite being protected by several of the countries where it occurs, giant armadillos also face illegal trade on the black market but rarely survive in captivity.

A group of Giant Armadillo Conservation Project researchers working in Brazil's Pantanal region began successfully monitoring one female giant armadillo and the birth of her young in 2013, gaining invaluable information on the species. The young armadillo was killed by a puma two years later, but the project drew considerable attention from the scientific community and the greater public alike, a positive step in safeguarding the species' future. "Thanks to our communication efforts [giant armadillos] have been selected by the state as one of the mammal indicator species for the creation of protected areas," said Dr. Arnaud Desbiez, head of the project. "A species few knew of five years ago will now be championing habitat conservation."

Conservation Status

● Vulnerable

The species has never been successfully bred in captivity.

Maximum claw length in inches

8 (20 cm)

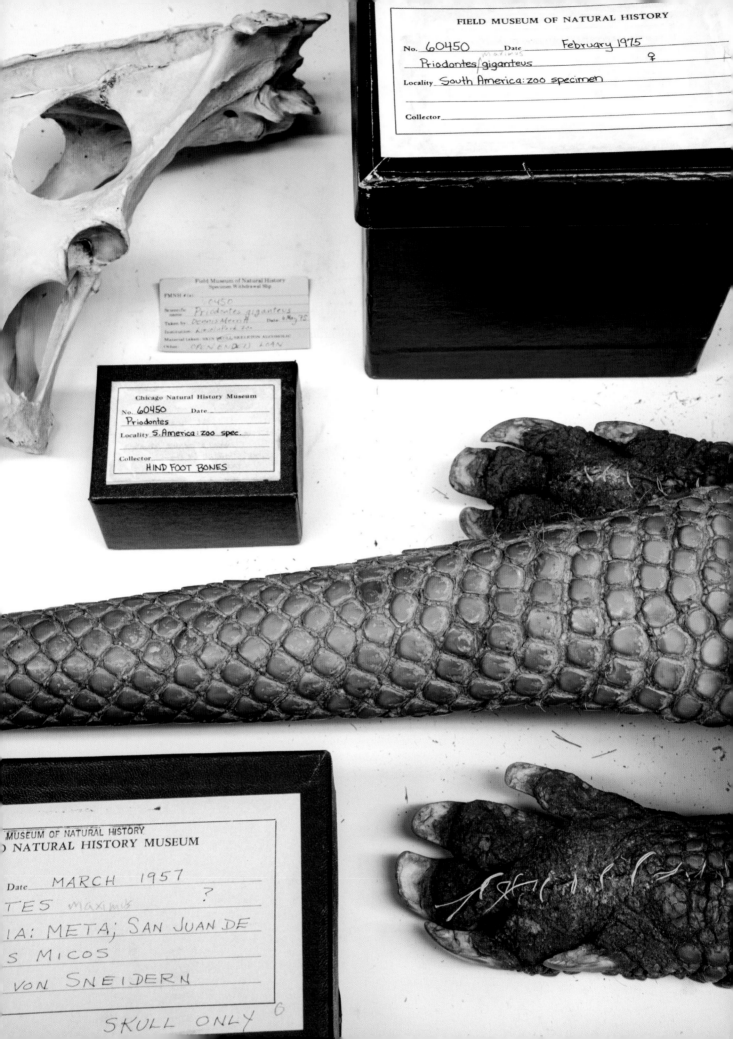

Golden Snub-Nosed Monkey

Rhinopithecus roxellana

The golden snub-nosed monkey is a species of Old World monkey (those native to Africa and Asia) endemic to western-central China. It is covered in long, thick fur, allowing it to withstand colder temperatures than other primates and it is adapted for the snowy, mountainous forests it inhabits at around 9,800 feet (3,000 m) above sea level. They live in social groups consisting of one male and several females and spend most of their time in trees, eating leaves, bark, and lichens. There are three other subspecies of snub-nosed monkey, all living in a similar range and habitat, and all are classified as endangered. The specimen pictured here was collected by Theodore Roosevelt Jr. (the eldest son of US President Theodore Roosevelt) on a 1928–1929 zoological expedition to Southeast Asia, sponsored by the Field Museum.

Golden snub-nosed monkeys have experienced a 50 percent population decline in the past 40 years; there are about 8,000 to 15,000 individuals left. Threats to the monkey started far longer ago, however, as it was thought that its fur had medicinal properties and it was widely hunted—Chinese aristocracy used to wear their pelts to ward off rheumatism. Today, this practice has more or less ceased, although some illegal hunting for their meat continues. The species is now mostly threatened by degradation and loss of habitat as forest is cleared for agriculture and commercial logging. Its preferred winter food source, lichens, grows in abundance on the bark of dead trees that are now logged instead of being left to decay in the forest. While golden snub-nosed monkeys occur in a number of protected areas, the steady loss of its habitat puts it at great risk of extinction.

Conservation Status

● Endangered

In their social groups, female snub-nosed monkeys take responsibility for choosing which males may join and replace members of the group, with very little fighting between males occurring.

Number of plant species in diet

84

31144 ♂

Rhinopithecus roxellanae ♀

China: Szechwan; Mupin

March 19, 1929

T. Roosevelt

Golden Lion Tamarin

Leontopithecus rosalia

The golden lion tamarin is a species of New World monkey that inhabits the tropical coastal forests of Brazil, spending most of its life in the tree canopy. It is a relatively small species, only reaching a length of 15 inches (38 cm) from head to tail and weighing around two pounds (0.9 kg). The tamarin is immediately recognizable by its bright orange mane, a unique characteristic that has contributed to its designation as the national symbol of Brazil.

In the 1980s, numbers of golden lion tamarin reached an all-time low, with an estimated 150 individuals remaining in the wild. By 1996 the tamarin was classified as critically endangered. This is largely due to habitat loss—90 percent of Brazil's coastal forests have been cleared for logging or development. The species also had to contend with collection for the pet trade, although this became illegal in 1970.

Fortunately for golden lion tamarins, conservationists have spent the last three decades fighting for their survival. With a captive breeding and reintroduction program initiated with zoos around the world, their number increased to 1,000 individuals in the wild by the year 2000. Their status was downgraded to endangered by the IUCN in 2003. Their numbers continued to rise to 3,700 by 2014.

Habitat loss is still a major concern and one organization, Saving Species, has taken practical steps to tackle the problem. Extensive research led the non-governmental organization (NGO) to buy and reforest corridors of connectivity between fragmented areas of suitable habitat. Chair of the NGO, Dr. Stuart Pimm, describes it as "stitching habitat fragments [together] to form much bigger habitats."

However, in 2016 an unfortunate new threat presented itself in Brazil—an outbreak of yellow fever that infected thousands of humans before it began spreading to primates in 2018 (researchers have since determined that primates are more susceptible to the disease than humans). Numbers of golden lion tamarins decreased by a third over two years—their population size now hovers at around 2,500 individuals in the wild. Golden lion tamarins are in desperate need of a successful vaccine and immunizing a minimum of 500 individuals would in turn curb the spread of the disease to humans as well. Even in light of this setback, conservationists continue to fight for the plight of *L. rosalia*, such as the nonprofit group Golden Lion Tamarin Association, who capture and vaccinate the monkeys and then relocate them to repopulate areas that were most affected by the outbreak.

Conservation Status

● Endangered

Adult tamarins give some of their food to juvenile offspring, and by doing so teach and influence the next generation's foraging choices.

Number of species in genus *Leontopithecus*

4

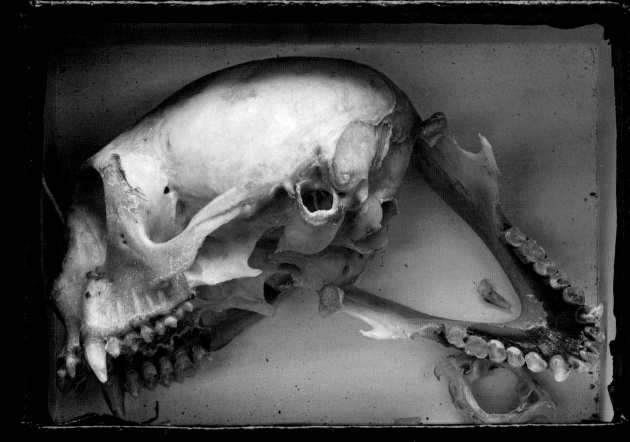

Ring-Tailed Lemur

Lemur catta

The ring-tailed lemur is one of the most distinctive species of lemurs, known by its ringed black-and-white tail that measures around 23 inches (60 cm) long, which is longer than its entire body. It is endemic to south and southwest Madagascar in a broad range of forests and canyons and can tolerate the most extreme environments of any species of lemur. Also unusual for lemurs, *L. catta* spends most of its time on the ground rather than in trees.

In 2014 the IUCN listed the ring-tailed lemur as endangered. Its population has become severely fragmented in the past decade. Madagascar suffers from an extremely high level of deforestation—forests are cleared to make space for grazing livestock and agriculture as well as harvested for timber to produce charcoal and firewood. This habitat destruction has had a negative impact on the ring-tailed lemur, coupled with hunting for bushmeat and collection for the illegal pet trade. They are also affected by drought—a particularly bad drought in 1991 to 1992 resulted in a 31 percent drop in one area's population that took four years to recover.

This species inhabits about 20 protected areas in Madagascar and international trade of the animal is prohibited under CITES, yet numbers of ring-tailed lemur continue to fall. By 2017 the population had decreased by 95% since the year 2000. Fortunately, the species fares well in captivity and numerous zoos around the world have implemented successful breeding programs. Zoos also play a part in local conservation efforts in Madagascar, contributing finances and expertise.

Conservation Status

● Endangered

41 percent of captive individuals in Madagascar are held to generate income from tourism.

Average number of individuals per social group

15.6

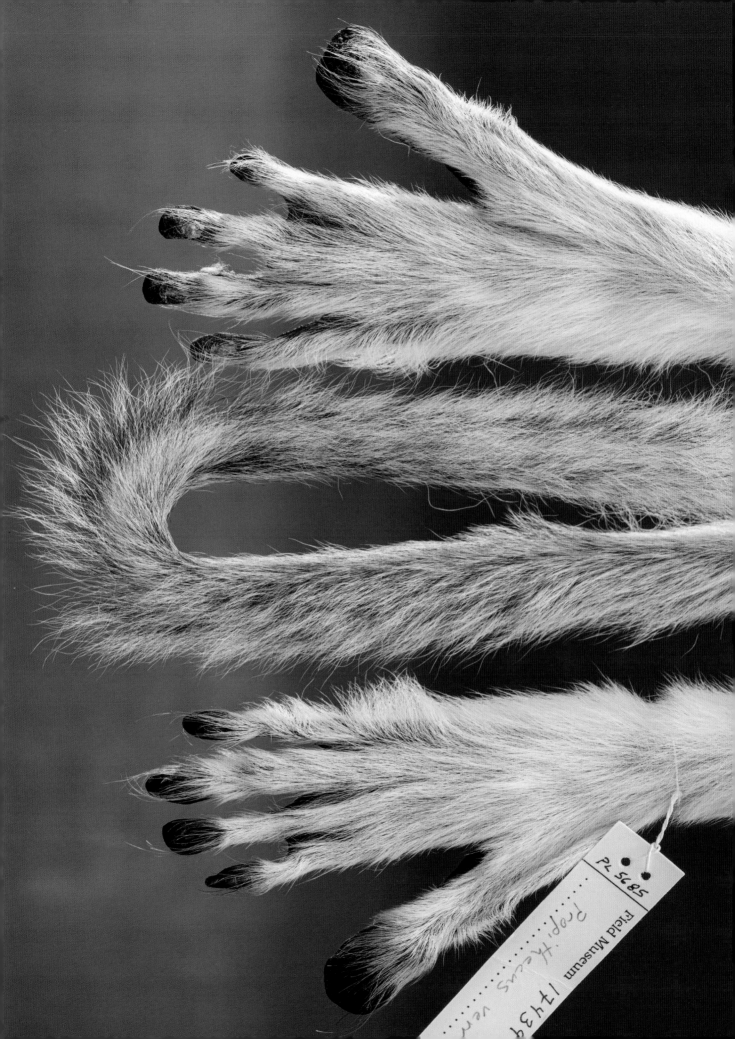

Okapi

Okapia johnstoni

The okapi looks like a mix between a zebra and a horse but it is most closely related to the giraffe. The animal, which has a brown body with black-and-white striped legs and a horse-shaped head, was not discovered until 1901. Okapi are eight feet (2.5 m) long and weigh 400 to 700 pounds (180–315 kg). It is native to Central Africa, primarily the forests of the Democratic Republic of Congo (DRC), and it previously occurred in Uganda.

It is roughly estimated that there are between 35,000 and 50,000 okapis left in the wild—it is difficult for researchers to ascertain a true population size as access to their habitat and their secret demeanor only allow for estimates based on crude data. In 2015 the IUCN estimated that okapi have suffered a 43 percent decline over 24 years (based on figures from surveys in the Okapi Wildlife Reserve), widely blamed on the decade-long civil war in Central Africa and ongoing security issues that plague the region. They have also suffered the effects of logging, human settlement, illegal mining, and hunting for their flesh and skin (okapis are prized as bushmeat), which continues despite full protection of the species under Congolese law.

The Okapi Wildlife Reserve is a World Heritage Site in northeastern DRC, established to protect the species and its threatened habitat. It was set up in 1992 and spans three million acres (1,214057 ha) of Congolese forest. The area had seen very little deforestation until a high spike was detected in 2021, most likely due to agriculture expansion, illegal gold mining, and poaching. John Lukas, co-founder of the Okapi Conservation Project, observed in 2019, "Mines draw in desperate people, depend on bushmeat to feed the miners, and are subject to extortion by rogue militias and the military."

In one tragic incident in June 2012, the reserve's headquarters was attacked by a militia group led by an elephant poacher, reportedly in response to a crackdown on poaching in the area. They killed six people, took 28 young women as hostages, and shot dead the 14 captive okapis living there—a stark reminder of the devastating impact security issues can have on a country's conservation efforts.

Conservation Status

● Endangered

The stripes that okapis share with zebras are an example of convergent evolution, where different organisms independently evolve similar solutions to the same problem.

Maximum altitude of habitat in feet

4,921 (1,500 m)

--- FIELD MUSEUM OF NATURAL HISTORY ---

FMNH 104084 - skin, skull & partial skeleton
Okapia johnstoni
Zoo: Zaire;

Chicago Zoological Society
06 Oct 1966

Red Panda

Ailurus fulgens

The red panda is admired for its beauty and its tree-climbing agility. It was first described in 1825 by French zoologist Frédéric Cuvier, who named it *Ailurus fulgens*, meaning "fire-colored cat," and referred to it as "quite the most handsome mammal in existence." The red panda became known to scientists decades before the giant panda of China, which is a bear, not a panda—making the red panda the only true panda by nomenclature. It looks nothing like a giant panda, with its rust-colored coat punctuated with patches of white on its face and a tail ringed in stripes. The relationships and taxonomic classification of the red panda have been under debate since the 1820s—it was first described as a member of the raccoon family (Procyonidae), later moved to the bear family (Ursidae), and now exists as the only species in its own family, Ailuridae, sister to raccoons and weasels. It is endemic to a small band of temperate forest in the Himalayas of Nepal and China at elevations of 7,200 to 15,700 feet (2,200–4,700 m) above sea level. Like the giant panda, the animal primarily eats bamboo and is active for just over half of the day.

The IUCN estimates that there are around 10,000 red pandas left in the wild, representing a decline of around 50 percent in the past 20 years. As the only representative of the family Ailuridae, its extinction would be "like losing the whole cat family, from lions to domestic cats," says Dr. Angela R. Glaston, who heads a management program for red pandas at the World Association of Zoos and Aquariums, a global conservation alliance. Destruction of its habitat, as forests are cleared and land is prepared for agriculture, is a major threat to the red panda. Historically, it has also been targeted for its fur.

There are several programs around the world, mostly in zoos, that focus on captive breeding of the species and on researching the behavior of this notoriously shy creature. However, only half of the red pandas born in captivity survive and overcoming this lack of breeding success is a major challenge for biologists. Many national and international programs seek to protect the wild population. For example, one nonprofit organization, Red Panda Network, pays more than 50 local people to monitor the population and the threats it encounters.

Dr. Elizabeth Freeman, a conservation biologist at George Mason University, works in China to observe the species and understand how they behave in the wild. While there have been positive steps made toward saving the red panda, Freeman remains skeptical about what can be done at this point. "I think down the road what may actually do them in is climate change," said Freeman. "Because they are in such a small niche in the Himalayas, and as climate change warms that area and moves that population higher in elevation, they're going to lose habitat probably faster than they can accommodate climate change. I see them as being a critical indicator species for the health of the Himalayan ecosystem, probably more so than giant pandas."

Conservation Status

● Endangered

Red pandas have evolved a false thumb, an elongated wrist bone that helps them to grasp branches while climbing trees.

Number of institutions housing captive red pandas

182

Red-Shanked Douc

Pygathrix nemaeus

The red-shanked douc, sometimes referred to as the "costumed ape," is one of the most colorful primates. Its yellow face is flanked with a bright white beard, and it appears as if it is wearing white gloves and orange stockings. Its face is almost doll-like, with a permanent serene expression. The douc—Vietnamese for "monkey" and pronounced "dook"—spends the majority of its life in tree canopies, eating mostly leaves. It is endemic to Southeast Asia and inhabits northern and central Vietnam, Laos, and Cambodia.

The main threat to the douc is hunting by humans for both food and use in traditional medicines—it is known to freeze rather than flee when confronted, making it an easy target. Its appearance and rarity also mean that the red-shanked douc has been heavily targeted by the illegal pet trade. There are laws in place to protect the species from hunting but they are poorly enforced throughout its range. Habitat loss is another contributing factor. Expanding human populations mean more forests are cleared for agriculture.

These forests were significantly damaged during the US-Vietnam War by the US military's use of the herbicide Agent Orange as a chemical defoliant. There were reports of soldiers using the doucs for target practice. In 2012, three Vietnamese soldiers admitted to torturing and killing two gray-shanked doucs they say they bought from local citizens. Education to raise awareness of the need for conservation of all doucs remains a huge challenge.

Pygathrix nemaeus has been classified as critically endangered since 2015, with a decline of 50 to 80 percent over the past three generations. Some conservationists predict that the decrease may continue at a similar rate over the next three generations. However, there is evidence that Vietnamese conservation efforts are providing good protection. Much of the red-shanked douc's habitat is now protected but without proper enforcement the primate continues to face the risks of illegal hunting and trapping, which could ultimately bring it to extinction.

Conservation Status

● Critically
 Endangered

Pygathrix species are unusual for their family of Old World monkeys, in that they use under-branch arm swinging as a method of locomotion significantly more than other species.

Average social group size

18

Thylacine

Thylacinus cynocephalus

The last known remaining thylacine, or Tasmanian tiger, died in captivity in 1936. By the time European colonizers arrived in Australia, the dog-like marsupial could only be found on the island of Tasmania, and it began attacking the settlers' sheep. A bounty scheme was soon in place, resulting in the eradication of thousands of them—by the 1920s wild thylacine were extremely rare.

The thylacine was a large carnivorous marsupial—mature individuals weighed about 45 to 55 pounds (20–30 kg). With its short legs and long torso, it most resembled a dog, one with a stiff tail and striped markings similar to a tiger. Its temperament has been described as nervous and shy, comparable to that of a Tasmanian devil. Most notably, it was able to open its jaws up to 80 degrees, wider than any other mammal and surpassed only by certain snakes.

Today the thylacine remains a major component of Tasmanian culture, maintaining an almost Loch Ness Monster status, with regular claims of unsubstantiated sightings—1,200 have been recorded between 1910 and 2019. The animal continues to be the subject of great debate after the Australian Museum in Sydney launched the Thylacine Cloning Project in 1999. In a process known as de-extinction, DNA is extracted from a fossil or museum specimen to alter the genome of a related living species and a surrogate mother would give birth to a clone, a genetically identical copy of the specimen. However, critics of de-extinction maintain that the process is further exploitation of the species, and that reintroduction could affect ecosystems in negative and unforeseen ways, especially given that an ecosystem's conditions may have changed since the species' extinction. Due to the poor quality of the samples, the project was halted in 2005 but scientists announced that they were finally able to sequence the species' genome in 2017, one step closer to cloning the extinct marsupial and resurrecting the species.

Conservation Status		Number of thylacine specimens used to extract ancient DNA in 2018	
● Extinct	Recent DNA analyses revealed that the thylacine may have already been doomed, as harsh El Niño climate events caused a severe reduction in population just before European settlers arrived.	51	

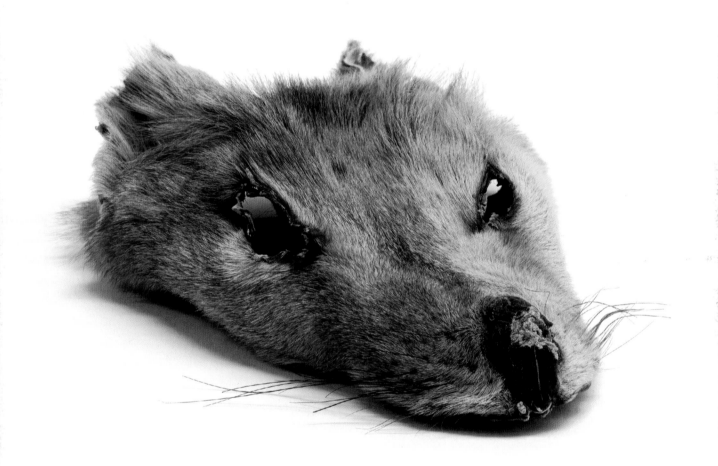

Glossary

abundance The number of individuals per species in an ecological community.

adaptability The way that species change behaviors to meet challenges presented by their environment.

adaptive radiation A process in which organisms diversify quickly from an ancestral species into a large number of new forms in order to exploit newly available niches.

algal bloom A rapid increase in a freshwater or marine algae population.

anatomical Relating to the representation and study of anatomy.

ancient DNA DNA extracted from deceased specimens at least decades old.

apex predator Predators at the top of the food web with no natural predators.

background extinction rate Based on the fossil record, the number of species expected to go extinct over time based on factors not human-related.

bacteria Ubiquitous one-celled organisms existing on most surfaces of the Earth and on organisms.

biodiversity The variability and variety of life on Earth. A contraction of "biological diversity."

biome Areas with similar climates, fauna, flora, and terrain.

bivalve A type of mollusk, such as clams, mussels, oysters, and scallops, with its body inside two hinged shells.

black market Illegal trade in officially controlled commodities.

boreal (zone) The subarctic forested ecosystem in the northern hemisphere.

brood-parasitism Brood parasites are animals that depend on other individuals, either from their own species or another to rear their young.

brumation A state of inactivity utilized by some reptiles during periods of low temperature, similar to hibernation.

bryophytes A taxonomic group of plants including hornworts, liverwort, and mosses.

calcareous Referring to a mollusk shell made of calcium carbonate.

carapace The hard upper shell on animals such as turtles and beetles.

cartilage Flexible tissue that is softer than bone; shark and other cartilaginous fish skeletons consist entirely of cartilage.

chlorophyll The green pigment in plants that contains the necessary biochemistry to perform photosynthesis, producing oxygen and sugars using sunlight as a source of energy.

CITES Convention on International Trade in Endangered Species, an international governmental agreement in 1963 to regulate trade in botanical species and wildlife.

clade A group of organisms descended from a common ancestor; lineage.

community An association of two or more species coexisting in the same area at the same time.

computational modeling The use of computers to simulate and study complex systems by building predictive models of an observed process.

connectivity A process in which landscape corridors and crossings link fragmented habitat areas, enabling colonization, migration, and reproduction.

convergent evolution The independent development of similar characteristics in unrelated species as a result of adapting to similar environments or ecological niches.

coral polyp A tiny soft-bodied marine organism with a calicle, a limestone base that forms a colony (and over time a reef) as the polyp divides into thousands of clones.

crash (population) A sudden decline in population size caused by disease or environmental stress, or the habitat's inability to support the population.

cultivated The preparation and use of land for agriculture.

cyanobacteria Aquatic bacteria that produce their energy via photosynthesis.

derived Pertaining to characteristics not present in an ancestral species.

description (of a species) A formal description of a newly discovered species, normally in a scientific journal, explaining how it is different from other species.

DNA Deoxyribonucleic acid is a molecule that contains genetic information for biological growth, maintenance, and functioning, and can be inherited down a lineage of organisms.

ecosystem A biological community of interacting organisms and their physical environment, all functioning as a unit.

electroreception Used by certain animals, including fish, to detect electrical fields generated by other individuals.

El Niño A climate pattern involving unusual warming of the surface of the eastern Pacific Ocean, impacting weather worldwide.

Endangered Species Act The primary law in the U.S. protecting threatened species, passed in 1973.

endemic Restricted in geographical distribution to a given area.

environment An organism's entire surroundings.

environmental DNA (eDNA) DNA that is not taken directly from an individual organism. Sources of eDNA include feces and shed skin and can be sampled from soil and freshwater or marine environments.

EPA Acronym for the Environmental Protection Agency, a US federal government agency established in 1970.

eukaryote An organism of one or more cells in which DNA, packed as chromosomes, is contained in a distinct nucleus. Eukaryotes are one of the three largest branches in the tree of life, the others being bacteria and archaea.

eutrophication The process by which an excess of nutrients in a body of water, often from agricultural runoff, results in an overgrowth of algae and plants that degrades the environment.

extant Still in existence; surviving.

extinction The process or state of a group of organisms having been completely eradicated.

extirpation The local extinction of a population of a species—the species may continue to exist elsewhere.

fossil record The history of life as documented by animals fossilized in sedimentary rock throughout geologic time.

fragment A group of individuals of a species geographically disconnected from the rest of their population or an area of habitat disconnected from a larger area, both often via human-related activities.

gene expression The relative level at which a gene's instructions are used to synthesize a gene's product, usually a protein. Not all genes' instructions are used all of the time.

genetic diversity Refers to the diversity of genetic characters present in a population's combined genetic heritage. It is the primary contributor to biodiversity in ecosystems; variability in a population allows natural selection to occur.

genome The complete set of genetic information, or material, in an organism.

genome sequencing The process of determining the base-by-base sequence of DNA instructions present in an animal's genome.

genotype The genetic makeup of an organism, its complete set of genes.

habitat The natural environment of an organism, with the resources to support survival.

holotype A single specimen used to describe and name a new species to which all other specimens are compared.

imprint A learning process in which a very young animal narrows its behavioral preference to the first object or organism it interacts with.

indigenous (see endemic) Originating in and naturally occurring in a particular area.

invasive species An alien species introduced to an area that has a detrimental impact in the novel ecosystem.

island speciation The evolution of new species with distinct characteristics not usually observed on the mainland, due to islands possessing atypical biological pressures and ecological niches.

keystone species A species that has a very high impact on its ecosystem relative to its abundance, such that most or all other species are dependent on that species directly or indirectly.

life history The sequence of events in an organism's life related to reproduction and survival.

lineage How an organism descends from a common ancestor. Also called a clade.

living fossil An extant taxon that resembles an ancestral species known only from the fossil record and that has remained relatively unchanged through time.

marine plankton Marine organisms that drift in ocean currents and cannot propel themselves. Phytoplankton are plants and zooplankton are animals.

mass extinction event A global and rapid decrease in biodiversity over a relatively short period of geological time. There have been five such events in history.

mitochondrial DNA (mtDNA) The genetic information present within mitochondria, an organelle of a eukaryotic cell that is responsible for the cell's source of energy. Mitochondria have mtDNA as they originated from single-cell organisms that merged with eukaryotic cells.

metabolism The chemical reactions in cells that convert food into energy.

migration The movement of organisms, often as a large group, to another environment, often on a cyclical or seasonal basis, to take advantage of more favorable conditions.

model organism A nonhuman species used to study biological processes in order to apply the insight to other organisms.

morphology The form and structure of an organism.

mortality The ratio of the number of deaths to the total population size.

niche (ecology) The specific environmental conditions, features, and resources within an ecosystem that a species interacts with and utilizes.

nomenclature A system of naming organisms in which a species receives a unique name, both the scientific binomial form originated by Carl Linnaeus in 1753 and a common name.

overexploitation The use or extraction of organisms such that the population is severely depleted.

pathogen An organism that causes disease.

phenotype All of an organism's observable characteristics, including appearance, behavior, and development.

pheromone A chemical substance released into the environment by an animal, especially a mammal or an insect, affecting the behavior or physiology of others of its species.

photosynthesis The process by which plants use sunlight, water, and carbon dioxide to create oxygen and energy in the form of sugar.

pollinator An animal, such as bats, birds, and insects, that transfers pollen from a flower's male stigma to the female stigma of the same or another flower.

population A group of individuals of a species interbreeding and living in a given area.

population bottleneck An event, such as habitat destruction or environmental disaster, that drastically reduces a population for at least one generation.

population fragmentation When groups of the same species become separated, resulting in inadequate gene flow; often caused by habitat fragmentation.

prehensile Capable of grasping or holding.

primordial Existing at the earliest stage of development; primeval.

pupation The stage of insect development in which metamorphosis occurs from larva to adult.

pursuit predation Predation in which predators chase their prey, solo or as a group.

reintroduction The process of raising and rehabilitating individuals of a species from captivity or places they can survive and releasing them into their natural habitat.

sex determination The establishment of the sex of an organism, usually by the inheritance of certain genes commonly localized on a particular chromosome or through nongenetic factors such as environmental pressures.

sexual dimorphism The differences between sexes of a species at a genetic and phenotypic level.

siltation The process of water-borne sediment settling, often undesirably in river channels and mouths.

sister group Two groups resulting from a split in evolution from a common ancestor.

speciosity Of a taxon or a group of organisms; rich in species.

subpopulation A subset of a population with common, distinguishing characteristics.

sustainable Conserving ecological balance by not depleting a natural resource.

symbiotic A close physical association between two different organisms, usually beneficial.

taxonomy/taxonomic The science of classifying, describing, and naming extinct and living organisms.

total species richness The number of different species in an ecological community.

trophic Relating to the feeding habits and food relationships of organisms in a food chain.

vascularization (plants) A feature of plants with vascular tissue called phloem and xylem that transport water, minerals, and the products of photosynthesis within the plant.

venomous The ability to poison via bite, sting, or wound with a gland secreting venom.

vestigial The retention of characteristics in an ancestral form that may no longer serve the function for which they were originally intended.

viability Relative to populations, the ability to thrive and to avoid extinction.

warm-blooded (fish) Having a high body temperature relative to the surroundings.

About the Author

Marc Schlossman grew up in Chicago and is a London-based freelance photographer and videographer. As a teenager he found a love of the natural world and remote places on canoe expeditions in the vast landscapes of northern Canada and Nunavut. Volunteering during his high school years at the Field Museum, Chicago, in the Mammals Collection, he spent one entire summer labeling just mink skulls.

Marc went on to attain a BSc in Wildlife Biology from the University of Maine at Orono. After university he worked installing fossil specimens in display cases in Iowa Hall, part of the University of Iowa's Museum of Natural History, and at the same time discovered photography, building a homemade black-and-white darkroom in a rented house in Iowa City. He relocated to London and joined the photojournalism agency Panos Pictures in 1992. An exhibition of his work documenting wildlife conservation work with the Arabian oryx and other species in Saudi Arabia took place at the US Embassy in Riyadh in 2012. His project on extinction has appeared in *The Sunday Times Magazine*, *New Scientist* magazine, *Biodiverse* magazine, and CNN.com.

Katie Davis, Executive Director of Wildlands Network in the US said, "For any tragedy, there comes a time when we must take stock of what we've lost. Marc Schlossman's book illuminates in vivid detail what we have lost or are at risk of losing as humans continue our assault on the natural world. Much more than a grim tally, the prose and photos beautifully elevate the names and stories of extinct and endangered creatures that don't make headline news—moving us beyond the world of alarming statistics to an emotional connection that inspires conservation action."

Explore www.extinction.photo, the website associated with this book, and find regularly updated life histories for all the featured species. See more of Marc's work at www.marcschlossman.com.

Contributing Writers

Species' Stories

Lauren Heinz worked in London for over 12 years as an editor, curator, and researcher in publishing, digital media, and the arts, specializing in photography. She was an editor at *Foto8* magazine and the *British Journal of Photography* before relocating to the US and working for Magnum Photos, developing their photographer-led workshops around the country. Lauren is currently a freelance editor, writer, and event producer. She has collaborated with Marc on his extinction work since 2016.

Chapter Introductions

Ben Schlossman read for an MSci in Biology at the University of Bristol, England, where he is a Research Associate, specializing in phylogenetics and molecular evolution. His research examines the evolution and emergence of vision in early marine animals.

Nathan Williams is a population ecologist with eclectic interests. His previous research examined the biological traits of organisms that determine extinction risk. More recently as a PhD student, he investigated the dynamics of red fox populations in central southern England.

Acknowledgments

A project of this scope takes on a life and momentum of its own as it grows and I am amazed that it always seemed to draw in the ideal collaborators at the right moment to get to the next level.

Special thanks to Lauren Heinz, the only person I wanted for the research and writing of the species' life histories. The words here convey the messages more than the images and I am extremely fortunate to have her dedication and energy in the work.

Special thanks to designer Paul Palmer-Edwards, whose creativity, enthusiasm, and ingenuity transformed lists of images and texts into a book that is more than I imagined it would be.

Special thanks to Ben Schlossman and Nathan Williams for adding time and depth with their chapter introductions. Their editing, research, and writing have brought so much to the book.

Special thanks to Matt Wreford for retouching work that has realized the full potential of these images.

Special thanks to Tom Hole for designing and developing www.extinction.photo, the forerunner to this book.

Thank you to Brett Foraker, Robert Brunton, Adrian Evans, Michael Regnier, Kristen Harrison, Adam Goff, Robert Hackman, Adri Berger, Tim Hetherington, Phil Aikman, Charlie Swann, Roz Arratoon, Jasper Jones, Max Wakefield, Tova Krentzman, Debby Besford, Simon Urwin, Jason Hook, Andrew Sanigar, Tim Edwards, Alwyn Coates, David Rowley, Eleanor Macnair, and Archie and Esther Lieberman. At Ammonite Press, many thanks to Dominique Page, Jonathan Bailey, Jon Hoag, and Jonathan Phillips.

At the Field Museum, thank you to Alan Resetar, Tom Gnoske, Ben Marks, Dave Willard, Mary Hennen, Matt von Konrat, Christine Niezgoda, Laura Briscoe, Wyatt Gaswick, Crystal Maier, Robin Delapena, Bruce Patterson, Lauren Smith, Caleb McMahan, Sue Mochel, Kevin Swagel, Jochen Gerber, JP Brown, Lawrence Heaney, John Weinstein, Daniel Le, Rüdiger Bieler, João Capurucho, Terrence Demos, Jacob Drucker, Adam Ferguson, Taylor Hains, Lucia Kawasaki, Abhimanyu Lele, Heather Skeen, Maureen Turcatel, Tyrone Lavery, Charlotte Gyllenhaal, Bethany Elkington, Thorsten Lumbsch, Ken Gioeli, and Sarah Ebel. Every conversation with museum staff and visiting researchers was valuable and thank you to anyone I have forgotten, you are all part of the work.

And finally at the Field Museum, special thanks to John Bates for his foreword and for opening the doors; to Mark Alvey for riding in with reinforcements at a pivotal moment; and to Steve Strohmeier, who knows why.

For John and Shirley, Nici, Ben, and Theo

"We could learn to live between all of the secrets that we found, before it's all gone."

Sel Balamir

Index

First published 2022 by Ammonite Press

An imprint of GMC Publications Ltd.
Castle Place, 166 High Street, Lewes, East Sussex, BN7 1XU, United Kingdom

Text and photographs © Marc Schlossman, 2022

Copyright in the work © GMC Publications Ltd, 2022

ISBN 978-1-78145-453-4

Publisher: Jonathan Bailey
Production Manager: Jim Bulley
Senior Project Editor: Dominique Page
Designer: Paul Palmer-Edwards

Set in Plantin.

Color origination by GMC Reprographics

Printed in Malaysia

FSC
www.fsc.org
MIX
Paper from
responsible sources
FSC® C001507

Picture credits

Key: a = above; ar = above right; al = above left; br = bottom right;
bl = bottom left; t = top; tr = top right; tl = top left

All photography © Marc Schlossman, except the following:
Adobe Stock: p15tr, br; p45al, tr; p83t, bl; p121tr, br; p143al, tr, br; p165tl,
tr, br; p185al, tr, br. CSIRO: p15al. Shutterstock.com: p45br; p83br; p121al.
© Tova Krentzman: p216.

Right: A drawer in the Bird
Specimen Collection of the
Field Museum.

Overleaf: Pepperpot
earthstar (*Myriostoma
coliforme*).

Extinct

Pterodroma carribea '
Oceanodroma macrodactyla ²
Camptorhynchus labradorius

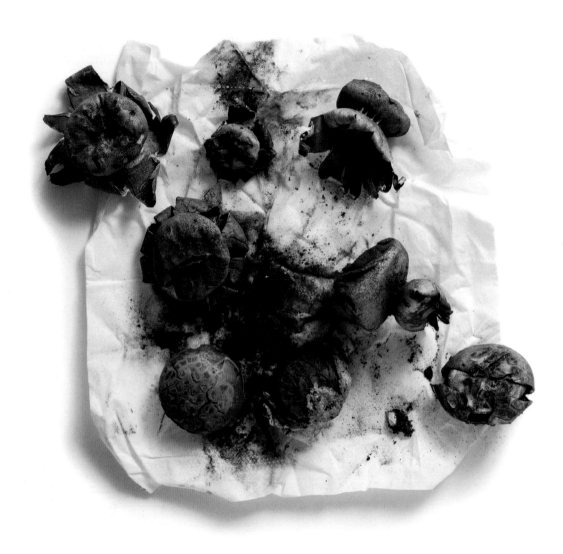

AMMONITE
PRESS

www.ammonitepress.com